FIREFIGHTERS
OF
CAMBRIDGE

FIREFIGHTERS
OF
CAMBRIDGE

DAVID BENNETT

AMBERLEY

In memory of Joan Smail and for Dave and Crocker, KC and Jonah

We're lucky really. You get the nippers growing up and they ask you: what have you done? Some'll say they shuffled papers 'round a desk for a lifetime. Others spent their time punchin' 'oles in bits of metal. What sort of life is that for anyone? We're lucky, really; I don't care what you say. Me? I'd rather be on the land. But there you are, you can't have everything. It's not a bad old job when you come to look at it. The money's there every week, or month as it is now. You can always make a shillin' on the side. And you arn't doing anyone any harm, are you? When you roll up to a job, people are pleased to see you, not like when I was in the police. We have some laughs too. Especially on nights. But there again, I'd rather not do nights ...

Firefighters of Cambridge contains certain terminology that may be offensive regarding race, sexuality and nationality. While we recognise that the terminology itself is offensive, its use in *Firefighters of Cambridge* is purely to give a true account of life on a fire station in the years 1951-1981.

First published 2010

Amberley Publishing Plc
Cirencester Road, Chalford,
Stroud, Gloucestershire, GL6 8PE

www.amberleybooks.com

Copyright © David Bennett 2010

The right of David Bennett to be identified as the Author of this work has been asserted in accordance with the Copyrights, Designs and Patents Act 1988.

ISBN 978-1-84868-954-1

British Library Cataloguing in Publication Data.

A catalogue record for this book is available from the British Library.

Typeset in 10pt on 12pt Sabon.
Typesetting by Amberley Publishing.
Printed in the UK.

Contents

Acknowledgements

Much of this book was written while I was a firefighter with the Cambridgeshire Fire and Rescue Service, 1972-1977. The rest was completed and the whole revised between then and the present. The book is thus based on personal experience as a firefighter and related reading, but above all it is based on working with firefighters, on observations and conversations with co-workers. Most of the impressions and interpretations are those of the time; where these have been modified by later experience, information and hindsight, I have made this clear. One reason for not attempting to go into print until recently was a reluctance to write candidly about my friends. Some readers will find it odd that I would write critically about such friends, something of which I am still acutely aware. In every case, retired Cambridge firefighters were open and helpful in commenting on the text of the book, even where the book was critical of their actions and even where their views diverged from my own. In some of the quotations by firefighters I have changed or suppressed the names of the source and those named in the quotation. Some personal information has also been omitted; this is not the sort of information which critics, particularly academic critics, could or should divulge. Yet I have nowhere deliberately distorted events and motives, nor the social, occupational and political predicament that firefighters found themselves in. I distributed a questionnaire to retired Cambridge firefighters in 2007. The purpose of this was not to make sociological generalisations thirty years after the event, but to illuminate the contentions made in the text. The questionnaire is reproduced in the Appendix.

Earlier drafts were read and criticised by Nigel Crisp, Peter Duncan, Sue Goodman and the late Ken 'Jock' Tanner. Derek Beales, John Beynon,

Ken Chapman, Neville Cross and Rob Gordon made helpful comments on a much more recent version. I benefited from discussion of the nature of the firefighter's job particularly with John Beynon, Neville Cross and Ian Grieg. For discussions of trade union politics at the time, I have to thank Neville Cross, the late Ron Knowles, Dave Mills, Roger Moore, Tony Pettitt and Tommy Tucker, as well as conversations and correspondence with Ken Aldred in 2005. Neville Cross supplied me with documents and, crucially, his contemporary notes on the national strike, while Tommy Tucker commented on the chapter on the strike at Cambridge. Retired Cambridge firefighter Peter Jenkins gave me valuable information and a copy of his extensive album of press cuttings, collected during the strike. Paul Clarke, a current Cambridgeshire firefighter, was also most helpful. I am grateful to retired firefighter Nigel Ogden for supporting me in reproducing documents that were given to me by his father-in-law, Sub-Officer Jock Tanner, so named because he had been in the Scots Guards during the war.

For the wider perspective on English society, Jo Anne Williams Bennett had an unfailing feel for what was going on, making sense of the bewildering flux of region, social status, occupation and peer-group milieu, largely from fathoming out the English sense of humour. I was always challenged in a friendly way by the late Joan Smail, whose appreciation of working-class life was phenomenal and unusual for the widow of a professor. The reader may discern the wider influence of Erving Goffman, George Orwell and Studs Terkel on the depictions of working life. What these very different authors have in common is that their generalisations, social, psychological and political, are all rooted in the concrete and the particular.

My principal thanks go to the firefighters of Blue Watch in the 1970s: Ken Aldred, Steve Andrews (deceased), Stuart Bartram, John Brain (deceased), Stuart Brignell, Bob Bunday, Frank Carter, Ken Chapman, Neville Cross, John Davey, Ron Farrow, Ian Grieg, Dick Haynes, Fred Howe, Russell Howard (deceased), Howard Morley, Mick Hurrell (deceased), Brian Ison, Andy Jones, Dusty Miller (deceased), Alan Payton, Dave Pettitt, Gordon Powell, Mick Richardson, Nick Richardson, Phil Scarr, Rodney Slack, Charlie Sutton, Mick Thomason, Derek Ward, Roger Westcott, Graham Williams, Ikey Williams, Alan West and Tug Wilson.

Special thanks are due to my friends Ken Chapman ('KC'), Andy Jones ('Jonah'), Neville Cross ('Crocker') and Dave Pettitt. From KC and Jonah I learned more about Cambridge in four weeks on the station than I ever did in four years as a student. Special thanks are due to Neville Cross; without many years of discussion and argument with Crocker, this book would have been very different or perhaps not written at all. Dave Pettitt

was firefighter, paratrooper, welder, countryman, piss-taker extraordinaire, thorn in the side of authority, jack of all trades, master of them all. If anyone made Blue Watch the riotous bunch of first-class firefighters that it was, it was Dave.

Some of the material in the book is based on documents of the Cambridgeshire County Council; the Cambridgeshire Fire and Rescue Service; the Cambridge Branch of the Fire Brigades Union; the National Joint Council for Local Authorities' Fire Brigades *Scheme of Conditions of Service*, second edition, September 1969, as amended (the 'Grey Book'); the FBU journal *Firefighter* and *Lessons of the Firemen's Strike*, published by News Line; and the journal of the Workers' Revolutionary Party in January 1978. Five books were also used, two of which appeared many years after the events depicted in the book:

Fetch the Engine ... The Official History of the Fire Brigades Union by Frederick H. Radford, FBU London, 1951 (a rare book which concludes just before the 'spit-and-polish' dispute of 1951)
Red Watch by Gordon Honeycombe, Hutchinson, London, 1976
Report from Engine Company 82 by Dennis Smith, Saturday Review Press, New York, 1972
Forged in Fire: The History of the Fire Brigades Union, edited by Victor Bailey, Lawrence and Wishart, London, 1992
A History of Firefighting in Cambridgeshire by Eddie Baker, Jeremy Mills Publishing, Huddersfield, 2006

Preface

This is a story that is both universal and very local.

It is universal in its account of a group of men, equal in rank, working together to common purpose within a hierarchical system. Here the men are from the Cambridge Fire Brigade; elsewhere they might be soldiers, fishermen, policemen or miners. Living in a private and very male world, they are clear-eyed and suspicious of their officers, unless or until they prove themselves worthy of respect. They are endlessly supportive of their fellow workers, even when they dislike them personally, unless of course, they let their mates down ...

It is very local in its manifestation. It evokes another face of Cambridge, where the life of the town goes on under the shadow of the great University, with firemen doubling as waiters at College Feasts and as boatmen on the river, and where country habits and ways of thinking and speaking co-exist with town and gown.

The author has the storyteller's ability to take the ordinary fabric of life and, with a few well chosen words, turn individuals into semi-mythical figures and events into the stuff of legend. People become characters we can all recognise, and events become universal symbols. Throughout, he has used examples and direct quotations and shows how what one can only describe as a continuous stream of humour or 'piss taking' is used to cut authority and fellow workers down to size.

David Bennett himself is an unusual, perhaps unique, mixture of doctor of philosophy and fireman. His is a genuine tale. He became a fireman not as an academic exercise for research or to write this book, but because that was where his life had taken him at that point. This duality is reflected in the book itself. One might, if one were concerned about academic

categories, describe this as philosophy or anthropology or a mix of the two; but it is also, quite simply, a good story.

He is passionate and prejudiced, making no attempt to hide his own views in false objectivity. I don't know this as a fact, but could well imagine that he is now himself a legendary figure in some parts of the Cambridge Fire Service: the working class public school boy, the 'professor' who became one of them and went on in later life to continue his own battle with authority as a global expert on safe working conditions.

I knew Dave in Cambridge where I was studying Philosophy and, through him, met some of the men he describes. It is a pleasure to meet them again through this well-written, entertaining and thought-provoking tale – which firemen and philosophers alike will enjoy.

Nigel Crisp,
Tutt's Clump
28th February, 2010

Prologue

In the autumn of 1971, I returned to England from North America, after five years as a college teacher and graduate student in philosophy. My wife and I, with our small son Russell, settled in Cambridge, where I planned to use the University Library to finish my PhD thesis for McGill University in Montreal. After that my plans were vague and my prospects of getting a job were poor. The work experience in the US and Canada counted for nothing in the UK and I had no network of contacts in any line of work. In the late winter, I spent a few weeks working on the huge dish-washing machine in the kitchens of Addenbrooke's Hospital; one of the filthiest and lowest-paid jobs I have ever had. Then I saw an article in the *Times*, saying that because of the current recession, university graduates were being forced to look for work in areas not becoming to a gentleman. Among the occupations mentioned were the police and the fire service.

The next day, I got my hair cut and walked round to the Fire Service Headquarters on Parkside. Two uniformed fire officers sent me up right away to see the Deputy Chief Fire Officer, Jimmy Nield. I had appeared at the right time, for the fire service was looking for more highly educated recruits. Nield said I should put in an application and, if accepted, I would be put on a waiting list. As a parting shot he said, 'of course, you will have to get your hair cut'.

The decision to apply to be a firefighter was not merely the result of desperation, a last resort. The 1970s were still a part of the era of the sixties, with its contempt for family and career, together with exhortations to turn on and drop out of the rat race. Yet, becoming a firefighter was not really a case of dropping out; it was still a job with prospects, however unconventional. When the word came, I had also got another job offer:

working in retailing on the shop floor of the John Lewis Partnership, selling pots and pans. Well, what would you have done?

I did not know what to expect. The job I had accepted was more an intriguing curiosity than the first move in acquiring a regular job with, as they now say, a career structure. I had decided to apply on an impulse, which only later crystallised into two themes or presumptions: that the job was both exciting and socially useful. These values, as it transpired, were shared to varying degrees by most of the Cambridge firefighters, 'doing people a bit o' good'. But there was one theme that was, for the firefighters, equally important: the job was regular and pensionable, less susceptible to varying levels of pay and the layoffs characteristic of the building industry, whence many of the firefighters had come. Nor – and this is perhaps surprising – was there any particular focus, preoccupation or singular interest in fire. One of the two officers whom I first encountered at Parkside had said that firefighting was 'in your blood'. So it was, for a few. But for the most part, there was no fascination with fire as such. Even those few firefighters convicted of arson (none at Cambridge, I must add) were rarely closet pyromaniacs. Excitement, risk and danger were certainly motives, but their focus was as much in the content of the work as in its objective: the ability to exercise practical skills under stressful conditions, where you could not afford to make a mistake.

I was an unlikely firefighter. Though I grew up in a rural working class community in the south of England, I was sent away to boarding school at the age of eleven, then to university. The result was that I was raised largely outside the village and learnt few of the wide range of practical skills that are acquired as a matter of course by the children of workers. I also had a university degree, rare for firefighters at the time, less so previously during the war and after the 1970s. That I was an oddity I was occasionally reminded, but rarely with malice. I do know that one of my nicknames was 'the professor'. No doubt there were other, less complimentary, epithets.

Before going away to fire service training school for three months, I spent three weeks on Cambridge Fire Station on 'days' (day duties). On the first day, I was issued with a full fire kit, then started to do the fire drills and station routines, all short of 'riding' to fires. The drill period was an hour in the morning, practising on the firefighting equipment. Routines were regular; work servicing the equipment while cleaning the station was known, as in the armed services, as 'fatigues'. Naturally enough, it was a story of not knowing what was going on and not knowing what to do. On the drill-ground, Ernie Tyrell, who always talked as if he were chuckling at some private joke, held up a piece of equipment.

'Hoo, hoo, know what this is?'
'No'.
'Hoo, it's a foam branch'.

I was none the wiser.

Training School:

I wouldn't want to go through Training School again, not even if it were the price of rejoining the job. But they were good old boys in my squad there; out every night. I wouldn't have missed it really ...

We did BA[Breathing Apparatus] at Training School. Tunnels and dead ends, everything. They stoked the place up, started up the smoke generator. We all got lost, couldn't see a thing. Bloody hot too. All of a sudden one of them foreign blokes on the course panicked, pressed his DSU [Distress Signal Unit]. They had them doors open like a shot, hauled him out and got the rescusitator goin'. Heard that DSU and bang! They had the place clear in ten seconds.

One Sunday afternoon in March 1972, I rode up the A1 on my motor bike to the West Riding of Yorkshire Fire Service Training School at Birkenshaw, my fire kit strapped precariously to the back of the bike. The training school was set up like a fire station, with a mess and dormitories for the recruits, bays for the 'machines' (fire engines), facilities for the equipment, a drill tower and an enlarged drillground for the sixty or so trainee firefighters on the course. There were two salient features of the training, which were related and inseparable. Training was only on the basic equipment of firefighting: pumps, hose, ladders and breathing apparatus (BA), not on the host of ancillary equipment that was used in emergency work just as much as the core equipment – and for which there were no set drills in the Fire Service Drill Book. The second feature was a service, both in training and operation, which was shot through with para-military discipline and procedures; the legacy of the wartime National Fire Service (1941-48).

In order to get the recruits used to doing things quickly, they had to change their clothes repeatedly in the course of a day – from PT shorts to 'undress uniform' for parade and inspection; undress uniform to fire gear for drills; fire gear back to undress uniform for tea breaks; into overalls and cap for cleaning work; overalls to fire gear and so on. Much of the time was spent in lectures. The practical training was for discipline, described as 'firm but not harsh', and the automatic handling of fire brigade

equipment. Some of the training was exhausting, such as repeatedly heaving a portable pump off a 'machine' (fire engine), 'getting it to work,' 'knocking off' (turning off the water supply) and 'making up' (gathering up and restowing the equipment on the machine). Apart from smoke and heat in BA, there were virtually no real fires used in training. For those not used to the use of tools and equipment under pressure, the training was in most ways appropriate. The downside was that the training inculcated needless haste that had to be unlearned when the trained recruit returned to the home station.

As for the para-military system, recruits had to bull their shoes with spit and polish, press their uniforms, march around, do drills on the double, salute the officers and call them 'sir'. The actual training, based on the Fire Service Drill Book, was done by numbers with military orders. The days of such a militarised system were clearly numbered, however effective it was in training firefighters. Some aspects of the training were obviously anachronistic, quite apart from the military bullshit. Getting a 'branch' (nozzle) to work from a machine seemed to be modelled on artillery gun drill from the Great War, more than half a century in the past. Instead of siting, laying, loading, aiming and firing, there was siting the machine, laying out hose, pumping, operating the jet of water and laying in a water supply, with the machine as the surrogate for the howitzer. The jargon was, however, naval rather than military, due to a century-old tradition in the London Fire Brigade of recruiting former seamen. Thus, recruits had to 'ship the standpipe', 'slip the escape' (a wheeled escape ladder), 'knock off and make up', 'stand from under' and tie knots in the naval style. Bewildered by this terminology? So was I. It will have to be explained.

A few recruits failed the course and were sent back to their brigades, where they faced dismissal. More common was dropping out; recruits would fail to show up after a weekend, either because they could not suffer the discipline, more often because they did not like being away from home, or (occasionally) because of difficulties with the training, like not having a head for heights. The unstated reasoning behind all this was that a firefighter who could not take the training would not get on well at the station. It was a crude but effective way of sorting the recruits. I was almost one of these who failed to reappear after a weekend, and the reason has much to do with the social make-up of those on the training course.

There were a few foreign students on the course, from such diverse places as Liberia, Hong Kong and Bahrein. Since these were often officers or trainee officers in their home countries and were not always young and fit, they did not usually do the drills with the other recruits. They were thus not entirely a part of the student body. The rest of the recruits were from Yorkshire, Lancashire, Teeside and Lincolnshire. Some were former

soldiers who had got out of the army to avoid doing another tour of duty in Northern Ireland. I was the only recruit from south of the River Trent and in fact the first to be sent to Birkenshaw from the Cambridgeshire and Isle of Ely Fire Brigade. In many ways, I was an outsider in a strange world full of strange people. The Yorkshire boys still spoke in the familiar form of thee and thou – but only among themselves. I overheard remarks like 'Th'art coont', when in the south we said 'You ain't 'alf a cunt!' The northerners were never unfriendly and eventually I was adopted as a sort of mascot, with that sort of warm, endearing condescension so typical of our northern brothers.

With the instructor of our squad, Sub-Officer Rodney Baker, it was a different story. Baker was a former Guardsman, a drum major whose military band had been, well, disbanded. Redundant, he had joined the fire service and had a chip on his shoulder about not being promoted to Station Officer. In the service, this was the lowest rank of senior officer, with a different uniform, higher pay and the prospect of yet further advancement. Baker was middle-aged and corpulent, incapable of doing the drills he dictated. He thus broke the first rule of military training: never order someone to do a job that you cannot do yourself. I made the mistake of bragging about how I had been to a boarding school organised in many ways on military lines and thus had no problem with fire service discipline. So there I was, the educated, bumptious southerner with an air of superiority. Baker did his best to have me thrown out. His first move – and a ploy that I saw later on Cambridge Fire Station – was to have me fail a carry-down. In this drill, a ladder was pitched to the fourth storey of the drill tower. One firefighter was equipped with a safety harness. The recruit assigned to do the carry-down hoisted the man onto his shoulders in a 'fireman's carry', swung onto the ladder, descended and deposited the person carried onto his feet on the ground. At the time I weighed 140 lb. Baker selected John Gilliver for me to carry, at 180 lb. Since I knew neither the drill nor that I was being set up, I was not nervous and did the carry-down successfully – just. Baker's first attempt had failed.

Then I was injured. One of the exercises in PT involved squatting and hopping with a medicine ball between the legs. I tore the muscles in my ankles and spent a week off. 'Was it boots?' asked Tony Brotchie, one of the officers whom I had first met at Parkside. The stiff leather boots were a common cause of injury, evidently. Incongruously, I spent the week in the University Library, doing research for my Ph.D thesis. I had not been back at Birkenshaw for long when Baker burst into a lecture room and, without acknowledging the instructor, yelled 'Fireman Bennett, Commandant!' While waiting to be called into the Commandant's office, I asked an instructor, 'Do I take my cap off while being interviewed?' Wearing

headgear in such places as the mess was, I knew, just not done. I got a 'bollocking' (dressing down) from the Commandant, was told that my performance was inadequate and put on report. How close I was to being sent home I don't know, but one factor was the animosity towards Baker by his fellow instructors. One of these enlisted me in his relations with the Commandant, at Baker's expense. Among the recruits in Baker's squad, the hostility towards him was so strong that we considered inviting another instructor to the celebration in the pub after the 'passing-out parade'. Baker, for his part, was most anxious that he would get the traditional gift from his squad. I – of all people – was left to chat up him and his wife, while the others enjoyed themselves. The late Rodney Baker did indeed get promoted to Station Officer and I returned to Cambridge as a Fireman, no longer a Recruit but as yet Unqualified.

Back home, I had been on the station for three months, swaggering as if I were a veteran, when Stuart Brignell came back from training school, like me at Birkenshaw. The bells 'went down' and instead of striding or ambling towards his machine, Stuart said 'I'm confused. I don't know what to do!' What Stuart did not know was that you had to wait by your machine until either it turned out to a fire or you were 'stood down'. He became a far better firefighter than I would ever be.

On the fire station there were three shifts known as Red Watch, Blue Watch and White Watch. I was assigned to Blue Watch, to take the place of Russell Howard, a Norfolk man and one of the most respected and well-loved personalities ever to pass through Cambridge Fire Station. So it was the men of Blue Watch that I got to know first. And what characters they were! There was Dave Pettitt, a man of phenomenal ability and humour, the most notorious piss-taker of them all. 'Piss-taker?' Wait for the explanation. There was his mate and fellow table-tennis player, 'Ikey' Williams, so nicknamed because he fitted the Semitic stereotype (actually, even that was far-fetched) – another piss-taker and a riotous mimic. Ikey had a younger brother, Graham, also on Blue Watch. There was Ken Chapman (KC), son of a coalman (household coal delivery man) whose family in Trumpington were known throughout Cambridge. He had a brother Brian, 'Noddy', on Red Watch and I worked for a time with his cousin, the boatman for St Catherine's College, who had a secret and mysterious talent for varnishing rowing eights to perfection. KC was slow-talking and unflappable, not uncommon among the Cambridge working class, yet his piss-taking was as devastating as that of Dave or Ikey.

When I first came onto the station, I heard much about Neville Cross, 'Crocker', who was off sick for several months and I got to know belatedly. Like Dave Pettitt and KC, he is still a close friend. Fortunately for the authenticity of this memoir, Crocker had no reservations, comments or

objections to my descriptions of his character, nor his part in the events that follow. Crocker was a coachbuilder by trade, who had done his apprenticeship during the transition in coachwork from wood to metal. He could easily have built the Emergency Salvage Tender; a specialised fire engine on a truck chassis with custom-made bodywork and interior design. In his spare time, he rebuilt vintage English motor-cycles. With his ferret face, bright blue eyes, a laugh that lit up his whole face, and left-wing political views, he was a natural rebel, disliked by many of the officers. His reputation lasted into retirement. When his son applied to the fire service, he was rejected without explanation and later got a job as a firefighter at a nearby army base.

Crocker was an exotic mixture of socialist and nationalist. Preparing to go by bus to a demonstration in London, he took a ceiling hook from the brigade stores. This was a sort of barbed spear on a broom handle, used for pulling down damaged ceilings. It could easily have been taken for an offensive weapon. Crocker tied the Union Jack to the ceiling hook and marched alone in the middle of the demo. Though this was regarded as eccentricity, it was really no different from George Orwell, who was deeply patriotic as well as being a radical socialist who protested the appropriation of the national flag by the Tories.

Crocker was a perplexing man; at times awkward and difficult. Driving to work, he would dawdle erratically, his mind seemingly on other things than the Highway Code. Yet driving to a fire, he could get a machine through fog and icy roads with the utmost concentration and anticipation of hazard. Crocker's father had worked for most of his life at the Chivers jam factory near the city. When in New York I was asked about the Chivers brand; I always thought of Crocker's Dad.

Crocker's complexity led to lively debate as to whether he was really any good as a firefighter. One conversation was ended abruptly by Graham Williams (a fellow carpenter) who simply said 'Crocker's a practical bloke'. As an estimate of ability by someone himself talented, this was the highest praise a man could get. Exactly what Crocker was good at was not an issue. The 'practical blokes' did not grade each other as to type and degree of skill; there was a single scale of practicality which tended towards the poles of 'practical' and 'not practical'. Part of Crocker's practicality was that if he did not think a job was worth doing, he didn't do it. This was one of the traits that got him into trouble.

Such people were different from each other but they had one thing in common. They were very proud men. They knew they were able, good at the many jobs they did, and did not need to brag about it or to justify the treatment and respect they thought they deserved. Firefighting was only one of the many things they were good at. Some of their inferiors would try

to emulate them as equals, to class themselves as part of a single category. These they would shrug off with casual contempt, as if such things were not worth getting excited about.

Andy Jones, 'Jonah', was a 'character'. His other nicknames were Mutley and Lurch. He was the son of a railwayman, a huge barrel-chested young man with a thick Fenland accent, whose hero was Elvis Presley. On the station, he put me through an initiation rite, which I literally fell for, nearly breaking my back. I hobbled around, incapable of doing anything.

'What am I going to do about this?'
'Book sick after your next shout'.
'What if it's a job?'
'Then you're in shit'.
'Well, thank you very fucking much'.
'Don't you worry about it, ma' owd booty. It's been done before. You'll be alright.'

I was. The 'shout' (fire call) came soon; it wasn't a 'job' (something more than a trivial incident), and I spent three days off sick, due to jumping out of a fire engine onto a broken paving stone.

As a character, Jonah was the source and the butt of much affectionate good humour. He had what was generally regarded on the station as the greatest virtue: helping a mate if he were in trouble or otherwise in need of help. 'If you broke down on the Motorway and phoned him up in the night, he'd be out there in an hour. He's a good old boy. He'd never let you down.'

Another character was the late Dusty Miller, foul-mouthed, roughly dressed and constantly complaining; he was regarded by some as a misfit. Once, a group of firefighters were in the station kitchen, Dusty ranting about something or other when the blokes silently exited the kitchen. It took Dusty, his back turned, about half a minute to realise he was ranting at thin air. He professed Communist views, yet he was the greatest entrepreneur on the watch, being a pig farmer on the side. Dusty was neither gregarious nor popular, yet at his retirement he paid a warm tribute to all his mates and was applauded in return. With the wives of his mates and women in general, he was the gentlest of men. Dusty gives a clue as to the working community of the fire station. There were a few detestable individuals, some loners and some who were simply not popular. Yet none were ostracised and all were, in practical terms, treated no differently from the rest. Some would spend much time with an individual in sports and pastimes, yet privately confide to another that his mate was a treacherous character, not to be trusted, nor respected. 'He's not my mate, but he'll do, if you know what I mean.'

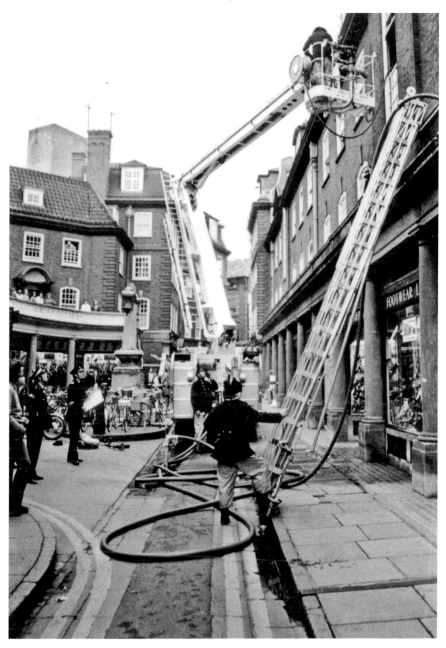

The Fire at Sidney Sussex College, August 3, 1972. (*Cambridge Evening News*)

Of Dusty:

Noddy: 'Ho, Dusty. Did you know? You're in a position to do me a great favour.'
Dusty: 'Ow, yiss. What's that?'
Noddy: 'Stand out in my back garden, stretch your arms out and pretend you're a scarecrow.'

Then there was Roger Westcott, trained in farm management yet obliged to work in his spare time as a farm labourer. Dusty had no time for Roger, probably because he thought that agricultural college was the last place to learn about farming. An ex-policeman, Roger's views were authoritarian and conservative, yet when Margaret Thatcher was seen to damage the interests of farmers, he promptly switched his allegiance from the Tories and voted Labour. He made no secret of the fact that he did not like police work. He didn't have the heart to prosecute members of the village of which he was the policeman, and thought it wrong to give tickets to speeders merely because they were outsiders. Roger said (no doubt an exaggeration) that he had never prosecuted anyone but a group of teenagers who were tormenting some cats before drowning them. He lost the case. Roger's turns of phrase were from the deep country, though he was actually from the prosperous South Cambridgeshire, not the poorer Fens to the north. He would say ''appen it might' instead of 'it might happen' so often that for a time he was nicknamed 'Old 'Appen'.

All of these individuals, and the rest of Blue Watch, appear in the stories that follow. Two characters who figure at length in connection with the union were Ken Aldred and Tony Pettitt. Ken Aldred joined Blue Watch in the mid-seventies, from Red Watch. Tony Pettitt (no relation to Dave Pettitt) spent all of the seventies on White Watch and, though I came to know him well, I never once rode to a fire with him.

Though I did not realise it at the time, my first contact with Cambridge firefighters was earlier than 1972. At dinner time in college hall, Cambridge students were waited on by a group who donned white jackets, served food and collected dishes after a day's work in the town. One of these college waiters was Tommy Tucker, who was later to become a fellow union official in the Fire Brigades Union (FBU). There was another future co-worker. In the spring of 1963 we had put on a cycle of medieval mystery plays in Sidney Sussex College chapel. This had to be inspected for fire safety. A fire crew came to a rehearsal one evening, eyeing but not querying the sets of bicycle lamps masked with red paper that marked the chapel exits and the steps to the altar. The officer in charge was Fred Howe, who nine years later became my junior Sub-Officer on Blue Watch. He eyed, but did not query my performance as a firefighter.

Part 1

On the Job

1.1

Introduction: Firefighting Appliances and Equipment

What this job's all about is those six machines lined up down there in the bays.

I hate that fuckin' Pump on nights – all the rubbish, chimneys and all that – clawin' 'round the town for fuck all. I'd rather be in bed. If that goes out with the HP, that's not so bad, 'cause then you might have a job.

Fire appliances were known invariably as 'machines'. The traditional term 'fire engine' was used occasionally, sometimes with irony. Cambridge Fire Station had six first-line appliances which served a town of over 100,000 and the rural areas within a radius of about five miles from the city centre. Beyond that area, fire engines from the station attended incidents in conjunction with the retained (part-time) fire crews dotted around the surrounding villages as part of an initial turnout, up to a distance of about twenty miles.

The six fire engines were:

Water Tender Ladder (WrL: two identical machines)
Hydraulic Platform (HP)
Emergency Salvage Tender (EST)
Water Carrier (WrC) and
Turntable Ladder (TL).

The Water Tender Ladders were originally Bedford Type TK, which had a specialised bodywork built on an ordinary truck chassis. They were underpowered, overladen, too light and too cramped inside the cab for

safety; in the seventies, they were replaced by Dodge purpose-built fire trucks. One serviced the county and was known as the Water Tender (or the watering can); the other serviced the city and was known as The Pump. They were fairly standard fire engines and carried a common cross-section of firefighting equipment: 500 gpm built-in pump, 45' extension ladder, 30' extension ladder, roof ladder, rescue lines and ropes, 250 gpm portable pump, 400 gallon water tank, delivery hose, hose reel, branches (nozzles) and other water delivery equipment, two BA (breathing apparatus) sets with spare cylinders, foam-making equipment and a fair amount of breaking in, cutting away, and miscellaneous gear.

They were manned by a minimum of four men, since four people were required to handle the 45' alloy ladder, which weighed well over 200lb. The officer in charge (Number One on the Water Tender) was a Sub-Officer or Leading Fireman, the two junior officer ranks. He sat in the front with the driver next to him, the third and fourth (sometimes also the fifth) man in the rear of the cab ('in the back'). The first and third men were the BA wearers, though in practice the third man and his opposite number in an accompanying machine formed the initial BA team in a routine job. They donned their sets on the way to the fire.

One Water Tender covered the city in conjunction with the HP; the other was assigned to rural areas and attended road accidents with the EST. The Water Tenders attended incidents on their own in the event of known minor jobs like chimney fires, lockouts (people locking themselves out), grass fires and rubbish.

In 1972 the ERF Hydraulic Platform (HP) replaced the 55' wheeled escape ladder. 'Escapes' were wooden extension ladders pushed into place by a large pair of cartwheels. The HP was a dual purpose rescue and firefighting vehicle, a cherry-picker with a cage at the end of two hydraulically operated booms, reaching 55'. It carried a 200-gallon water tank, a 500 gpm built-in pump, 30' alloy extension ladder, short extension ladder and the rest of the usual firefighting equipment. As a rescue vehicle it was quicker and easier to operate than a wheeled escape, and there were water delivery outlets attached to the cage. But since the cage could not of course be detached from the vehicle and the vehicle itself could not operate on small service roads and in other constricted areas, its range was more limited than what it replaced. The 45' ladders and the portable pumps on the Water Tenders were even more vital than before.

The Emergency Salvage Tender (EST) carried rescue equipment of all sorts, an electrical generator, salvage sheets, spare breathing apparatus, and a large amount of miscellaneous gear. It had no pump and a minimum of firefighting equipment. Though there was an attempt to equip the EST for all eventualities, its winching and cutting gear were the most important

and the most used. Stowed on the machine were Turfor winches, shackles and steel cables as well as cutting equipment powered by BA cylinders of compressed air: the Sengar Saw, the 'jaws of life' for prizing open twisted metals and the 'zip gun' (panel opener). The machine was used essentially for rescue and salvage work and its equipment was essential at road accidents; but it was also used as a control unit and BA centre at large fires.

Of the compressed air cutting gear on the EST, the jaws of life were the most useful and effective. The panel opener was used quite a lot, but rarely on large expanses of flat metal such as car roofs, for which it was best suited. Since the metal of cars in road accidents was crushed, the use of the panel opener was limited. The Sengar Saw was an automated hacksaw blade but since the blade was not braced, it broke frequently under conditions for which it was not designed, so that operator as often as not finished the job with a simple hacksaw.

The Water Carrier (WrC) had a large 900-gallon water tank and considerable foam-making apparatus. It was a back-up machine for fires where there limited water supplies such as on farms and at airports. It incorporated a built-in pump and, like the other firefighting machines, was capable of pumping from open water. It had a second function as a foam tender for use on flammable liquids.

The Turntable Ladder (TL) was a purpose-built fire engine with Dennis bodywork, a Rolls Royce petrol engine and a 100' German Magirus Metz ladder on a mechanically-operated turntable. It was a beautiful piece of machinery, already about 25 years old in the early 1970s, with a high replacement value. A driver who mastered its murderous crash gear box could make it move very fast indeed. Unlike some TLs, it had no built-in pump and took all its water from other appliances. It was used as a rescue vehicle and water tower. The job of TL operator was the only specialised job on the station. The TL was part of the routine turn-out for high buildings; but it was rarely used in anger. The older men who drove the TL could come to work fairly confident of a quiet shift.

Firefighters on large fire stations such as Cambridge were omnicompetent. Most became BA wearers and drivers within a few years of taking the job. There was no distinction between ladder companies and pumpers, as in North America.

1.2

The Fire at Regent Terrace

First flashover I've seen. Last fucker I want to see and all.

By November 1972, I had been on the station as an operational firefighter for nearly six months. We had been busy with serious incidents of all sorts, but I had attended no major fire in the sense of more than two machines in action at any one time. One night, this was about to change. The men of Blue Watch were all as deep asleep as they could be. About 3.30 in the morning, the 999 pre-warning bells sounded, a gentle breezing ring. This was a sign that someone in the county had phoned the emergency number, not necessarily 'a job' and then not necessarily for us at Cambridge fire station. 'Nines', someone yelled, and a few lights went on, over the bunks in each of the two dormitories. The men slid down the poles into the cold, dark appliance bay, stumbling almost automatically towards the machine to which they had been assigned at the beginning of the shift. The station and yard lights went on, followed by the loud, harsh ring of the big alarm bells echoing through the bays, prefacing a message over the tannoy. The drivers climbed into their cabs, pulling out leads from battery chargers and cylinder block heaters. The newer drivers made a quick mental check of the switches to be turned on in case the door in front of them went up: ignition, headlights, two-tone horn and blue flashing lights. 'Fire at Regent Terrace, Hydraulic Platform; Water Tender Ladder'. The men climbed onto the two machines, four on the HP and five on the water tender. The doors in front of us went up and the two machines were away, without much noise, since the two-tone horns were not normally used at night.

Regent Terrace was a stone's throw from the station; in the daytime, it could be seen from the control room, the appliance bay and the Clubroom

above it. But as the men changed from their overalls into firefighting gear, there was no sense of urgency – time enough for what sounded like a pile of rubbish or a malicious false alarm, since no house number had been given over the tannoy. Regent Terrace was a rear alley behind shop fronts on the main thoroughfare, Regent Street. There were some terraced houses and rear shop entrances in the alley, which faced onto Parker's Piece, a large green that separated the fire station on Parkside from Regent Terrace. Ikey Williams told Gordon Powell driving the Water Tender to turn the machine into Regent Terrace, leaving Fred Howe in charge of the HP to split the turnout and cover the front from the main street. It proved to be a good move. Drawing up to the terrace, we saw a bright glow from a basement window along the block and as Ikey jumped from the machine shouting 'It's going well', flames burst from the basement. He grabbed a branch already connected to a hose and delivery valve on the machine. Gordon put the pump in gear and within seconds, Ikey and Rodney Slack had water on the fire. Gordon fitted a collecting head to the pump eye so it could take a line each from two different hydrants to feed the pump.

We had in fact arrived at the rear entrances of an irregularly shaped old suite of offices. Down the external steps to the basement, Ikey and Rodney pushed their jet in through the shattered window but it was not doing a lot of good so they tried to force the door to hit the fire from the inside. Ikey was wrestling with the latch when Rodney saw a large plate of glass detach itself from a frame above and come hurtling down. He shouted at Ikey to get in the doorway and as Ikey jumped in and froze, the glass smashed on the steps. They got the door open and poked the jet in but the fumes were so hot that they couldn't advance.

Walter Purr, the senior officer, had arrived in a fire car and (for reasons unclear) took the two away from the seat of the fire. He directed them to a flat roof two stories up, with a second jet. Using the 30' ladder up to a platform on the first floor and a short extension ladder to the second level, they got the jet up there. Again, a large window blew out. The building was well alight. But only a trickle of water came from the jet and Walter told Ikey to knock it off. Since Ikey had an open branch (a nozzle without a shut-off valve) he had to come down to tell Gordon at the pump to close the delivery valve. When he did, Purr came up and demanded to know what the hell he was doing, with Rodney still up there and water still flowing when he had been told to knock off. Ikey told him he had an open branch. Purr apologised.

Purr gave me a hand-controlled branch (one with an adjustable flow) and told me to replace the open branch on the flat roof. So I climbed up, changed the branch and Rodney shouted to Gordon for 'water on!' but again, only a feeble jet of water. The pump was overrunning its supply

and we were ordered down. John Mallon, the Divisional Commander, had by now arrived and took charge. He took off his helmet and used it to smash a window on the ground floor at street level. Rodney did the same but what he hit was a form of double window with the second pane a few inches from the first. He cut his hand badly and was taken by police car to hospital, where he had eleven stitches. Mallon told me to take the jet that had been used in the basement and I pushed it through one of the smashed windows.

From the time the water tender arrived to this moment, I had not time to think about anything, no panic, no adrenalin, or so it seemed. But there was haste enough that I had forgotten to replace my soft cap with fireman's helmet. I had started to push the jet in through the smashed window when Purr kicked in the ground floor door, following a rule that had become instinct – always fight the fire from the inside. He followed me in with the branch. We were met with a wall of flame so I retreated and started to hit it from the outside. This was not good enough for Walter, who took the jet and directed it against the ceiling to bring down any loose plaster and debris. He handed back the branch, shouting 'Get in there' – the fire officer's war cry – and behind him Mallon yelled the same, as he fed us more hose from the outside. When the worst of the fire in the room was

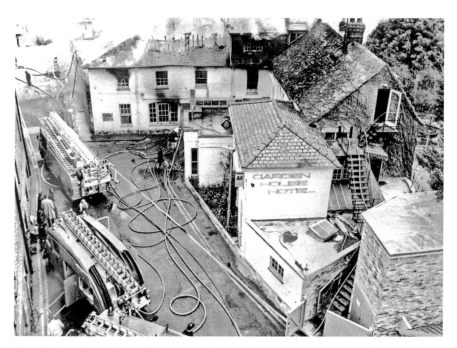

The Garden House Hotel Fire, 24 April 1972: the fire engines arrive. (*Press Association Image PA – 829 - 8520.jpg*)

doused, I crouched in a corner, eyes streaming from the smoke, damping down the last of the flames when two figures appeared through the murk from the far side of the room. They were the crew from the front of the building.

Until we had got the ground floor door open, there had been much confusion, typical of a large fire. Ikey and Rodney made a start in the basement but there weren't enough men on the initial (split) turnout to get a BA team working and there wasn't enough water to supply two jets from the pump.

Phillip Nightingale and I had started to look for a hydrant as soon as the machine drew up. He ran with a standpipe and hand lamp but it seemed ages before we found one at the end of the block on the main street round the corner. Down the road, we could see the HP crew at work. We got the lines of hose mixed up ferrying them from the machine to the hydrant. Finally, we got the water supply to work with a red flashing light on the standpipe to warn traffic before the police sealed off the street. Gasping for breath, we returned to the machine. I took off my soft cap, replaced it with helmet, then reported to Purr. We were in for a bollocking (dressing down) for having taken so long and through the next day, the tangled lines of redundant hose lay around the edge of the Piece, accusing us. That there were no recriminations was perhaps surprising. Walter Purr, an older man who had been in the artillery during the Second World War, was a huge figure, known for his prowess at hoeing sugar beet and cutting a meadow with a scythe, when harvesting was still sometimes done by hand. He disliked Phillip and treated him with a belligerent animosity. Phillip, a motor mechanic by trade, was quiet-spoken with barely a trace of a Cambridgeshire accent, while Purr was the opposite. The irony was that they had somewhat similar 'fiddles' (part-time jobs), Phillip as a watch and clock maker and Purr as an ornamental engraver.

For all that, Ikey and Rodney had never lost water when they were attacking the fire in the basement, so Purr had nothing tangible to complain about. But the second jet on the flat roof was still not getting enough water when I joined Rodney up there. The hydrant which we had set in turned out to have been fed by the same main as that supplying the HP crew. Not until Phillip rushed around, getting a second hydrant to work did the jet aloft do any good. By then the fire was under control.

In the meantime, the HP crew had a dangerous job. When they drew up, the windows of the shop front and the doors above were blackened with smoke and oily soot. Fred lifted the flap of the letter box. Smoke billowed out. He got two men rigged in BA, a jet laid out and a nearby hydrant set in. He went through a passageway to see how Ikey was getting on at the back of the building since he had seen the flames at the rear

when he split the turnout. Then he returned to the HP and ordered two more machines on the radio. By then, Tug Wilson and Alan Payton were ready in BA with a charged jet, so they smashed the glass panel of the front door and advanced inside with a guideline made of thin rope. They groped up the stairs through the smoke when the fire flashed over (a flashover is an explosion of hot gases through what is known in North America as backdraught). This engulfed both men in smoke, causing them to disappear from view. The plate glass of the shop front windows blew out, propelling fragments over the machine and the men standing by it. Graham Williams quickly poked a jet in and within a few moments the fire on the ground floor was under control. Up above, Tug and Alan were oblivious of the flashover and worked their way into the fire with the jet until they found an area of floor which had caved in. Since they could do no more useful work, they came out – to the relief of the crew on the street. They had escaped relatively unscathed, with minor cuts and burns around the neck and their guideline burnt through. Whether the flashover was caused by an inrush of fresh air from the rear, was debated for many months after. It seemed that when Mallon and Rodney smashed the rear ground floor windows with their helmets, this was long after the flashover had swallowed up the front of the building. The burst that had hit Ikey and Rodney on the flat roof earlier had also blown out the front windows onto the street.

By this time, other machines were on the scene. Ian Grieg arrived with the second water tender and Dave Pettitt drew it up behind our machine. The pair of them went into the basement in BA to deal with what Ikey and Rodney had found too hot, but by then the fire had abated and they hit the remains with a hand-controlled branch, bursts of water here and there. The concrete floor above was sagging dangerously and they had to creep around the sides of the room.

When the HP crew appeared at the rear of the ground floor, having entered from the front, I took the jet out of the rear entrance. The officer in charge had first been Fred on the HP, then Walter Purr, then John Mallon. Not to be outdone, he made the complements of machine up to five from Fred's four, ostensibly to give the retained (part-timers) some practice on BA. I was put on the BA control board for a rest while a retained crew went into the basement to ventilate after Ian and Dave had come out.

Then the Water Tender Ladder crew was relieved and we went back to the station. One further retained crew was there, covering the city while our machines were at the fire. We sat around drinking tea before being sent back. By then, it had been possible to make a thorough search of the building even though it was unlikely that anyone had been in there and even less likely that they could have survived. One crew was still inside,

where they had put salvage sheets over piles of stationery in the basement (remarkably, more or less undamaged). They knocked out the remaining 'bullseyes' of flames and embers in the wooden beams, pulled down bits of masonry and timber, and were now pumping water out of the basement with an electric pump from the Emergency Salvage Tender. Rodney had arrived back from the hospital and was put on the tea urn. A man came up to him and asked him if he had sugared his tea. 'What do you expect me to do' asked Rodney, 'Drink it for you as well?' It turned out to be Jimmy Nield, the Deputy Chief Fire Officer. He had arrived at the same time as the Chief, completing the hierarchy, about twenty minutes after Fred had made up to four pumps (machines).

We could now see what damage the fire had done. Two floors of the building, an estate agency, were gutted, with severe damage in the basement, where the fire had apparently started. A desk on the first floor sat poised on the edge of a gaping hole in the floor. A suite of rooms on the second floor were all damaged by a covering of smoke and soot. The fire had just crept through the skirting in a paint shop next door when we had got it out. Had we arrived ten minutes later, the whole block would have gone and the property damage would have been immense. Forestalling this eventuality was our main achievement.

At about 8.30, the bosses of the firm arrived and began directing their office staff to another building. They did not seem at all perturbed about the loss of their business, nor their files and equipment. They promised a donation to the fire brigade. Gordon, who had done some part-time work for the directors, got them to make out the cheque to the Sports and Social Club. When 9.00 came, we were relieved by the oncoming watch. Dave Pettitt and I strolled across the green to the station in the sunshine, carrying our BA sets. In the afternoon, the Fire Prevention Officer satisfied himself that the fire was well and truly out and gave permission for the place to be boarded up. A couple of months later, a tower crane appeared on the site and as we sat in the Clubroom overlooking the Piece, we could see what we had been unable to save and parts of what we had saved being knocked down and a new set of offices going up.

Saving the whole block was what we had accomplished but the firm seemed to have lost very little as a result of their enforced move to a new suite. Walking back across the green to the station, I did not see it like that. Though the intense action was over in less than an hour, I was both exhausted and exhilarated, one of the best moments in my life. Again, it was not until later that I was able to get the excitement and exhilaration into perspective. I have always thrived on stress. I love the creative tension of writing and the drama of public speaking, the sound of my own voice. The thrill of firefighting was, strangely perhaps, akin to the stresses of less

active pursuits. And though the excitement of the job was a motive of many of the firefighters, I doubt whether it was, normally, the product of a character who thrived on stress, someone who lacks equanimity, living for kicks, socially acceptable though most of them were.

In the lore of the fire station, the job at Regent Terrace would be remembered until all those who attended the fire had retired. It was remembered if not as 'just another job', then as one notable job among many. As for Tug and Alan, who had been briefly in mortal danger, few if anyone remarked on that. It was 'just part of the job'.

28 November 1972 – Cheffin, Grain and Chalk, Cambridge
Seven fire appliances from Cambridge, Swaffham Bulbeck, Sawston and Cottenham attended a serious fire at 03.25 hours at this Estate Agents office in Regent Street. The fire was extinguished by the use of six jets and six BA were used. Severe damage was caused to 60 per cent of the building and contents and the fire also spread to an adjoining shop and store.
 – Eddie Baker, A History of Firefighting in Cambridgeshire

*

The firefighter's job is a strange blend of periods of relative inactivity with spasmodic episodes of violent excitement, usually productive, occasionally futile. A few of the men, especially after the keenness of the first couple of years, said they only wanted a quiet life and that what they liked about the job was that, much of the time it was an easy number. If there are no fires, both firefighters and the public can relax in peace. But if there was a scrap, like Regent Terrace, most wanted to be in the middle of it. Once we rolled up to another job in the middle of town in which the basement was smoke-logged. The officer in charge ordered two BAs and Dave Pettitt put a set on. Seconds later, he returned to the machine and slammed his set on the seat in the back. 'Whenever I get a BA job, the fuckin' set packs up!' Few liked to ride the Water Tender Ladder on night duties, since it was often turned out alone to 'piss on a pile of rubbish'. But this was the price to be paid for the serious jobs, large or small. These were what the men liked; what they disliked were the prolonged periods of inactivity, since the serious jobs tended to be unevenly spaced, a case, if you like, of cycles of feast and famine.

Regent Terrace was a major job but it was not a Baptism of Fire. At Cambridge, what was so regarded was attending a bad road accident for the first time. My first accident, as it were, had occurred during the summer before.

1.3

Road Accident:
the Sweet Evil Smell
of Petrol and Death

You know the bloke what we cut out of his Minx on the Madingley Road? Well, he died. Something to do with his lungs. I was surprised really. When they are yelling and shouting like he was, they are usually alright. It's when they are all quiet that they are badly hurt.

Soon after eleven at night the bells went down. Most of the men were still in the Clubroom upstairs and wide awake. They slid down the pole-drops and lolled around the appliance bay, waiting for an announcement from the tannoy while a couple of junior officers went into the control room to hear the message as it came through. The big bells sounded briefly, indicating a turnout from our station and the incident was announced – a road accident on a main road about six miles from Cambridge. As the Water Tender left the bay, Jonah leaned into the back with the news, which he had somehow gleaned from the control, that there were two dead ones. 'Best of luck', he said, with irony. The machine was quickly away, the EST lumbering along behind it.

Driving through Cambridge, the crew donned fire gear and red fluorescent jackets. Rodney Slack, gauging the distance to the accident, lit up a cigarette. The machine raced up the main road, touching sixty-five, not much, but plenty for an overladen old Bedford, ice-cream wagon turned fire engine. The attention of the crew shifted from the speed of the vehicle and its progress through the traffic to a cluster of blue lights on the road ahead. The police and ambulance had arrived first.

What the Water Tender crew saw was a big car sitting diagonally in the middle of the road and an ambulance man covering a casualty with a blanket on a stretcher at the side of the road. A pair of firefighters rushed

up to the car with flashlights; a cursory glance showed that no one else was involved. Jonah had been wrong. The driver of the saloon car had skidded badly or perhaps rolled his car and ended up in the middle of the road, the front seat torn off its mountings and the steering a bit buckled. He had been thrown clear, not seriously injured. Good! Sweep up a few bits of broken glass and back to the station for, perhaps, a quiet night. Tug Wilson, the officer in charge, came up and the picture changed. 'In the ditch' he said. There, by the light of the lamps we could see what looked like a little Fiat 600 but was in fact an Austin Mini. Inside were two bodies, a young man and a woman about the same age, dressed in a pant suit.

Two officers arrived in fire cars and the crews were soon at work. Someone disconnected the battery of the large car, a Rover. Another laid out a line of charged hose to cover the vehicle in the ditch and the rescuers in case of fire. Rodney handed me the hose, telling me to turn the water on at the nozzle and hit it hard if I saw a flame 'no matter who is working there'. Derek Ward fitted a short length of hose from the delivery outlet of the Water Tender back into the eye of the pump in order to cool it down with occasional flushes of water from the tank on the machine. A man was sent into the field beyond the ditch with a lamp to make sure no one had been thrown from either of the two cars. Others set up floodlights, powered by a generator on the EST. We were starting to lay out the Turfor winching gear when John Mallon, who had taken over from Tug, decided to call in a breakdown lorry to drag it out before we tried to free the bodies.

A fellow came up and said he thought the people in the Mini might be mates of his from Leicester. He looked at the mess, decided they weren't, and went away, clearly upset. Derek, minding the pump, stayed away this time, clear of the whole thing. He always said he was sick on accidents. This time he took time off from the pump to throw up, in the ditch. A doctor who had arrived on the scene hung around with a stethoscope, not ready to pronounce the two dead, yet not prepared to examine them till they were taken from the car. (The doctor was from MAGPAS, the Mid-Anglia General Practitioner Accident Service.)

The breakdown lorry arrived and the driver, a mechanic from a local garage, was so unnerved he couldn't even face hitching his cables. John Mallon put him up on the lorry to supervise Dusty and me on the winch cables while Tug and Alan wound the cables round the car and fixed the shackles. The motor was out of the ditch in a few minutes and the breakdown lorry disappeared.

The woman was lying with her head buried in one corner of the back seat, her twisted legs in the front. Her face looked as if it had been sprinkled with a dusting of chalk over a bluish hue, as if cold from the wind. The

man was sitting in the driver's seat, his legs trapped by the pedals, the engine and God knows what else. He looked more or less alright, though his trunk lolled like a doll or a puppet. A gash still bled from his forehead. About the place was the faint sweet, evil smell of petrol and death.

The initial reaction of men new to the job was to rush around in a panic, a move instilled in them by the regime of training school, which put a premium on doing things quickly, at the double. Even this initial panic had worn off. Now came the to-ing and fro-ing between the machines and the wrecked car, to assemble the cutting equipment, the suggestions as to what to do, how to reach the bodies best, what tools to use, who to do what, when and how. This was usual. Altogether, there were six firefighters and two senior officers on the scene, but at this stage only a couple of men were needed. The focus of work on such jobs is small, with two or three men working with different tools in a severely cramped and confined space. They would give each other orders and advice, some of it ineffective, with several false starts.

A good firefighter in the right position could often get things organised right, but it is a slow and frustrating business in marked contrast to fighting fires. Methodical care is needed to avoid hurting a trapped person and to get the tools to work properly; expanders firmly wedged between surfaces they will prize apart; a saw at the right angle and pressure to avoid breaking the blade; choosing the right strip of metal to take the pressure off a crushed limb. Outside the car, you could hear the rattling thud of compressed air saws and panel openers, scraping of hacksaws, creaking of metal forced by the hydraulic gear, muffled instructions and curses.

The woman came out first, the bottom half of her clothing still caught up in the wreckage, her muscles showing in a wound where Tug and Alan had unavoidably scraped a leg in extricating her. Her bones were so broken that she slipped through our hands like a jellyfish. It took five of us to lift her onto a stretcher. As the firefighters moved her, the doctor shouted 'Be careful with her!' He fiddled with his stethoscope as the ambulance men covered her up and took her to their vehicle.

Throughout the two hours on the job, a rear light bulb of the Mini had been glowing brightly. Somehow a circuit had survived the wreck. We had neglected to sever the battery leads. Details such as this were recalled in countless conversations on the stations in years to come. On a later accident, a dead woman in one of two cars seemed to be leaning out of a front window to stare at a solitary onion, sitting in the road between the two cars.

It was not death itself that perturbed the men on jobs such as these, nor even the blood, vomit and excreta. It is the thought that a casual shopping trip for vegetables or casual talk driving along a main road could be

obliterated suddenly and pointlessly, invariably without a pause of awful realisation that the trip is over, life is finished. Many firefighters felt sick over accidents and were unable to face food when they returned to the station, but they got over it, acquiring over the years a species of indifference without ever really getting used to them. John Mallon, who had pushed me into the Mini to help extricate the woman (a sort of initiation which he felt to be his duty) put it, 'After a time you become callous. Well not callous, really.' All the same, Derek Ward sold his Mini a couple of weeks after the accident, vowing never to buy another. Though road accidents were the most prominent part of the Cambridge firefighter's job, they were grimly disliked by most. A survey would probably have shown that most cases of what is now known as post-traumatic stress disorder were caused by attending road accidents – discovering a dead relative lying in the road or cutting out the body of a child from a wrecked car.

The report of the accident in the local paper the next day said merely that a young couple had been killed; the driver of the Rover had been taken to hospital with cuts and bruises but was allowed home later; and that a crane had to be called in 'before the bodies could be freed by firemen'. Some weeks later, at the trial of the driver of the Rover, it was found that he had driven out of a roadside pub on the wrong side of the road without lights, certainly without headlights. He was fined £150 and given an endorsement.

One of these bleeders a month and we've earned our money.

1.4

Fires and Accidents

That accident on the Huntingdon Road in the summer of 1972 had come at a busy time for Blue Watch. Earlier the same evening we had been called by some students to help free a kitten whose neck had got caught in a length of metal pipe – two fire engines and six men milling around in fire gear. Then we went to a block of flats where an old woman had locked herself out. Then the accident, after which we got some sleep till morning.

The next night the watch came on duty again at 6.00 pm. The firefighters were called an hour later to a local hospital where an automatic alarm had gone off, a false alarm as usual, caused this time by someone smoking under a detector head. At 8.00 pm two machines went to a big house on the outskirts of town where the light of the sunset had been reflected off a magnifying mirror in the bedroom and caught two curtains and a pelmet alight. A freak. Just after midnight, the bells went down again for another road accident, a few hundred yards from the station. A Hillman Imp had hit a lamp post; the driver was badly hurt and taken to hospital before we arrived. The car was a write-off. Inside the cab, the steering wheel was buckled and there were gobs of blood on the front seat. We disconnected the battery, swept up broken glass and cleared odd bits of wreckage off the road. At 3.00 am someone phoned in to say he thought he saw flames around a large country house five miles from the city: a routine search with flashlights.

Throughout the night, one of the machines had been standing by at a pig farm where, the day before, a bad fire had broken out. One of a pair of semi-detached cottages was badly damaged, 300 pigs killed, farm buildings burnt and many tonnes of feed destroyed. Dave Pettitt, Alan Payton and I had the last shift from 6.00 am to 9.00 am, when we were relieved by the oncoming watch. Before lounging in the fire engine to keep warm, we had

a look around. Sows and their litters were lying in rows in their pens, many of them unblemished, having died from the smoke. The bellies of others were grotesquely swollen from the heat of the fire. The officer in charge of the station arrived a bit before 9.00 am and caught us dozing in the Water Carrier. When the officer asked us for a cup of tea, Dave pointed to an urn that had been brought to the farm the evening before. Surprised at such cooperation from Dave, his sworn enemy, the officer poured himself some tea. He threw most of it away, cursing under his breath.

Few of the incidents on the second night were serious and some of them could have been dealt without the firefighters attending. But the watch had been kept up both nights. The firefighters felt they had earned their money in that two hours on the Mini alone.

The main lifesaving work at Cambridge fire station was in fact on road accidents; the worst incidents involved extricating the dead and injured; they were one way of dating events on the station by way of milestones. They also became part of station lore. Several of the road accidents in this lore were quite macabre.

The firefighters went to a job and found a load of barley spilt on the ground where a lorry had overturned. The officer in charge ascertained that the driver was alright and sent the 'stop message' (no further assistance required) back to control. Roger Westcott saw a hub cap in the barley and thought nothing of it until the lorry driver appeared and asked about the car. 'What car?' Underneath the barley was a small heap of twisted metal, the remains of an MGB with the mangled corpse of a young nurse inside.

Then one night the Watch went to a reported accident outside the City. Finding nothing, the machine was turned around to continue the search from the opposite direction. From a side road, the firefighters saw the glare of a fire. They raced up the road towards it. In the ditch an Austin 1800 was burning furiously, the charred remains of three unidentifiable bodies inside. A passing motorist had pulled a fourth person out of the wreck and laid her on the ground, while telling her companion to phone 999. The woman rescued lived for thirty-two days. Her rescuer was given an award. Fortunately, road accidents rarely involved serious fire.

Red Watch went to a Mini which had gone under an articulated lorry. It took them over three hours to get the three dead occupants out. KC went to a plane crash and found nothing recognisably human but an empty rib cage. Dusty Miller had shovelled someone's brains off the road.

'I heard he scraped them away with his hands.'
– 'Dusty's not that uncouth.'

*

Fires:

When you see water runnin' down the street, chances are they are flooding it, doin' no good at all. You get a bunch of cowboys or a bad officer in charge and there'll be water all over the place, things smashed up, and all that. Needless damage.

You never want to keep a full bladder on this job. I've pissed myself on a job before now.

If you break the rules and cock up a BA job, they'll have you on a charge. You break all the rules and pull someone out, they give you a medal.

During the drought, we were out all the time. I used to come home knackered every night. One afternoon we were out on standing crops. Control was pushing out all the machines we had, all over the county. We were stretched to the limit. The radio was going all the time; machines were being sent on from one job to the next. All of a sudden, down comes the rain. We didn't have to use a jet, or beaters, or anything. The radio calmed down – one call to a lightning strike, and another for flooding, then dead silence.

When you get a two-pump shout at 2.00 or 3.00 in the morning, you can be pretty sure you got a job. You got to get a BA set on: that's going to be full of smoke, and that.

Burning Foam Rubber:

We had this bloke come down to the Station. Don't know where he was from. Plastics Manufacturers' Association, or something. Tries to tell us that the smoke from foam rubber and plastic, and that, wasn't no more dangerous than wood. Well, you come out of a house fire and get clearing it up – I mean after the job's finished, when you've taken your [BA] set off. The smell's horrible. It gets down your lungs and feels like your whole system's packing up. Completely fucked. That's where the danger is. Not the fire when you've got BA on. It's afterwards, when you're clearing up, damping down and letting the smoke out. They don't think about that. What can you do, anyway?

Fires in Laboratories:

Every now and then we have a job at the Chemistry Labs – University, Lensfield Road. Usually in the night when all the gear is set up and working and no one to see to it. Thousands of quids' worth of damage. Mind you, they're insured for it. We have a trip round there about every year to get the layout. I can't tell one part of it from another; but there you are. Half the stuff in there, they don't know what it is. They just tell you to get a [BA] set on and chuck a lot of water on it. Hope for the best, like. White Watch had a shout there one night last week. Billy got a load of stuff over him. Don't know what it was. Bundled his uniform up and destroyed it tho'.

Chemical Road Tankers:

Talk about this tanker drill – BA and full protective gear. We were lookin' at one that had overturned, just to make sure there was no sign of fire and the stuff wern't leaking. Three of us kitted out, BA procedure, tallies, the lot. Up comes Matthey – no set, no fire gear, nothing. Breezes up to the tanker, wants to know what is goin' on. What's the point of all this procedure if the first thing an officer does is to go and break it? Now you tell me. Maybe I'm thick or something. 'Do as I say, not what I do'. Bloody idiots.

Of a Station Officer:

He was first on the scene at the Rose and Crown and got an OBE. I was first on the scene at the Garden House Hotel and got a bollocking for having tea early.

There were a number of official ways in which fires were classified, according to what was on fire, how many machines were in attendance and the number of jets (of water) used; but there were, in reality, roughly three sorts of fire: big, small and trivial. Big fires in industrial premises are naturally difficult and dangerous. While firefighters have been killed attending all sorts of incident, industrial and warehouse fires have taken a terrible toll of firefighters' lives through flashovers, inhalation of chemical vapours, and collapse of buildings on teams of firefighters, often in BA. On the other hand, if a building is 'going well' and the place is known to have been deserted, firefighting is done from the outside, and a dazzling

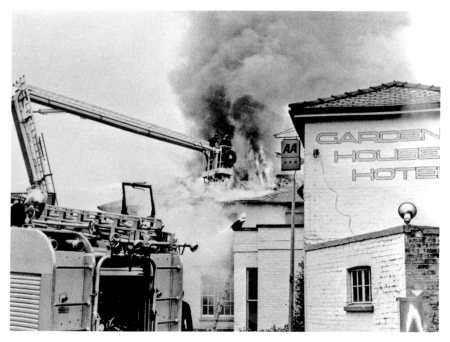

The Garden House Hotel Fire: the first major job for the Hydraulic Platform. (*Press Association Image PA – 829 8506.jpg*)

spectacle is in fact an easy job. To 'car-park' a building is firefighter's slang for a burn-out, usually used in jest, alleging a cock-up (botched job).

Large fires in residences such as hotels, hospitals and old people's homes were the worst, because of the need to rescue large numbers of people. Casualties among firefighters and residents can be heavy, as Gordon Honeycombe illustrated so vividly in *Red Watch*. The biggest fire of this sort in Cambridge in the 1970s was the Garden House Hotel fire in 1972; two residents died.

The Rose and Crown Hotel fire in Saffron Walden in 1967 killed eleven people. In five years, the closest I got to a disaster of this sort was when we were called to a theatre in the middle of the city, the centre of a haphazard block of historical buildings. Two deep fryers in a small kitchen had caught alight and the staff had been unable to put the fire out with foam extinguishers. Smoke engulfed the kitchen and a public restaurant area. Everyone was out of the building but Nick Richardson and I did a quick search in BA as a precaution. Then we went into the kitchen with CO_2 extinguishers and an asbestos blanket. The CO_2 did no good at all as the fryers were so hot that the fat kept reigniting and we got it out in the end with the asbestos blanket. Graham Williams started cutting away where the fire had spread from the fryers, using the hose reel as he exposed the

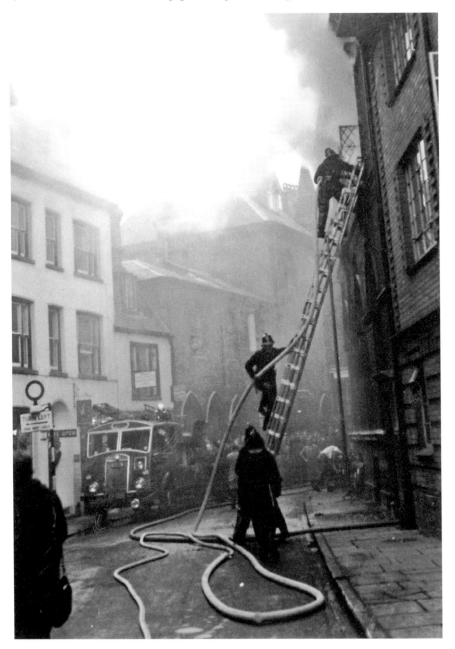

The Turk's Head Hotel Fire, 18 December 1967. (*Cambridge Evening News*)

remaining pockets of glowing embers. Up on the roof, Ken Aldred and the others were dousing out the fire where it had broken through, removing boards with a large axe and crowbars. Nick and I emerged, covered in muck and sweat, while the staff gave us all cups of tea. The kitchen should never have been allowed to operate with deep fryers in a confined space, a flimsy wooden structure on the top of a large block of buildings. The staff should have had enough training and equipment to get the fire out. It could have been any of us in BA. But this was the sort of job that gave us young firefighters a great deal of satisfaction. Nick and I went home happy.

Small fires in private houses were the firefighter's stock in trade. There was a saying among the instructors at training school that no two fires are alike. While this acknowledges that no fires are without hidden dangers, there were incidents approximating to a typical job:

Firefighters would get a call to a residential street and find a house or a room full of smoke. Two men would go in, in BA, have a quick look around for anyone who may still be in the house, open the windows to ventilate and then carry out a piece of burning furniture or upholstery, a sofa, armchair, bedding or mattress. Or the men would take in a hose reel and do some cutting away as they put out the fire, cigarette ends, oil heaters, faulty electrical appliances and wiring being common causes of the fire. The main fatalities in this category were people asleep, overcome by smoke.

Lower down the list but still potentially dangerous were the regulars, such as chimneys, rubbish, grass verge fires, chip-pans and cases where there was smoke but the occupant could find no fire. Then there were a whole host of trivial incidents like automatic fire alarm malfunctions, malicious false alarms, hoaxes, and cases of 'false alarm, good intent', such as calls to smoke that turned out to be steam. All such incidents had to be taken seriously; even small fires could be vicious little encounters.

In all but trivial incidents, there were some salient features about which it was possible to generalise. A 'two-pump shout' late at night or in the early hours was likely to result in firefighters 'having a job' (that is doing something worth talking about: 'did you have a job?'). This was because a fire had had a chance to 'brew up' while the residents were in bed, usually to be awakened by the smell of smoke. Further, any job bigger than a small fire often resulted in one or more firefighters being injured.

A case in point was a job when one evening, the lads were called to a residential street, 'persons reported' over the tannoy. They arrived and two foreign students were hanging out of a front window on the first floor of a suburban house and another on the ground, shouting 'He's doing it again next door!' Ikey was in a quandary, not knowing which house to get into first, but he got a ladder up to the students as there was a lot of smoke on the

ground floor; Rodney escorted them down. The police, who arrive at every incident sooner or later, apprehended a man next door as Stuart Brignell and Stuart Bartram went into the first house in BA. The fire seemed to be coming from a cupboard under the stairs and in the smoke, they couldn't find the door. So Stuart Brignell kicked in a board of the door panels, which flew back at him and caught his foot. Unable to pull his foot out by the bootstrap, he took his foot from his boot and then the boot from the panel. As he was putting his boot back on, there was an explosion that blew them both to the ground. Stuart Bartram got up and pulled his mate out of the house. He had been knocked unconscious and concussed, spending two weeks off sick with shock and painful burns around his neck, arms and hands. The BA mask had saved his face. What caused the explosion was never ascertained. A man was later prosecuted for arson. He was a jilted lover who had set fire to his ex-girl friend's house.

The unexpected was normal. Ian Grieg was in charge of the first machine called to a fire in the small hours. In the morning light he could see a pall of black smoke ahead. Thinking it was a pile of rubbish, he turned to the young lads in the back and told them not to bother with BA. It turned out to be the Garden House Hotel, well alight, the fire spreading and moving along 'as fast as a man can walk'.

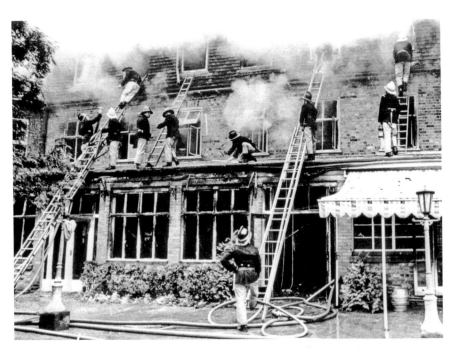

The Garden House Hotel Fire: Cambridge Firefighters at Work. (*Press Association Image PA – 829 8531. jpg*)

The unexpected can occur in what seemed to be a small job. Blue Watch was called to a derelict pub near the station, which had been used recently as a hostel for the homeless. Two members of the crew entered in BA but as the smoke was not heavy, two more went in behind them without BA sets. We found a tramp sitting by a fireplace, the woodwork surrounds smouldering harmlessly. Then there was a bang like a thunderflash and the four got out quick, dragging the man with them. A flashover.

Such incidents require presence of mind in which both training and the situation call for immediate, unthinking action. We were called to a job where an electrical fault had melted a lead pipe under the stairs and caused an explosion. A young couple had got out by jumping from a first floor window. Two men entered in BA with the ground floor well alight and turned off the gas. To have simply put out the fire would have invited another fire from the escaping gas.

Later, we were called to a spacious workshop in which welding equipment had caught fire. The firefighters crouched behind a low wall of Jersey lintels spraying the cylinders while Bob Bunday, in charge of the incident, calmly walked through the smoke and water and turned down the demand valve of the acetylene cylinder to zero.

On some jobs, firefighters got wet, cold and dirty. Usually the enemies were smoke and heat. Smoke from wood or paper was something firefighters got used to but was the least dangerous. The worst hazard, both immediate and with long-term effects, was smoke from contaminants, chemicals, synthetic materials and super-heated smoke. Such fires were difficult and often painful. These were so common that BA was almost universally used as a precaution. Heat is what you would expect – from haystack fires, heath fires and standing crops alight (both very hard work), to large volumes of combustible materials with a good air supply.

But the worst heat was in confined spaces where the fire had a chance to brew up. Once Ikey and Rodney had to go up a narrow staircase in BA to get at a fire in a locked room on the third floor. The smoke-logged staircase was so hot they had to come out. So Rodney and Jonah went up in the cage of the HP, smashed a garret window and got into the bed-sitter, letting the smoke out. A young woman had left washing too close to a heater and gone out; the floor boards had burnt through.

In terms of fatalities, firefighting was not, statistically speaking, a highly dangerous job, compared with other industrial occupations. But the injury rate was very high. The firefighters were well trained with clear cut procedures. What made the job dangerous was the unpredictability of emergency work, an unpredictability shared with other occupations such as the police, the armed forces and rescue at sea.

It was also true that most emergencies were not done by the book – the seven Manuals of Firemanship and the Drill Book. This was partly because the scene of the fire as it first appeared was confusing and uncertain, partly because an initial turnout could not do everything all at once, and partly because of an understandable tendency towards hasty decisions. When there was confusion on the fireground, such as wrong priorities, tangled hose, overrunning a water supply or using the wrong equipment, it was then easy for firefighters to claim that a job was a cock-up or car-parked. In general, this was no doubt true; but how far the confusion was avoidable and how much it contributed to needless damage is harder to say.

The main debates were over firefighting procedure. The starting-point was the legend of the 'smoke-eating fireman' who would brave the smoke, heat and danger, come what may. The younger firefighters were taught not to emulate this model, even though only a very few of the older firefighters believed in anything of this sort. Rather, there was a scepticism about what had been heard about American firefighters charging into a fire yelling 'Geronimo' or being killed by falling through burning roofs.

Yet there was still the article of faith as official doctrine that all fires should be fought from the inside. In general, this was quite correct; but in the informal debates about the job, the universality of the doctrine was questioned – too many lives lost trying to save mere property and no chance that anyone inside could have survived. Some of the procedures seemed to have been put in place to preserve the official doctrine. For instance, BA guidelines of thin rope were instituted after a fire in smoke-logged tunnels killed several firefighters. But for house fires and fires in which the BA-wearers took in a jet and hose, guidelines were only an encumbrance, tying them off at turning points on the route being a waste of time

1.5

Lockout:
A Lady Locked
Out of Her House

One dinner time (lunchtime) we were called to a lockout in an affluent part of the city. For some weeks previously the woman of the house had noticed small things missing, usually of a weekend. Eventually, responsibility was traced to a part-time gardener, who was sacked. But she told the insurance company who either increased her insurance or cancelled it altogether. So she had the place secured like a fortress. The woman who had locked herself out was fussing and thanking us for coming, at the same time directing operations.

We got a ladder off. Roger Westcott climbed up to what looked like a promising window at the front of the house. He got in alright, locked the window after him, came down the stairs and opened the front door from the inside. He stood on the doorstep, his back to the open door, looking pleased with himself. Ikey was just getting the woman to sign the form saying she would pay the fee when there was an awesome bang of the huge hardwood door, which wiped Roger's triumphant grin right off his face. Roger had locked himself out. Not only had he secured the window but the ladder was already stowed back on the machine. 'You don't have to pay twice', sniggered Ikey in embarrassment. We heaved the ladder off the machine again and Roger prized the catch open with his 'shut-knife' (penknife). The woman was already urging us into the house for a glass of beer.

The house was the home of the widow of a prosperous doctor, who had treated the philosopher Ludwig Wittgenstein; he had died in the house over twenty years ago. The woman seemed to have spent her time telling anecdotes about the man when he lived in the house in the months before his death. There was sculpture in the garden and contemporary art all over the place.

We had already got off to a good start, laying it on to Roger how he would never live it down at the station, when the woman took us on a conducted tour of the ground floor. It was too much for Ikey. One of the ploys of a first-rate piss-taker is to treat the antics of a third party with a mock seriousness so as to induce sudden uncontrollable laughter from the knowing audience. Ikey was magnificent. Every dotty picture he gasped at, staggered by its ingenuity, overwhelmed by its subtlety. The last straw came with a circular kitchen table. She had designed a large top to fit over the table with an adhesive to stop it from sliding, so that the table could seat more people. 'Incredible' Ikey said, 'I've *never* seen anything like that before. Ever.' The woman was in her element. 'Have the other half' she trumpeted, referring to the beer. But even Ikey couldn't take it anymore. The corners of his mouth began to tremble. The rest of us could turn away but Ikey was caught. 'No thanks' he said, 'we got our dinner to get back to'. He beat a hasty retreat, apologising for the mess we had made of the job.

*

The job has its funny side even in the worst situations. Tony Pettitt was operating the Turntable Ladder at a major fire at the Rose and Crown Hotel, across the county border in Saffron Walden. When he got there on a make-up (more machines summoned after the initial turnout), dead people were literally hanging out of windows, overcome by smoke before they could be rescued by the retained crew that had been the first on the scene. A girl was found only ten feet from a door to safety. Knotted sheets drooped from the upper windows, but not long enough to save residents from jumping to their deaths. Someone had jumped to what he thought was a safe flat roof but it was made of asbestos; he fell through and was killed. The retained Station Officer was later given an OBE for a 'job well done' though the universal sentiment was that the job was a cock-up.

The officer thought he saw movement by two bodies a couple of stories up and told Tony to set up the TL for a snatch-rescue. The machine was in the wrong position so Tony had to manoeuvre it before lowering the jacks and training the ladder. There was hose everywhere 'like Spaghetti Junction' so there was no alternative but to break the rules and drive the TL over the lines of charged hose. The Station Officer, full of himself, yelled at Tony not to drive over the hose. Tony, who was by now well steamed up, asked the officer if he knew how to operate the TL. 'No', he replied. 'Well *fuck* off then', Tony said, at which the officer retreated. Then with Brian Ison at the top of the ladder hitching the bodies to the rescue sling, they got them down.

They were then ordered to set up the TL as a water tower, to pump water onto the fire from above. Brian was on the nozzle at the head of the TL when Tony, operating the turntable, heard a feeble voice, 'Oi, mate'. He thought nothing of it. Again, 'Oi, mate'. Only on the third 'Oi, mate' did he look round and above him. And there, hanging on to some builders' scaffolding adjacent to the hotel, was the figure of a man. 'They've taken the ladder away', he shouted helplessly. A spectator, he had climbed a ladder a half an hour ago to get a good view, when some firefighters decided they had a use for it and failed to see our man, who was left clinging to the ironwork. Every station had stories of this sort, which lasted a generation until after the players had long retired. This story was told by Tony Pettitt himself, as a great joke. However, as will be seen, the whole job and the fatalities affected him deeply, a case of what we now woodenly call Post-Traumatic Stress Disorder.

Minor Incident: A Chimney Fire

One dark evening we were called to a chimney fire on the edge of Cambridge. The house was in a row of pre-war dwellings where the Council housed some of its 'problem tenants'. As the machine drew up, we could see the figure of a man standing in the front doorway. The house seemed to have no lights burning. He told us that the fire was on the ground floor at the back of the house, so we took a flashlight to check the room before bringing in the chimney gear. The design of the house was common: inside the front door was a small hall with the stairway leading directly to the first floor. The entrance to the front room on the ground floor was to the left of the hall; you went through the front room to get to the room at the rear and the adjoining kitchen.

Inside the front door we were met with the howl of three or four barking dogs. The scene was utter confusion. The room was filled with stacks of old televisions, one of which was connected to the central light socket, flickering in the darkened room. We picked our way through, with the dogs yapping around us and the man yelling at them to shut up. The room at the back was lit with a single dim, unshaded bulb. It was otherwise no less uncluttered than the room at the front, though this time it was not televisions but fridges, cookers, dressers and other bits and pieces. There was just room between a dining table and the wall for one to walk round to the fireplace.

In the room were an old couple, standing. There was scarcely anywhere to sit. The man was short and small, dressed in an old suit with a scarf around his neck. On his lapel he had pinned what looked like a coloured paper copy of his campaign ribbons stuck to a strip of cardboard. On the wall was a photo of him as a recruit in the Great War 1914-18 and

another on the mantelpiece of him in uniform a couple of years later: a short semblance of order, perhaps, in an otherwise shapeless life. The woman wore a thin cotton dress and a pair of shoes. She was grey-haired and white-faced, with a thin hooked nose. She grinned and shook her head all the time and spoke in a high-pitched, crowing voice. No one could understand what she said. In the light we saw that the man we had first met was middle-aged and unshaven, dressed in an old raincoat tied with a piece of string; the cartoonist's portrait of a tramp.

All the while in the dull light and clutter the dogs yelped and howled. The younger man tried to force them all into the kitchen and out of the way but no sooner had he got two or three in but one would escape as he opened the door to push in another. Eventually he settled for three in the kitchen and one perpetually running about and barking at everyone.

We got the hose reel and chimney rods into the house. The gear is like a sweep's outfit but instead of a brush on the top of the leading rod, you have a rose-nozzle attached to a length of garden hose which joins up in the hearth to the hose reel from the fire engine. We had only got a couple of rods up the chimney when we met an obstruction (not unusual) which meant that the job would have to be tackled by squirting water down the chimney from above. Normally one man stayed down below, covering the fireplace with a canvas sheet to prevent a cloud of soot or a spray of dirty water from going all over the room. The job is an easy one since the man below does not have to help with the ladder and roof ladder, nor climb over the roof in the dark and wet. But the scene inside the house was so depressing that everyone drifted out into the street to get the ladders off the machine. Only when everything was set up did I venture back into the house.

The younger man meanwhile had gone outside and I was left with the old couple. I tried to get from the old man how he was related to the individual outside, but all he did was complain repeatedly and bitterly how the man wanted them out of the house, how the Council would not help them, and how he had turned their place into a warehouse. He was obsessed with this, as well he might be, and did not seem to realise he was being asked a question. The woman understood what he was talking about. She muttered to herself, nodding and grinning.

Eventually cold water started to come down the chimney and I called outside to the firefighter on the roof to knock off. It did not take us long to get everything stowed; we were anxious to get away. Outside the house was a boy of about eleven on a bicycle. He said he was going round to sleep with his girl-friend and would not be back till twelve or two. Ikey asked him if his Mum would not want him back earlier so he would be ready for school the next morning. The boy said he didn't go to school much and

anyway, his Mum did not mind. He said he was sorry for the old man in the house. Everyone made fun of him and the local boys shouted at him as he walked down the street.

Back at the station, Ikey said that a place like that made you realise how far down you had to go. Phillip just washed the machine down and said nothing. Often after a job like this, there was a lot of comment passed about the muck and squalor that people allowed themselves to get into. This time there was none.

It was not as if there was a rigid class division between the firefighters and the 'problem tenants' of Haldane Drive, though those that had relatives on that Council estate would be reluctant to admit it. As a crude rule of thumb, the tradespeople and the better educated among the firefighters would have been less likely to have relatives and acquaintances on such an estate. Further, while the less educated on the fire station were sometimes seen as figures of fun, this was invariably with affection, not contempt. People were respected for who they were, not their pedigree, nor, in the end, their abilities.

1.7

Ken Aldred's Story of the Fire at St Mary's Hostel

This night we had a shout to St Mary's Hostel. There were a mattress on the pavement outside the main door. When we come up, chap comes running out, shouting 'It's all right; it's all over; don't need you', and all. Up the steps in the hostel were bits of mattress bloody smouldering, smoking and flaring like buggery. Jesus wept, I thought, what we got here? I knew it was hell of a sleeping risk, sleeps about 168 or something. I were concerned what were alight, especially with him and a bloody old girl saying nothing to worry about. My concern was what were alight; show me. Well, they'd dragged it from the second floor, han't they. They had it in this kitchen, utility room I call it; took it out of one of the rooms and turned the tap on; thought that'd put it out, which it hadn't. This old boy said that he'd done this an hour before. But it smouldered up I suppose, and smoke-logged the bloody place, that is what it did. Then someone raised the alarm; he and his girl ran back, dragged the thing out of the sink in the bloody utility room. Well by that time it were all burnt; pulled it down the stairs, and I suppose by that time it was smoking like hell round the landing on the first floor down to the ground floor and out into the street; stamped on it and buggered about with it.

Up the stairs I said to this old boy, 'What did you do when you found it were alight?'
'Well, I took it out of there, my mate's room, put it in here, and I thought it would be alright.'
'And what happened then?'
'Well, someone was shouting fire; bloody thing had flared up, you see.'
I said 'Listen a minute. You first found it alight in your mate's room?'
'Yes'

'What did you do?'

'I chucked a pail of water over it'.

'Oh well, let's have a look at your mate's room'.

'Ah, but he's out. He's took his girl friend to Huntingdon'.

'Well, which is his fuckin' room ?'

'This one.'

So he takes us there eventually.

'But you can't get in there because he's gone out'.

'Well, where's the bloody hostel keeper, you know, the janitor?'

Poor old fucker comes up there, about seventy.

'Who's in charge of this hostel ?' I says.

'I am', he says. 'They are always', he says, 'they are always up to these bloody tricks. I can't cope with them, you know'.

So I said, 'Have you got a key what'll open this door ?'

'Yes', he says, 'I've got the master key'.

'Open this door!'

 The student bloke was fucked. As soon as that door were open, he was fucked. He thought that while that were locked he would bamboozle me. There weren't nothing else alight. I'd accept that he'd chucked it out. I'd piss off. He didn't think I'd pursue it to the stage that I'd open the door, you see.

 Opens the door, in we goes. 'This is my friend's room' he says. Winders all wide open. So I said, er, well where were this bloody mattress then? He said that it laid here on the carpet. So I said, well how did it catch alight? Ah, he said, I don't know. My old mate must have dropped a fag in it. Oh I said, so you chucked a bucket of water on it?

'Yes'.

I said 'where did you get the water?'

He said, out of the sink. So I had a look at the bloody sink 'cause they had a little wash basin in the room. It were bone pissin' dry, hadn't had no fuckin' water in it all bloody day, you know. So I felt the carpet where it laid. That were bone dry.

'Hadn't had no fuckin' water in here mate. Hadn't been no fuckin' mattress in here either'

He said it had been.

I said, 'Don't you fuckin' flannel me, boy. Where'd that fucker come from?'

Well, then he changed his story. He hadn't wet it in here, only in the sink in the utility room. I says to the old boy, 'you see,' I said, 'this is your mate's room. Where's your room?'

Went and had a look in there. Nothing in there. Perfectly all right. But I knew something had been burning in there. I wasn't saying incense;

it weren't perfume. You know you get certain bushes that give off a peculiar smoke. And I still don't think that mattress came out of there, or the other room.

By that time the law were up there. Well this bloke, sergeant, came in. They knew what they were on, no messin'. In they went. He tipped the bloody bin up, didn't he, waste paper bin. That were full of these bloody, you know, I call them torpedoes. These tablets you get; they pulled them apart; I didn't know this but they come apart, did you know that? One part slides over the top of the other, with the powder inside. Emptied out what were inside and chucked the bloody capsule parts, the plastic thingomy. It were full of the buggers, all sorts there were. He'd got him then. 'Come on lad, where is it? Hooh! What you had in here? Haaa!'
I thought it was time I pissed off out. Went for a walk down the passageway. I thought I'd go and see if there's any other rooms open, you know where this bloody thing could have come from, 'cause we couldn't trace it other than from that bloody utility room. That's been in there and that's been well alight in there, because it was from there they dragged it down the stairs, burning all the way down the stairs. I still weren't happy, 'cause there may have been something alight in the place somewhere.

I went round and there were this bloody poster on the wall, weren't there. I thought it were bloody clever because the law man copped a pissin' nark. I dragged him through to have a look at it because that tickled me. That was about the time the [Cambridge] rapist was about, you know. Someone had done a drawing you see of the supposed bloody rapist you see with a bloody helmet on, law man you see: WANTED, RAPE, KNOWN AS THE FUZZ. They wrote something on there, quite good actually. I can't remember what it said now, but that made me chuckle so I called the law. Look at this; what do you think of this fuckin' poster? 'Course, he copped a bleedin' nark didn't he, straight away. He went thunderin' off to fetch the fuckin' sergeant, to have a look at it. That was at the time Haskell said, come on, we'll piss off and leave it to the law.

Well, the inspector came, he walked in you see and the old sergeant who had been sorting out these bloody things and one thing and another. They'd got the bloke sitting on the bed then, grilling him. And the inspector walked in, that was when I walked back you see from lookin' at that bloody poster, walked back and 'course had a look in you see, followed the inspector in. And the bloke what was sitting on the bed looked up and said, 'Oh', he said, 'I suppose you'll want us to come down to the station tomorrow morning', he said, 'to make a statement'.
'No ,no, lad', he said. 'Get your bloody coat on', he said, 'you're coming now'.
You're coming now! Made me smile. Had a chuckle about it.

The Fire at 'The Elm Tree' and the Death of Peter Gowing

Sorry to hear about your old mate, Dave. Still, he must have gone up like a torch, all that alcohol inside him.

Round the back of the fire station was an old pub called the Elm Tree. It was in a part of the town called The Kite, which had so far escaped the wrecking ball. In the last century, the Elm Tree had been a private house. Since the cellar had not been designed for keeping beer, it had to be heated in the winter and cooled in the summer. It had been converted into a one-bar pub, having a small square lounge with a bar counter taking up most of one side. Recently redecorated by the brewery company, the lounge lost none of its charm and comfort, with an open fireplace and Britannia tables, round, three-legged cast iron tables with wooden tops, often a century old. The landlord was Peter Gowing, a thin man with glasses. He was an alcoholic in his fifties and came from a Norfolk family with, as he put it, 'a history of liver trouble'. His wife's name was Dawn, from a German military family, a granddaughter of Liman von Sanders, the mainstay of the Turks in the Great War.

For a time, the pub was my local. The draught beer ('real ale') was exceptionally good. In view of this, Crocker and I arranged for the station bar to deal with the brewery to which the pub was tied, Charles Wells of Bedford. (Like many landlords who kept a good pint, Peter did not drink the stuff, preferring 'the vod.'). Peter and the station Club used to help each other out with cases of beer when one or the other ran short. We would also help Peter up with crates of beer from his cellar, since he was too enfeebled to lift such weights. Several members of Blue Watch used to visit the Elm Tree, particularly Crocker, Jonah and myself, sometimes

after work at six in the evening, until Peter decided not to open until eight (or even later, or not at all). The younger men would sometimes use it as a rendezvous for a night out on the beer. The Elm Tree had its own set of regulars, as did the Free Press nearby, which used to open at nine in the evening unless the landlady, Brenda Nicholls, knew there was a game of crib or a celebration in the air. Red Watch, as it happened, called at the Elm Tree too, though under somewhat different circumstances.

Peter was a 'character' and liked by the firefighters in spite of his classy accent and elegant manner. He had once been an office manager at Pyes, then a local electronics firm and a major Cambridge employer. Bill Hayden, a fire control operator close to retirement who had once worked in Peter's office, used to relate how Peter would get into the Fleur de Lys of a lunchtime and do impersonations of the directors on half a bottle of vodka. Before becoming landlord of the Elm Tree, Peter had considered taking a post office. He had, evidently, other business interests in the city. He was subdued and kindly without booze inside him; on a bottle or so of vodka, he was a high-spirited raconteur; on more than that, he could be morose, irritable or abusive. Yet even on that amount, he served competently. The beer was rarely in poor order and he always gave the right change. He did a good job in spite of his condition and sometimes because of it. His life was far from wasted.

One summer he spent in and out of the alcoholism units at Fulbourn and Addenbrookes Hospital. At about this time he was once sitting behind the bar, shaking his head and saying it was all over. Some of his customers (not the same type as the firefighters) were consoling him with words like 'Oh, Pee-tah, don't say things like that; you have a beautiful wife and everything to live for.' But an old lady who lived locally and sat at a table over a bottle of Guinness said 'Oh why don't you let him go. He wants to go, can't you see?' On another occasion I came in and he shouted angrily at me, 'Oh hello David. What the fucking hell are you doing in here?'

Later, one lunchtime, Crocker and Jonah were having a pint at the Elm Tree. Peter was in his cups, slurring his words, lurching about and embarrassing everyone. Dawn stood silently behind the bar, pushing her glass from time to time up to the whiskey optic. Suddenly, Peter turned on his wife and, as if in a scene from Shakespeare, announced in the clearest of tones and the right gestures, 'And as for you, woman, you are a liar and a thief and no doubt an adulteress as well. I give you an hour to pack your bags and get out of here, into the *gutter* where you belong'.

Red Watch happened to be on duty on the two or three occasions when Dawn phoned in the small hours to say her husband had got locked in the toilet. The crew would go round in the fire engine and open up the toilet in the bar. Peter would come staggering out, apologising profusely for having

'accidentally' locked himself in, insisting on giving the firefighters a drink. Despite being turned out of bed, the men did not mind. They saw Peter for the character he was.

> Jock Tanner: 'Come on old chap, open up.'
> Peter: 'I'm – not – coming – out.'
> Jock: (grinning and shouting): 'Right lads, get the axe and crowbar!'
> (Frantic scraping of the bolt on the toilet.)

The last occasion was a different story. Peter came downstairs before daylight and found the ground floor of the pub full of smoke. He went back to fetch Dawn and she preceded him into the street. Dawn looked back for Peter but he had either not emerged from the pub or gone back in for valuables. There was a flash and the whole building was well alight. When Red Watch arrived, they had an easy job, saving the shell and much of the woodwork. But it was some time before they found Peter, a scorched little heap in a corner near a door to the outside. Whether he had died of his condition or was overcome by smoke, will never be known.

When I came on duty just before nine, I saw two machines being washed down and an officer talking to one of the men, still in fire gear. It was obvious that they had 'had a job'. A pub had caught fire; someone had been killed; a dosser in a derelict pub; The Elm Tree -
'Ha' yer heard about your 'owd mate, Dave?'

John Gibbs, the brewery rep., had given the watch a case of beer. It lay under the wash all that day. The Elm Tree was refurbished. The Free Press was boarded up, its future uncertain, a likely victim of 'planning blight', its license liable to be transferred to another house. (In fact it reopened, somewhat gentrified.) Little Les and Big Les, friends of KC and regulars of 'The Box' (The Free Press) continued to come to the station bar during Blue Watch tours, but bemoaned the loss of their local. Brenda and Dawn moved out and lived nearby, near their old houses, in Council flats. The job at the Elm Tree was to become part of the station's memory for nearly thirty years, when the younger lads who went to the fire would have all retired.

1.9

Reflections on Leadership and the Common Pursuit

Memories:

I know he's an officer now but I knew him when he was a fireman, I was in a BA job with him in front. It got quite hot and all of a sudden he turns round and comes chargin' out. I nearly got trampled in the rush. That's the sort of fireman he was.

The tannoy:

Putting that tannoy in the office, that's the last thing we wanted. First thing it did was to upset the Control with another set of voices blabberin' on the station. They sit down there and press that button, too lazy to get off their arses to go and find someone. Half the time they don't really want you anyway. It's a waste of time. I suppose they think they sound good. Still, if I'm hiding away somewhere and they want me, at least they ain't goin' to find me doin' fuck all; so I suppose I shouldn't complain.

The Queen's Commendation:

There was this bloke up a tree, nutter he was, drugs and booze and all. Wouldn't come down. Mallon went up the TL and tried to coax him down but he wouldn't come. So he calls Jock up. Jock gets him onto the ladder after a bit of a struggle and they got him down. By then he'd calmed down and they put him on a stretcher. All of a sudden, he starts

flailing his arms about. They had to put him into a straight jacket. Mallon got the Queen's Commendation; all Jock got was bruised ribs. Mallon was embarrassed about it, actually.

Wearing BA:

Never seen Jim in a BA set; conk's so big it won't fit inside the mask. Still, he used to have to wear two nose-clips with the old Proto sets, so I suppose he's better off.

How safety standards are set:

You get them sittin' 'round in London talking about safety and BA and that. But they don't do anything. Not till half a dozen blokes gets killed in a job; then they hold their enquiries and things gets changed; until the next lot of blokes gets killed. It's lives that changes things. Nothing else.

Showing respect:

Visiting officer in the Clubroom: 'Where is the Conference Room?'
Firefighter: 'Over there, mate.'
Officer (enraged at being called 'mate' rather than 'sir'): 'What did you say?'
Firefighter (taking the officer by the arm): 'Just up there, mate.'

The fire brigade was a disciplined service. Officers were to be called 'sir' and saluted by the ranks. The service abounded with orders, reports, parades, staff, drilling by numbers, tactical exercises, uniforms and bullshit. Some of this amounted more to form than to content: at Cambridge, 'sir' was rarely heard and saluting almost unknown. Generally, the fire station was more relaxed than Training School, where orders and discipline were explicit and the militarised system more immediate and obvious.

Leading Fireman, taking the practical exam for Sub-Officer, in the drill yard: 'Your standing to attention. You can do better than that.'
Firefighter: 'Stand to attention! I been in the Army. I been here twenty years. I know more about standing to attention than you'll ever know.'

One aspect of discipline was of central importance, the Discipline Code. Before the Second World War, some fire brigades had discipline codes and

firefighters in the old police brigades came under police disciplines. The Discipline Code was inaugurated and became universal in the National Fire Service during the war; it was confirmed by legislation in 1948. Under union influence, the Code of 1948 became more equitable than in the war years, including the offence of abuse of authority, more rights for the defendants and the opportunity for union representation. While the Code was not a substitute for a system with impartial verdicts such as grievance arbitration, it protected firefighters to a large degree from victimisation and arbitrary dismissal. There was a complex procedure of hearing, punishment and appeal, if necessary up to the Home Office. The Fire Brigades Union (FBU) provided a 'friend of the accused' and professional legal aid in serious or contentious cases. Just as the union opposed the use of the Discipline Code in industrial disputes, it was also wary of using its industrial power to influence discipline cases. Though there was pressure to have the Discipline Code relaxed, there was little opposition to the Code itself. The punishments under the Code were dismissal, requirement to resign as an alternative to dismissal, temporary loss of pay or reduction in rank, reprimand and caution. The net result was that after the probationary period, a man could be dismissed from the service only by redundancy, medical discharge, and serious or repeated breaches of discipline, and then only after due procedure. During the seventies, the Discipline Code was used rarely. Nationally, there were barely three dozen cases of dismissal or requirement to resign. A common punishment was the caution, which did not go on the firefighter's record, though a caution could, of course, add to a fireman's reputation as a troublemaker.

The elaborate formalities of the Discipline Code can create a misleading impression, since there were essentially only two cardinal sins in the ordinary run of things: being late for work and 'missing a machine' when it went out. Persistent lateness, a cause of discipline, was not common. Missing a machine was again rare, but it was more common than met the eye, since it was often enough covered up by the junior officers. (The author missed a shout once in five years but was never late for work.)

Discipline was exercised predominantly at fires when orders were to be promptly and unquestioningly carried out. Invariably, as in the armed services, there were a number of ways in which orders could be ignored or circumvented.

> Officer: 'I want you to go out on fire prevention and show the film.'
> Firefighter (carrying the projector): 'I'm not going'
> Officer: 'Yes you are.'
> Firefighter: 'No, I'm not.'
> Officer: 'Yes you fucking well are.'

Firefighter (dropping the projector): 'There, I've dropped it. It's broke. Now I can't go.'

Outright disobedience did occasionally occur. Derek and Rodney were on a branch at the Garden House Hotel fire when John Mallon came charging up, yelling 'Get in there!' and pointing to an open doorway. Derek said, 'I'm not fucking going in there!' Seconds later, a bath and fittings came tumbling through the ceiling into the room. Rodney reckoned he owed his life to Derek. This case was peculiar in that John Mallon was respected as a hard-working officer who led from the front. Other cases of disobedience occurred more in sorrow than in anger.

The role of officers at fires varied from incident to incident. In theory, the officer-in-charge at a fire was not supposed to work, only to give directions. At one extreme, a good officer-in-charge could get things sorted out quickly, without panic and confusion. At really large fires, the job was less to give orders to individual fireman and more a matter of getting firefighters and machines deployed. At the other extreme, officers made a mess of things, a common sentiment being 'We'd ha' been better off without an officer at all' – something comparable to the one that says sergeants run the army and lead the troops in combat, not the idiots from Sandhurst.

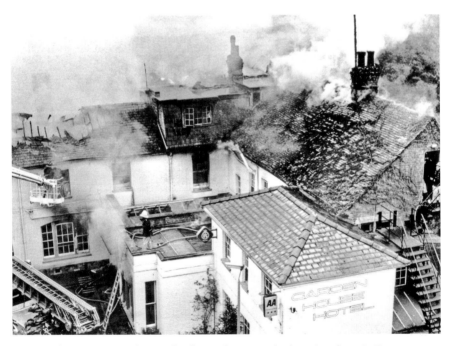

The Garden House Hotel Fire: the fire under control, 'damping down'. (*Press Association Image, PA – 829 8542.jpg*)

The most common criticism was not that an officer gave wrong orders but that 'he won't make a decision', that he would not do the job that he was paid to do. By contrast, John Mallon was reckoned to be a good leader at a road accident as he did not panic and was helpful to the less experienced firefighters. At fires, the reputation of 'the Major' (he had been a sergeant major in the wartime artillery) was different. It was said of him that he used to charge all over the place, shouting and bellowing orders to all and sundry. But this was not held against him. He did his job. Later, it became far more common for an officer to arrive belatedly in a fire car as the hard work of clearing up began and then to disappear soon after he arrived. The old school of those who had worked their way up slowly through firefighting experience, gave way to the newer breed of 'man managers' whose prime concern was not firefighting.

In between the extremes just mentioned, there were a large number of incidents in which leadership was not a function of rank, responsibility and authority. At small fires, the leadership from the junior officers was often good but not necessarily because they were exercising their nominal authority. For one thing, the older firefighters who were the peers of the junior officers in experience did not usually need to be told what to do. In practice, a job got sorted out because someone 'takes a lead', and taking a lead was a matter of firemanship and only incidentally of rank. Hence the common sentiment, 'the job carries itself'.

There should be nothing surprising about this, since the informal and unofficial modes of leadership have long been recognised as essential to emergency work. Hence 'the buddy system' in the U.S. Army, the Australian 'mateship' and 'fire teams' of combat soldiers who do their jobs well because they are self-directing rather than because they are ordered.

*

The phrase 'he's a good fireman' was often heard on the station. A good firefighter was one who looked after his own safety and the safety of his mates; he erred on the side of caution. He was a person interested in firefighting, not paperwork or promotion. Foolhardiness in a young firefighter was not, however, always condemned; it was sometimes the saving grace of a character who would otherwise be regarded with contempt and ridicule. If a 'good fireman' got the wind up, say, in a dangerous BA job, he was reckoned to be wise and careful; in a 'bad' firefighter it was seen as panic or cowardice (the latter term rarely used as such).

Estimates of firefighting ability were bound up with general moral estimates of character (of which more, later). But there was one salient feature in the appraisal of firefighting ability. This was the tendency to

rationalise and explain away the mistakes of the good fireman and to see the failings of a bad fireman as confirming the general estimate of the man. If an individual was respected by his peers as tradesman, firefighter, sportsman, drinking companion or whatever, he could do no wrong, since he shared a common system of justifications, covering up, mitigating circumstances, a common evaluation of what was important in life and work, and what was not. The facts of day-to-day living, duly interpreted, were invoked to vindicate and shore up a value system. The value-system was not a construct of salient facts and attitudes.

> *I don't know what you think; but after you've been in this job for five or six years, you know about all you are goin' to know.*

The adjective used most often of the good fireman was 'practical'. 'He's a practical bloke' was an expression of high praise and would silence other criticisms. The practical fireman 'did the right thing', without panic. If a job needed to be done quickly, he did it quickly; otherwise, he did not rush around and waste his efforts. The practical fireman 'knows what to do'. Knowing what to do involved the right selection and use of tools and equipment. Utilising equipment in ways for which the tool was not explicitly designed, was a mark of ingenuity and resourcefulness in situations where there was little time to think things out. The practical fireman worked and thought for himself, *with others,* unprompted. On a job, there was invariably a blend of practical ideas, sometimes with one firefighter taking a lead, at other times not.

The firefighter's skill was not taught on the whole by formal training; it was the result of a tradesperson's kind of craft, combined with experience of firefighting. The best firefighters were often tradespeople. They were also (sometimes in addition) ex-servicemen, either as regulars or as National Servicemen. The ex-servicemen were the least inclined to panic on a job (or so it seemed to me). Other good firefighters learned the job the hard way, slowly, making mistakes and unlearning their panic; the differences between a tradesperson and a clerical worker tended to even out over the years. Yet others seemed to be 'born firemen'. There was much debate as to whether some were intrinsically better firefighters than others or whether it just took longer to train a young scatterbrain than it did a tradesman in his twenties. There were a few who left the job after thirty years as ham-fisted as when they came in.

> *I was on the Water Tender, in the back. It was one morning, early, going across the Elizabeth Bridge. Graham was driving. We went into a skid, coming off the bridge. The front of a twenty-ton artic come towards us in*

the oncoming lane and I thought the crunch had come. Graham sat over the wheel like some fucking great spider, his arms spinning the wheel back and forth. In the back, we saw the grass verge on the left swing into view, then the lorry again, then the traffic ahead of us in our own lane. I was shit scared. Graham, he didn't bat an eyelid. Just stopped at the place and put the pump in gear. That was it.

Of all the skills on the fire station, good driving was the most admired. The good drivers made no secret of the pride they took in their driving. The reason for the high estimate put on driving skill is not easy to fathom. Perhaps it is because however good a man was at firefighting, there was rarely anything spectacular and singular about it. Good firefighting was the result of collective effort and was rarely the subject of a public exhibition. But driving a heavy vehicle in an emergency through fog and heavy traffic or on an icy road was a demonstrable skill, all the while having to know the limits of the machine and the vagaries of the route.

These young lads, they're good drivers. There's no doubt about that. But when they first start driving, they're too fast. If that's a chimney or a pile of rubbish, there's no sense trying to kill yourself; you got to get there in one piece, else what good are you doin'? You got to think about the lads in the back, trying to get BA on. Then you got to allow for other drivers; there's some right idiots on the roads these days.

He's terrible. He stamps on the brakes, murders the clutch and gearbox, can't read the road, or anything. I've seen him go out of the bay, dragging the battery charger by the lead, the engine heater, and everything. He goes to the fire like a bloomin' snail and then tears back, like his lights and horns are still on. Funny thing is: he's never had an accident. He's a terrible driver; frightens the life out of you. But he's safe really, when all's said and done. It's nerves, I reckon.

You only got to touch something on the road and there's reports flyin' all over the place for months after. It's not worth it: never smack up a motor. We're lucky we don't have more accidents really. The last one was when Phillip went into the back of a trailer loaded with caravans; he wern't even on a fire call. Wrote two of the vans off and the whole cab of the Water Tender. I was Number One and thought we'd have to radio for the ET. Phillip was lucky he wasn't trapped or hurt. Our little friend in the back, he didn't half squeal. Then before that, Roger hit a lorry in the Carrier on a shout. The lorry was at the lights and let Dusty through, in the Water Tender. 'Course, he didn't think there was a second motor

coming. It's always the way. That was Roger, behind Dusty in the Water Carrier. Dusty looks in his mirror and starts shouting and crowing: 'He's hit the bastard. He's hit the bastard' ... The fuzz are pretty good about it really; they try to get us off if there's no bother with the other party's insurance. Or they'll take you through the courts and as likely as not give you a discharge.

I was driving the Water Tender through Willingham in the fog; it was early one morning. It went into a skid. There was nothing I could do. Daren't touch the brakes. So I let it slow down best I could, keepin' it out of the spin. We ended up arse end in the ditch. Drained the water out of the tank and got the Carrier to pull us out. Frit me. Worst one I've been in, in spite no one was hurt and no damage.

<p style="text-align:center">*</p>

The union campaigned for the promotion system, with written exams, to counter favouritism and the 'old-boy network'. There were a series of examinations for promotion to the ranks of Leading Fireman, Sub-Officer and Station Officer. The first two had a practical exam for those who had passed the written part. A firefighter who passed the last of the three exams could in theory aspire to the rank of Chief Fire Officer or Her Majesty's Chief Inspector of Fire Services. The latter two exams could be passed by anyone with a basic literary and mathematical education and (above all) a good literal memory of the extensive Manuals of Firemanship. The Leading Fireman's exam was different in that the written part contained no test on fire brigade matters at all, only language and arithmetical tests. In addition, there was a general knowledge quiz: roughly, if you didn't know who painted the Mona Liza or who won the FA cup in 1972, you could not become a Leading Fireman, nor of course were you eligible for the two subsequent exams.

In any case, the promotion exams did not, and probably could not, test leadership and practical firemanship. The result was that the promotion system favoured those with academic ability, often at the expense of those whose talent was predominantly practical. But this, after all, was the point of the exams: to favour those who would later fill senior positions in fire prevention, administration and training, regardless of the fact that a senior officer may not have the firefighting experience and ability commensurate with his rank. Again, rapid promotion could be achieved by moving from fire brigade to brigade; characters who did this could have very little interest in the local community, the brigade, nor in the particular job that they took. They used the station, 'as a transit camp', choosing to divorce themselves from the blue-collar collective, the foundation of their success.

Such considerations were one reason why some doubted whether the promotion system was any more effective and rational than what it replaced. Another reason was that the pool of qualified people for any one job was invariably large, leaving scope for favouritism within the restricted yet still extensive range of candidates.

Some firefighters had mates who had gone up the ladder of promotion. The term used of such individuals was that they 'changed' according to their new rank and non-manual work; that is, they adopted a wholly new set of precepts about the nature of the firefighter's job and the role of authority which informed it. To 'change' was usual, not exceptional; but unless the colleague changed beyond recognition, he was not begrudged his effort, nor his reward.

All this is a generalisation; it is based on an outlook which was most characteristic of the older firefighters who were also qualified tradespeople. As such it is only one view among many, in which there were several shades of opinion and aspirations within the service. If he had a trade, a firefighter could pursue his own line of work as a 'fiddle' (part-time job) and so have no need of the increased pay that rank in the service would bring.

There were perhaps two types of rationale for the generalisations about rank, authority and occupation within the fire service. Both started with the premise that the essence of fire service work was firefighting, a practical job in which leadership and authority through rank were different things, only casually related and overlapping. The other work, such as fire prevention and administration had no connection, or intrinsic connection, with the firefighter's job. The personnel who did such work were really irrelevant in the scheme of things, irritants when they asserted their authority and at best a nuisance when they showed up at fires.

The second manifested itself in a far more profound social conservatism. This was the idea that societies were essentially static. They rested, and would always rest, on basic needs of food production and shelter, which were secured by practical skills of which the building trades and the farm labourer were the paradigm. Everything else in society was basically irrational, a creation of value-added which was, morally, of no real value at all. In this schema, senior officers who did non-manual work were not considered firefighters, nor even workers at all.

There were all sort of debates, rarely couched in such terminology, as to whether this critique was really correct. Was society changing and, if so, what were the consequences for the firefighter's job? The firefighters talked and argued about whether there should be a 'two-tier entry' into the job, to attract people who could work effectively in a new social milieu; whether the firefighter's job really was becoming more technical; whether non-operational work were better done by civilians or by a wholly separate

branch of the service. The union too saw that the best chance of raising the status of the firefighter's job was to have them do much more fire prevention work in between fire calls. But when the General Secretary of the FBU, the late Terry Parry, referred to firefighters as 'highly skilled fire prevention technicians', some of the older firefighters responded with derision. On the other hand, a consensus developed that the job really did become more technical, from about the 1970s onwards (see the Appendix).

Part 2

On the Station

Introduction:
Cambridge Fire Station

On nights:

Old Dick, he was so fast asleep he used to come down the pole drop, stand by the riders' board holding his trousers up, to see which machine he was ridin'. Else he'd never get out at all.

Piles:

Look at him, on that soft seat, can't sit still. He's primin' us; shan't see him at work tomorrow.

Testing Hydrants:

'We got a lot to do today boys, and we're going to do it', he says.
First stop: Post Office for his pools.
Second stop: nearest bloke's house for a cup of tea.
That was Abdul [Wal' Smith].

Cambridge Fire Station was built as a large one, with six bays for the first-line appliances. The station was manned continuously year-round. Thus it was a communal home as well as a base for firefighting, with bunk beds in dormitories, a mess and washing facilities. It would have been possible for firefighters to stay on the station for weeks on end, as they often did a century ago. I had been to a boys' boarding school and was used to all-

male communal living. I took to the firefighter's way of life immediately and vastly preferred it to a nine-to-five sedentary job. When I left, I missed the communal life and the close comradeship of firefighting in ways I had not imagined. I still do. At the same time, I was something of a loner in personal life; I was not naturally gregarious. So the communal living provided a social structure into which I fitted willingly and gratifyingly. Not all the firefighters relished this collective life. Some were rarely seen in social settings on the station, such as conversations in the locker room, table tennis matches or around the bar in the evenings. They would sit apart at the mess tables during meals and resented the 'moral centre' of the watch, which comprised the 'good firemen', the tradespeople and the ex-servicemen. They came into their own in formally structured situations, such as watch gripe sessions in the lecture room or the union meetings that were held on the station.

The three watches (shifts) each had a strength of twenty-one firefighters, of whom about seventeen were on duty at any one time. They worked a nine-day cycle of three days from 9.00 to 6.00, three nights of 6.00 till 9.00 am and three days off. This averaged out to fifty-six hours a week. When we went down from fifty-six to the forty-eight, the firefighters took 'Red Rota' days or nights off within the nine-day cycle.

Cambridge Fire Station.

When the operational firefighters came on duty at 9.00 am, the first thing they usually did was to put their fire kit on their assigned machine: boots, plastic or rubberised leggings, heavy woollen tunic and helmet. If their machine went out to a fire on the shift, they first stepped into their boots, pulled the waterproof leggings up over their trousers, donned their tunics and put on their helmets. The BA man would wait for a straight, clear stretch of road ahead, when the machine would not brake and lurch excessively. He would then be helped with the awkward job of donning his BA set.

A firefighter coming onto a shift would often arrive several minutes before the hour, thus saving his predecessor from a last minute turnout. The union had negotiated an agreement whereby the man relieved could go straight home without being formally dismissed on the hour. Certain men were known to be 'good reliefs' because they could be counted on to arrive up to half an hour early; while others got there at the last minute. The firefighters would in general give their mates many hours of their time by way of standing in or early relief but would not tolerate working without pay.

The firefighters rode different positions on different machines on each shift, though appliance drivers tended to be assigned to drive one machine or another every time they came onto a shift; they disliked being 'in the back'. This meant that any one firefighter might not see action during a shift even though it was a very busy one.

A tally board in the muster bay next to the appliances told firefighters which machine they were riding and their position. The junior officers in charge of the watch took a roll-call on the hour, the firefighters parading in undress uniform. The watch officer assigned routine duties and made any necessary announcements, such as road closures in the station area, items lost and found and censures for the watch. The watch then had half an hour to do routine duties and get changed into overalls. The BA wearers checked their sets and the drivers their machines, though in practice these things were usually done prior to the parade. It was the custom at Cambridge for the BA wearer 'in the back' to check the BA set of the officer in charge of the machine. Drivers were responsible for the state of their appliances: petrol, oil, water, water tank full, lights, indicators etc in working order, equipment secure and the bodywork free of dents and scratches.

Other routine duties included checking the BA sets on the EST and in the BA room; filling in the mess sheet (dinner list); checking over the hydrant van, light truck and fire cars in the same sort of way as the machines

The officer in charge of the machine was known as No. 1, the driver as No. 2 and the rest in the back as No. 3, No. 4 and, sometimes a No. 5. An

The Rolls-Dennis Turntable Ladder.

assignment, 'you are five on the pump and jumping the ET' meant that the firefighter was fifth man on the water tender covering the city and third man on the Emergency Salvage Tender if you were not already out on the pump. If you were 'on the bits', you were the third man on the EST and the TL, whichever went out first.

The drill period was from 9.30 until tea break at 10.30. Two or three of the fire engines were backed out onto the drill yard and the firefighters practised on the equipment – slipping and pitching the ladders; getting a jet or hose reel to work in the drill tower; getting a portable pump to work from a pit of water in the drill yard etc. Or the EST would be drawn up at the back of the yard, the firefighters cutting an old car to bits with the compressed air saw and zip gun, using the 'jaws of life' or jacking it up, using hydraulic jacking gear. The men practised on the HP cage controls by the drill tower or used the TL for simulated rescues using a dummy body in the rescue sling. Sometimes there was an exercise simulating a fire: lines of hose and water or foam everywhere. On wet or icy days the drill period was spent in the appliance bay when the firefighters did locker drill (making sure they knew where on each of the machines the equipment was stowed) and practised knots and sheeting up, simulating salvage work.

Two drills were phased out in the 1970s. The first of these was with hook ladders, short wooden ladders with a folding, serrated hook. These

could be used to climb storey after storey of a building by knocking out the windows and using the hook to anchor the ladder while the firefighter climbed up to the next floor. The value of this drill was that it helped give firefighters a head for heights; it was otherwise obsolete. The second was 'live carry-downs', as described in the Prologue. This drill too was obsolete: we once saw a film of a live carry-down from Chicago but the body was in fact very light and very dead. In practice, almost all rescues from heights were done by a firefighter escorting the person down a ladder, while descending first, or by the infirm or injured person being put into a rescue sling. There was an even better reason for the union's attempt to suppress the carry-down drill: it could be used as a weapon for ruling a firefighter unfit for duty through failing to carry down. There was not much to stop an officer ordering a 150lb firefighter to carry down a 200lb man, nor for ordering the drill to be repeated on the grounds that it was not completed or not done properly. Or a firefighter returning from extended sick leave could be ordered to do a difficult carry-down. I once saw something like the former happen while, as to the second, a watch officer declared, of a man returning from sick leave, 'We are not carrying Crocker', meaning that no concessions were to be made to the man returning from sick leave, a man who was known as a rebel and dissident.

The drill period used to be sacred. For instance, if the brewer's dray arrived during drills with beer for the club bar, the watch barman used to have trouble getting time off from the watch officer to take delivery of the order and get the empties down from the bar. Then things became more relaxed. One fire engine was quite often out doing school fire drills; urgent jobs were given priority over drills and older men were occasionally told to get lost, leaving the younger lads to get practice on the HP and EST, training they didn't get during their initial three months away at training school.

After the 10.30 break, there was a two-hour period for station work. The watch's hose men cleaned, tested and repaired hose, hanging them from the drill tower to dry. The battery men checked the fire engine batteries, BA lamps and handlamps; the map men drew their plans of high fire risks in the map room. The BA men serviced sets and recharged cylinders on the compressor, particularly if there had been BA drills before the break. Others were assigned cleaning jobs: the fire engines, equipment, certain parts of the fire station, or the smoke house after a BA drill in which fires had been lit or obstacles spread about to simulate fire conditions. As likely as not, one or two appliances would be out in the town or country, on radio call. Their crews tested hydrants, carried out elementary fire prevention inspections, or checked the plans of certain premises, partly for familiarisation in the event of a fire and partly to be sure the plans were up to date.

Similar things took place after the dinner hour but things often quietened down and the firefighters began to lounge around before they were stood down at 4.00 pm. From then till they knocked off, the time was their own. Most of the men went up to the Clubroom, made a cup of tea, read the papers, watched television, played darts, cards, table tennis or billiards. There might be a game of volley ball in the yard. A couple of men would go running around the yard or do weight training in the hose room. However, there was no systematic exercise apart from drills and fire calls, an undoubted failing that was remedied in later years.

When the night shift came on at 6.00 pm it again had half an hour to get changed, check the appliances and BA sets. Most of the men made up their beds straight after the parade in the muster bay (an armed forces tradition) and lay around in the dormitories; there were no station duties in the evenings. From 6.30 to 7.30 there was another drill period, though in general, less time was spent in the drill yard than in the mornings – a short, set drill or a spell of equipment testing. More often, the hour was spent in the lecture room or the quiet room, where the men were tested informally on the topography of the town and the location of the villages in the South Division of the Cambridgeshire Fire Brigade. Though few people on a watch knew all the streets of the town, all the major risks and all the villages, the older men knew most things. Almost always, at least one member of a crew knew what needed to be known and where to go.

Alternatively, there might be a lecture from the watch officer on fire prevention inspections; what to expect at special risks such as refrigeration plants or radioactive sources; new brigade standing orders were read out and debated. Friday night used to be station cleaning night; the last vestige of this working class tradition was that the watch barmen cleaned the pipes of the beer engines and on Friday afternoons, the appliance bay floor was washed with cleaning machines.

From 7.30 till the morning, the men were stood down. There were a few minor things to do in the morning such as cleaning up the kitchen, bar and the Clubroom tables, cleaning the washrooms ('bogs and basins'), and carrying out the appliance radio tests, all of which duties ('fatigues') except the bar work were assigned in rotation. Some of the men made themselves breakfast and at 9.00 am they knocked off.

From midday on Saturday until Monday morning the shifts on duty were stood down; no station duties or work off the station were done in this period, except that is, for servicing machines and equipment (notably BA sets) after a fire, which was classified naturally as emergency work. And all the time, days and nights were punctuated or interrupted by fire calls. Standing by at a fire that had been extinguished meant an extended

period off the station, while peat fires in the Fens could keep a whole series of shifts off the station for days on end.

The first fire alert was the gentle breezing ring throughout the station of the 999 pre-warning bells, indicating that a call was coming in from somewhere in the Division. As like as not, 'stand down' would be announced as the call had been assigned to other stations. In the event of a turnout from Cambridge, the murderous 'big bells' would go down and indicator boards lit up to turn out the machines, sometimes a single machine, at other times up to five out of the six. Then the location of the fire would be announced and one officer rider would collect a risk card or village map from the hatch of the control room at the side of the appliance bay. Sometimes there would be no 'nines' and the big bells would go down directly. At night, this was traumatic. One particularly sadistic control operator would not trip the big bells but hit them hard, causing the men, sleeping in their overalls, to jerk awake as if electrocuted.

As the machines were announced, the overhead doors went up and the machines were away, blue emergency lights flashing with (daytime only), the two-tone horns. It happened occasionally that a driver forgot to disconnect a battery charger from a machine, which would bounce along behind the appliance, to the embarrassment of everyone, not least the senior officer following in a fire car. The big bells were eventually replaced by bleepers.

On arriving at the incident, the officer in charge would book 'in attendance'. He would then give progress reports on the radio, such as 'all persons accounted for' and, in the case of bigger fires, 'fire surrounded'. To call for more machines was to require a 'make up'. To send a 'stop' message meant that no further assistance was required. When a machine left an incident it would 'book mobile'.

The station had a different atmosphere at different times of the day and week. At weekends the HQ staff and all the officers were off the station and the watches were more relaxed. At five in the afternoon of a weekend some became bored and wanted, not a 'shout' to a fire, but only to go home. 9.00 of an evening was time for a drink at the bar (Cambridge was a 'wet' station) and close harmony on the watch. In the mornings, men would stand by the big picture windows in the Clubroom above the appliance bay, some of them commenting on the people and the cars they knew in the street below, others 'eyeing the crumpet' on their way to work.

Look at the tits on that. Like a pair of ferrets trying to get out.

In stand-down times, some of the men (particularly those from the rural areas) would sit for hours by the window, no doubt perfectly relaxed and contented, an art which has declined radically, even in a generation.

The strangest time was in the appliance bay in the middle of the night. There were a few lights here and there and in the control room where the staff dozed by the phones; otherwise the place was still and quiet, the machines looming in the darkened bays. Then a phone would ring in the control room, to be answered immediately. The 'nines' would sound, followed by the yard lights and the bells. Pole-drop doors banged and the men stood by the machines, saying little. One man was notorious for having to consult the duty board to remind himself which machine he was riding. A brief announcement, the doors in front of the machines would go up and the machines were away. The remaining men pushed the buttons to bring the doors back down and they melted away again to bed. The place went dark and quiet apart from the buzz of messages in the control. Around the mess tables the next morning there would be stories to tell.

But the firefighters also had a sense of when 'there was a job', that is, a major incident. They would hover around the control, waiting for the 'make-up', when the senior officer on the scene would order more appliances, maybe specialised equipment and ambulances too. At the Flixborough chemical fire disaster in June 1974 (Nypro Chemical: the explosion killed twenty-eight workers) the order was reputed to have been 'make pumps twenty-five', meaning that a total of twenty-five machines were required. In cases such as this, machines from the retained and other whole-time stations would come in to cover Cambridge while machines from yet further afield and outside the county would move in to cover the gaps. Gordon Powell once drove the EST to Newport Pagnell in Bedfordshire, half way to Oxford.

Both the number and the frequency of the calls were unpredictable, though there was some pattern according to the weather and the season. A Guy Fawkes night without a fire call was a rarity.

2.2

Recruiting and Training

You got to have a bit o' discipline; I don't care what you say.

When people applied to become an operational firefighter, they took a test in English and mathematics; their height and chest were measured and their eyesight tested. If they passed these hurdles, they were interviewed, usually by a panel of senior officers with an FBU observer. The successful interviewee was then given a thorough medical exam, including measurement of chest expansion. The brigade gave the person a strength test in the form of carrying a firefighter a few dozen yards. The person was then appointed or promised an early appointment as soon as a vacancy arose. The maximum joining age was thirty-one, or thirty-four if the person had served in the armed forces. Since the retiring age for firefighters was fifty-five, an individual who joined later in life could not get the full thirty years' pension. (A firefighter could retire with thirty years' service if over fifty.) There were about twenty enquiries for every vacancy filled.

Recruitment at Cambridge was largely by casual enquiry or through acquaintances already in the service. A third to a half of the firefighters were related to each other, to firefighters on other stations or to those retired. At the same time, there were the first signs of advertising the service as a career, occasionally among university graduates, more often among school leavers. The first woman firefighters were appearing in some brigades; they became common at Cambridge only in the 1990s. Ethnic balance in recruiting was not yet an issue.

The idea of recruiting people without prior industrial experience would no doubt increase conformity in the service, with the recruits more likely to accept the prevailing ideology and the concept of the service which the

senior officers wanted to promote. Since they had no other work experience, they were beholden to the fire service as a career. They had nowhere else to go. The most notorious rebels on the station were invariably ex-servicemen who could see through the bullshit and took a naturally cynical view of authority. Further, the qualified tradespeople were less beholden to the job since they could earn as good a living outside the service.

During the three months that the recruit spent at training school, the military discipline was laid on thick, less so back on the station. This was partly because the military system was more relaxed but also because the firefighters had, as it were, adopted or internalised the disciplined life. Though the discipline and working conditions of the quasi-military era had become easier by the 1970s, the life was still, by our current standards, hard and rough. When the system changed, as it gradually did in the 1990s, one instructor at the Yorkshire training school remarked with derision that a recruit had complained at being shouted at!

In the history of the FBU which appeared in 1992, it is stated that those firefighters who joined the service from the armed forces at the end of the war expected something different from the fire brigade. This was not my experience. Though there was plenty of complaining about bullshit, both at training school and after, few criticised the system as a military relic. The reason, it seems, was that those with military experience knew how to work the system, to subvert it when necessary and generally to render it innocuous. The few occasions when an officer complained on the job that an order had not been carried out or that the job had not been done 'by the book' (the firefighter's drill book) were not seen as a deficit of the system, only an individual. Of twenty-one retired firefighters polled in 2007 (not, admittedly, a scientific sample), two said it was a good idea to end the disciplined military system, one was ambivalent, but all the rest said it was a bad idea. Those who had been through the military system and knew no other, believed in the regime. So it is possible to exaggerate the anomaly of quasi-militarism. But an observer could not fail to discern the parallels, for instance, between training school and an RAF camp in the 1920s, as described by T. E. Lawrence in *The Mint*. At least the military authorities in Lawrence's day were embarrassed by his revelations.

How effective, really, was the training? There was a similar relationship between military training and action on the one hand and, on the other, firefighters' training and effectiveness on the job. In both cases of action, assigned roles and functions changed; procedures were in practice haphazard and the hierarchy of command broke down. This is because there was little direct relationship between the modes of training and the unpredictable chaos of action. Yet in both cases, we can make estimates of the effectiveness of the training. While in both areas, there were critics

and proposals for radical change (witness the unusual modes of training in the Israeli Army, where in action, there was – and perhaps still is – no hierarchy of command), the most likely verdict is that firefighters' training was good enough as a preparation for firefighting, which then provided the experience that makes a good firefighter. The ability to learn on the job was at least as important as the preparatory training.

Where the system fell down was in the changing nature of the firefighter's job, from simple fires to new and often different hazards. So we could argue that the increasing variety of chemical fires and industrial hazards should have influenced training sooner than it did. Then again, the main rescue work at Cambridge was in road accidents. Here the training was less good and less appropriate. Training in First Aid was rudimentary and there was none of the para-medical expertise needed for safely extricating injured persons trapped in vehicles and the like.

On returning to station, the average former recruit was full of keenness and enthusiasm. On jobs, he tended to try to do everything too fast, all at once. Gradually, he would learn to weigh things up, before rushing in. The keenness would wear off after a year or so, though rarely followed by disillusion and cynicism. For two years from recruitment, the firefighter was on probation, with tests and periodic reports, subject to dismissal without redress and without the protection of the Discipline Code. However, few were dismissed during probation, at Cambridge none in the 1970s, so far as I am aware.

The attitude of the union was ambivalent. While the union had no formal power to protect probationers, it certainly had informal power in the form of industrial muscle. The union defended every member in trouble and implicitly challenged the right of the employer to push anyone around, under any circumstance. (Even those accused of child molesting had rights, which the union, to its credit, attempted to defend.) Union leaders were also well aware that a favourite tactic of the employer in industrial disputes was to attack the probationers, which came to a head in the dispute of 1951. On the other hand, some members tended to resent the union defending 'wasters'. (Terry Parry, the former FBU General Secretary, was characteristically blunt: 'we can't support sub-standard people'.)

Why should we defend someone who is only in the job for what he can get out of it? He didn't give a monkey's for his mates. Why should his mates give a toss for him?

After four years and further tests in driving, BA, first aid and fire prevention (FP), a firefighter attained Qualified Fireman's status at an increased rate of pay. Turnover in the job was slow but steady, usually because of better

prospects elsewhere. One reason for leaving, invariably unstated, was that wives did not like their husbands being on night duty.

On a firefighter's retirement, his watch laid on a celebration with another watch, on duty, acting as hosts. There was a lot of good feeling, sentiment and tears, especially when the retiree was known for 'the job being his life'. The retiree was also a guest at the brigade's annual dinner. After retirement, the individual was often seen around the station, calling in casually or coming up of an evening for a drink with his old watch around the station bar. Some of those retired took non-uniformed jobs on the station to supplement their pensions: the pension plus a low-paid manual job meant that the individual was somewhat better off than when he was a firefighter, with easier hours, less strain and no pressure to fiddle.

2.3

Avoiding Useless Work: Skiving

The working life and the social life of a fire station were impossible to separate. Skiving (pronounced skye-ving) is a case of not-working, itself with a strong social dimension.

Skiving is not doing what you are supposed to be doing. Within the confines of the station, you could be in the wrong place at the right time, the right place at the wrong time, or the right time at the right place doing the wrong thing; or doing nothing when you are supposed to be doing something. There was only one general rule of skiving: the safer the place to skive, the harder it was to escape from it in the event of imminent detection. The more obscure a place was, the more it tended to have a single way in and out. The most important thing about a place to skive was that it should be within the sound of the bells. There were a few odd places on the station which would be ideal but for the fact that you could not hear the yard bells, and there was no tannoy loudspeaker within earshot. Next, it should be warm and comfortable. From the seats of the reserve fire engines in the back garages, you could see the yard and the rest of the station without being seen yourself, just right for a smoke and a chat, though a bit too cold in the winter.

Picture a beautiful summer day in the drill yard during the station work period. The whole fire station seems deserted. The 999 bells ring. A group appears from the back garages; another firefighter with his shirt off and a sleepy look in his eyes descends the smoke-house balcony. About four issue from the hose room, though only two were supposed to be there. In the appliance bay, a pole drop door bangs on the first floor and a firefighter descends, recently asleep in one of the dormitories.

A firefighter might be detailed to clean a fire engine. It turns out to be in good order so he might take a shovel from one of the lockers, get a piece of emery paper and some back paint from the station stores and proceed to the hose room in the warm where a few other like-minded individuals have also congregated, the shovel and paint a perfect excuse for being there.

If you are about to be caught you could stay put, or cut and run. One fellow in the cab of a machine in the back garages might slide out and into the back of a lorry, keeping low. Another might grab a piece of equipment nearby and stride purposefully across the yard in sight of the approaching officer, thinking desperately of why he should be taking that piece of equipment to the appliance bay when it went out of service ten years ago and he was supposed to be mucking out the drying room anyway. Walking about briskly with a clip-board and pen was a passport to almost anywhere on the station.

You could be caught red-handed. Once Crocker was sent over to the smoke-house to bundle up a pile of old newspapers for charity. He sat down and got absorbed in some magazines when the figure of John Mallon, 'The Major', the terror of the station, loomed in the doorway, blotting out the sun. Crocker thought it would be most undignified to make a move so he let Mallon just stand there, giving him a casual little glance of acknowledgement.

'Well, are you going to move or am I?' said the officer. Crocker put down his magazine and sat tight. 'We don't ask much of you', Mallon continued, 'but we expect you to get on with it. What are you supposed to be doing?'
'Bundling up these newspapers' said Crock. Mallon pursed his lips.
'Well get on with it then'.
'But I haven't got any string', wailed Crock. John Mallon's face went deadly white and began to shake. A vein in his neck appeared in high relief. The usual symptoms.
'I ought to take you up to the Deputy right now' he raged.
'That you did', said Crocker, sympathising with his plight.

It was the last straw. Mallon began to bellow, waving his arms about, yelling at Crock to see him in his office after the break. So Crock crept away for his string, Mallon shouting abuse behind him. Crocker: 'My cheese roll didn't go down very well, that morning'.
On another occasion, a firefighter was talking with Derek Ward, one of the two watch hosemen, who was sitting down in the hose room. Mallon came in with another individual to check something or other. Derek's companion carried on as before, so as not to be intimidated. But poor

Andy Jones and Dave Bennett, Blue Watch, with Neville Cross, FBU Branch Chairman at the time of the national strike.

Derek, straight in Mallon's line of vision, was caught. Still sitting, he clawed at the hose-winder nearby in a ludicrous attempt to be seen to be doing something. Mallon had made his point, shown who was boss and made a subordinate look silly.

It was possible to turn the tables. Jonah was once caught out and an officer ranted at him, telling him to get into the station office. Jonah knew he was in for it. As soon as the officer came in behind him he said 'All right, I know I was wrong, go on, bollock me!' The officer was instantly deflated. A good bollocking depended on the person arguing, so that the officer could shout back, threaten to put the person on a charge and, in a final climactic bellow, order him out of the office. Jonah had defused him nicely.

You didn't have to be on the station to skive. If one of a crew wanted to go to a certain shop in the city while testing hydrants in another part of town, the Leading Fireman could take a hydrant sheet from the folder with the street on it where the shop was, to provide an alibi if necessary for being in the wrong place. You could even skive on the fireground. The officer in charge of an incident was not supposed to work; he had to go around supervising. But if the fire was 'a goer', the sub-officer in charge could get into the building on pretext of vital work there so as to be 'out of the way' when the senior officer arrived on the scene.

Stuart Brignell and Andy Jones of Blue Watch.

Skiving was a function of the mode of authority and the contrast between emergency and non-essential work which was often menial. As the seventies proceeded, the fire station was run less on para-military lines with authoritarian values, and more on theories such as 'man-management' with a newer breed of officers without an armed service background. At the same time, union pressure did away with a lot of unnecessary work. For instance, the station acquired a cleaner to do much of the cleaning work on the operational side and wash down the officers' cars. The firefighters had to do far fewer menial jobs, which often did not need doing or which were only ten-minute jobs spread over two hours. The result was that skiving as an art declined. Essential work such as BA servicing and hose repair were never arenas for skiving. Quite the contrary; skiving here was regarded as a vice, not the norm.

Meals on the Station: The Mess

Lovely little Banty's egg. You see the yolk sittin' up proud as a virgin's tit and you know you've got an egg, master.

The Mess Club existed to provide meals and foodstuffs for the firefighters on the station. Both were provided at little more than cost. The fire authority paid the wages of two cooks who worked days from Monday to Friday and alternate Saturday mornings. They cooked a dinner (traditionally in England in the middle of the day) for whoever wanted one and made the tea and coffee for breaks. The County Council also paid for the gas used in the kitchen so that the firefighters paid only for the food going into dinner and into meals which they cooked or consumed at other times in the week. Also, the Watch Officer may decide that a meal had been spoilt as a result of a fire call and the cost of the food (still edible, or not) was reimbursed.

A few of the firefighters would make themselves a breakfast before going off in the morning, especially if they went straight to their fiddle after work. Several made some sort of evening meal after drills on the night shift. Sometimes a volunteer would offer to cook for whoever wanted a meal on the watch, perhaps bringing in food such as meat or fish for the purpose. Alternatively, someone would be sent out to buy fish and chips, a curry or a Chinese meal for the night watch, provided the watch was not down to its minimum manning. When this happened, a visiting off-duty firefighter would step out to buy food or a returning fire engine would stop at the chippie en route.

Overnight, two large kettles of water were left simmering on the stove, ready for tea after a job. Some instant coffee was drunk on the station, increasingly by the younger firefighters; but tea predominated.

On Blue Watch, five who ate a Sunday dinner went into the kitchen on a voluntary rota, to cook Sunday dinner. At this gathering, the watch was at its most relaxed. There were no senior officers, civilians or others around the station. Even those who did not take dinner, including the junior officers, would do their turn in the kitchen. The control staff took turns to come up from the control room for their meal.

The Mess Manager in the 1970s was Ken Chapman (KC). The official conditions of service laid down by the National Joint Council for Local Authorities' Fire Brigades stated that the Mess Manager and his deputy were to be paid a small fee. In addition Ken or his deputy would book in on overtime some mornings when they were off duty either to get food in for the mess or to help in the kitchen in the absence of the cooks. This was not the subject of a local agreement between the union and the Chief Officer but it was never queried. The fee and payments are examples of the way in which the social life of the fire station were built into the structure of the job.

Each of the watches had two mess representatives who met on the mess committee and did certain routine jobs when their watch was on duty. They took the numbers of those on the station wanting a dinner; helped the cooks at tea breaks, cashed up the till at the end of a shift and generally

Brian Ison, Blue Watch; Rodney Slack, Secretary, Sports and Social Club; Ken Chapman, Mess Manager.

tried to prevent their respective watches from turning the kitchen into a pig sty.

KC took the Mess Manager's job over from Russell Howard when he retired. Russell in turn had accepted the job towards the end of his service when his health was failing and he wanted to show that he was still of good use on the station, this at a time when pension and medical discharge provisions were poor. In the end, they gave him no bother at all. He slept in a corner of one of the dormitories on nights and was 'carried' by the watch in his last few weeks.

Ken took on the job for Russell's sake, though he would far rather have been the watch barman, pulling pints. He made a first-rate job of the Mess, for instance buying canned food in bulk from a supermarket chain, the sort of slightly damaged goods that you see on sale in the aisles. The firefighters got cheap food and the mess made a small profit.

But the position, like those in the union and in the Social Club, gave rise to social tension. One of the many troubles centred around the cleaning of the kitchen. When the union branch was negotiating for a station cleaner to leave firefighters free for their newly-agreed fire prevention duties, it also pushed for extra cooks so that shifts could have meals cooked for them in the early mornings and at night. There was a lot of evasion from the management side which came down to the usual shortage of cash: the rate of pay for the cooks was so low that even getting a relief cook for holidays proved difficult, and there was even less chance of getting people for the early mornings and late evenings. The union was not in a strong bargaining position since it could not claim that the shift was engaged in FP work when the meals in question were being prepared. The new station cleaner was not required to clean the kitchen and there were no extra kitchen staff. The firefighters served notice that they would no longer clean the kitchen after use; they would only clean up after themselves individually.

This put KC in an ambiguous position. He was as good a union man as any, but every proposed action hurt not the management but the cooks, who would arrive in the mornings faced with a pile of muck in the kitchen and the floor covered in grime. So KC and some others on Blue Watch went against union policy and continued to clean the whole kitchen as well as carrying out voluntarily, what had been kitchen duties, part of morning 'fatigues'.

The issue died a natural death. Members of the union branch committee argued that the new work routine that they had negotiated was so beneficial that it was not worth jeopardising, through stirring things up over the kitchen. In addition, the formal abolition of kitchen duties meant that junior officers on a watch began to do their share of kitchen work,

when previously they had been forbidden to work in the kitchen. Though it was now well understood that kitchen work was voluntary, a firefighter's name still appeared on the list of kitchen fatigues and the moral pressure to do a share of kitchen cleaning increased. KC even got a volunteer crew to clean the kitchen periodically from top to bottom – floor, ceiling, walls and equipment – during drills on the night shift.

The older men on the fire station lamented what they regarded as the casual sloppiness of the younger firefighters, speculating that the lack of service experience resulted in less regard for cleanliness and for the idea of everyone mucking in to keep the place and the community going. By the same token, the discipline of service life taught you when to cover up, when to do the work, what work was important and what you could 'scrub 'round'.

The arguments over cleaning the kitchen can seem trivial. But they are the sort of tension that arise when people live and work together for years on end. The quarrels, episodic and endemic, were a symptom of community as much as the harmony and the common pursuit.

2.5

Cambridge Fire Station Sports and Social Club

Club Secretary:

'If that's how it's going to be, running the Club, I don't want no more of it. It's hard enough without people on your back all the time.'

'You're always going to get that. Whatever you do, you'll never be right.'

Service at the bar:

Double Diamond? No, thankyou. All I want from you is a pint of Charlie Wells and a bit of civility.

The beer that fell off a lorry:

Fred, he came in with a keg of Double Diamond. Picked it up on the road. It had literally fallen off a lorry. So we switched it for a barrel of Charlie Wells with the brewery. Free beer.

The most important social institution of the fire station was the Sports and Social Club. In many ways, the Club was no different from hosts of other clubs in factories and working class communities. The main difference was that the Club's activities were centred essentially in a place of work, in which working and social life were inextricably mixed.

Most of the sporting activities of the fire station were run by their own separate clubs and informal groups, such as football, cricket, table tennis and squash. Fishing and golf came under the Sports and Welfare Association, which received financial help from the fire authority proportional to the numbers employed by the Fire and Rescue Service. The Sports and Social Club gave some help to the sporting groups; for instance, it purchased sports shirts for the station's table tennis teams and bought bats and balls for general use. The Club paid for its two televisions and the upkeep of its games equipment: the dartboard, billiards table, tennis table, volley ball net and some miscellaneous sporting gear.

The Club made its profit from the station bar and used the money for various other social activities. There was a party for the firefighters' children held on the station every year at Christmas. When a member was in hospital or his wife had a baby, a box of fruit was sent around. The Club took over the running of the Firemen's Ball held annually in the city; this proved to be successful though the revenue varied from year to year.

The main social events on the station were about six social evenings a year, mainly in the winter months. The watch on day duties got the Clubroom ready, setting up an extra bar, a stage for the band and preparing refreshments for the evening. The watch on nights acted as hosts, serving food and drink, attending a cloakroom and a car park in the drill yard, selling admission and raffle tickets. Should the watch on duty be called out in strength, club members among the guests took over the running of the evening until the firefighters got back from the 'shout'. The Clubroom held up to 250 guests: firefighters off duty and their partners, friends of those on duty, friends of friends and so on. The 'socials' filled a gap in the dancing entertainment available in the city. The Club got a bar extension till midnight; after that, the firefighters cleaned up the place for a couple of hours, with the oncoming day watch doing the final clearing up.

The attendance at socials then began to decline. The Club committee speculated that the socials were too close together and members were not doing enough to sell tickets among their friends. The most likely reason was that the socials appealed more to an older generation, since the committee decided to substitute a number of disco events for certain socials to attract a younger set of people. One of the watches had organised a number of successful disco events on the station in aid of the Fire Services Benevolent Fund.

The centre of the Club was the bar. Cambridge was a 'wet' station. In the earlier part of the last century, urban firefighters lived on the fire station for days, even weeks on end and beer was a normal part of the diet. This was reinforced by the distribution of alcohol while on active duty in the armed forces, such as the rum ration in both the navy and the army.

The tradition persisted on most large fire stations throughout the country during the 1970s, though the question of whether new stations should be wet or dry had sometimes been an issue. The beer was the cheapest in the city. Drinks were served on formal events such as the annual visits of H.M.'s Chief Inspector and visits by various committees of the County Council concerned with the fire service. The bar was open for an hour at dinner time and in the evenings after drills. As such it was one of the areas of the station in which the shift congregated during stand-down times. An individual might drift back and forth from the various groups at the bar, the mess, and a variety of games including darts, cards, chess, dominoes, billiards and (notably) table tennis, as well as the newspapers and the television. On a particularly busy evening, the watch barmen might serve a couple of off-duty firefighters with wives or friends; a visiting ladies' darts team, and a retained fire crew from one of the villages, cooling down after BA training in the smoke house. When a firefighter transferred to another watch or left the job, there was a general celebration: as likely as not, the man was tucked up in bed for the night and his name discreetly taken off the riders' board in the muster bay.

Formally, there were no rules about how much a firefighter on duty could drink, since the Discipline Code forbade only being drunk on duty. In practice, there were rules, which were enforced by the watch officer to a degree which varied from officer to officer, watch to watch, for instance getting the bar shutter down well before due time. But responsibility was essentially a personal one. Drivers in particular knew their limit.

The Club was run by a committee of Chairman, Secretary, Treasurer, two representatives from each watch who acted as barmen, a floating rep, a control room rep and an HQ rep. The Chairman was a senior officer and one of his main functions was to see that the decisions of the Club did not conflict with the wishes of the Chief Officer. For instance, supplies were being ordered from a large number of different firms, causing accounting confusion, and the Chief told the Club to order from one source only. The Secretary and the Treasurer did a large amount of day-to-day work, much of it during stand-down time, and they were responsible for organising the Club's social evenings. The barmen also put a lot of time in, serving drinks, keeping the bar, equipment and store clean and tidy, taking stock, ordering drink, and accepting deliveries.

Rodney Slack took over the Secretary's job. He was from the Peterborough area, where his father had worked as a labourer in the brickfields. Rodney had an identifiably northern accent, which was unusual on Cambridge Fire Station. He was something of a celebrity in the brigade, having once kept goal for Cambridge United. After a fire, people would come up to him as he sat behind the wheel of a fire engine and ask him 'Is Rodney Slack

still with your mob?' Rodney would allow them to go on with a critical appraisal of his goal-keeping prowess before revealing who he was.

Initially, Rodney found the paper-work and organisation hard going and got a bit prickly when people criticised the running of the Club. This was a typical initial reaction among officials of any organisation on the station. Later, he settled in and did the job very well, taking the criticism in his stride and subtly taking the piss out of the more ignorant and awkward of the moaners. He would keep the peace between the watches, whose barmen had somewhat different ideas of procedure, different standards of keeping the bar and the accounts. Yet he never quite carried it off as KC did in the Mess Club. KC would sit through animated discussions of the Mess and the station, unflappable, usually with the ghost of a smile on his face. His devastating dismissal of the more asinine criticisms he disguised as a joke. On the job or off it, he moved only as fast as the situation warranted, like a lazy reptile. Nothing fazed Ken Chapman.

People took on positions in the Mess, the Social Club and (for that matter) the union, for a variety of reasons, the main one was simply to 'do your bit' on the station, in the way an individual enjoyed the most or disliked the least. By contrast, 'being in the job only for what you can get out of it' was a description of those few who, among other things, took little part in the social life of the station. But there were others who had no interest in organisational work yet were willing to help their mates in less formal and regular ways. Such people were still regarded as 'doing their bit', even though their contribution was less obvious.

> If you broke down on the Motorway and phoned him up in the night, he'd be out there in an hour.
> He's a good old boy. He'd never let you down

2.6

Moonlighting Firefighters: Fiddling

When you're here, you don't always have to do a lot. When you are fiddlin', you're really working.

The beauty of a part-time job is if they start messin' you about, you can say 'Stuff your job. I'm off.' You're free. You can do what you like.

A large number of the firefighters were tradespeople, mainly the building trades, car mechanics and welders. Others picked up some sort of industrial skill either in the job or, more usually, before they joined. There were, for instance, watchmakers, engravers, sign-writers and photographers, a great opportunity for mutual help which reinforced the communal life of the fire station.

At certain times on the fire station, particularly at weekends, the firefighters cleaned and repaired their cars and motor cycles. They were allowed to use the pit in the rear garages for repairs and the wash-down facilities at the rear of the appliance bay for cleaning. A lot of advice was offered about the cars, particularly by the mechanics, who were in demand for doing repair work and consultation over the right way to do the job. Alternatively, a firefighter going off duty would drive off in another man's car for repair at home and bring it back to him on the station the following evening.

Similarly with house repairs, since the station was well represented by bricklayers, carpenters, plumbers and electricians. Some of the firefighters *never* called on a firm to carry out house repairs and alterations, car repairs, to give the boys in their home a haircut or to mend clocks and watches. The price for such work was a function of how much of the work

was done on the station and how close as workmates the worker and the client were; it was never at the market price. Sometimes the favour was returned by service of some other sort or by payment in kind. Where, as was usual, little or no money changed hands, the web of obligation came into play, but not in terms of formal debit or credit. *'Things even out, by themselves'.*

'Not a bad motor I picked up. Needs attention.'
'Needs attention! You need attention, my old beauty. Difference is, it needs more than a bit of tape to fix you up.'

None the less, it was probably true that the motor mechanics gave more to the society than they took out of it. Most of the firefighters ran British-made cars between two and a dozen years old, fighting a running battle, as like as not, to keep them on the road. Like farm labourers with tractors and agricultural machinery, most of the men had the ability to carry out routine fault-finding, service and maintenance on their cars, plus bodywork, brakes, plugs, points, valve adjustments, the salient parts of the electrical system and sometimes clutch maintenance. For anything more than this (and sometimes less), they preferred to rely on their mates' expertise, chancing their luck if it were not available. But the skill of the motor mechanics was really indispensable, if only in avoiding costly mistakes.

Without the combination of do-it-yourself and mutual self-help, it would have been impossible for firefighters to maintain the standard of living which they enjoyed. They belonged to the consumer society only in a qualified sense and, because of the nature of the job, even less so than the norm for the working class. Theirs' was not a wasteful, throw-away society. The one area where there was not the expertise for mutual help was over electronic equipment. Electricians could repair pre-transistor radios ('wireless') but they were overtaken by modern electronic equipment of all sorts.

*

Grave-Digging:

We had this grave to dig at Chesterford; I think it was Chesterford, anyway. Re-opener. So I goes out there with me shovel to Great Chesterford, finds the spot marked out and had it done by about 2.00; funeral was at 2.30. About ten past, Bert rolls up in his motor, says 'what have you been doin?' 'Diggin' this bleedin' hole', I says. 'That you have' he says (you know how he whines). 'You dug it in the wrong fuckin'

place'. It was Little Chesterford, not Great Chesterford. So we goes harein' off in Bert's car to Little Chesterford, like a pair of blue-arsed flies. Throwin' the dirt out we were, like a pair of maniacs. Got it done by 2.30 tho'. At least deep enough to put the box in.

When I'm Cleaning Windows:

We were doin' windows, me and Tom. We went round to this house on the Arbury, bit of stuff invites us in for a cup of tea. So we stand around chattin' and Tom asks her where the toilet is. 'Upstairs', she says. So I was down there with her; all of a sudden there is this fuckin' great long fart from upstairs. Real embarrassed, I was.

'Fiddling', doing part-time work off the station, got its name because of its association with fiddling or cheating the tax authorities. The term was not peculiar to the fire service but among the firefighters, the term and the practice were widespread. If tax were paid on a firefighter's fiddle, he would try to up the rate for the job so that the take-home pay amounted to the same as if no tax were paid. Fiddling was regulated both by national and local conditions of employment: firefighters were supposed to get permission for each type of work undertaken and could not fiddle, for instance, after 1.00 pm if coming to work at 6.00 pm on the same day.

Not only did people help each other out on personal work; they often did part-time work together off the station. A pair or trio of firefighters would do a window-cleaning round together, service fire extinguishers, or share a driving job, according to when one or the other was off duty. Alternatively, a group would come together for a single casual job, particularly 'on the building', where several different skills were needed. In general, the tradespeople did not have a regular fiddle; they took on jobs casually. The unskilled members of a watch often had a fixed fiddle with a regular wage, such as van driving, taxi driving, petrol pump attendant, or working as barmen, porters, labourers and so on.

I come in this job so I wouldn't have to do carpentry. When I go out of here, I just don't want to have to think. I get a gut-full of it here. Driving a van is all I want to do.

The idea of a fiddle might seem to be to take in the greatest amount of money for the least amount of work; but this was not always true. Some of the tradespeople, for instance, preferred not to pursue their trade in their spare time, making an exception for their mates. A few sold their tools; that they

were qualified tradespeople was not widely known. Such people did not want the bother of having to plan and concentrate on a job once they had gone off shift. Others were simply fed up with their old trade and the grind of a building site, resenting the way they had been pushed around as apprentices.

> You go through all that lark and then they have the cheek to turn around and say you have to do another year as an improver.

The best paid regular fiddle was grave-digging. A novice on the station was not invited into work of this sort for some years. Lorry-driving jobs, using the heavy good vehicle license acquired through the brigade, also brought in the cash, more than ferrying cars for dealers and car hire firms. Casual house-painting jobs were common among the unskilled. Window-cleaning was popular but hard work; there was a temptation to take on more houses than the individual or team could manage. Large houses and pubs brought in the most cash, which was offset by cleaning the windows of pensioners' houses for little or nothing. Most window cleaning rounds were done by car, but you could still see cleaners riding bicycles with ladder, pail, chamois and a 'piece of scrim'.

> You can't up the rate for windows. Not too often anyway. The best thing is to let some of them go. Then they start crying out for you. That's the time to go back. You can charge near enough what you like then. Me, I've got enough as it is, down Trumpington, where they know me. I'm always finished by 1.00; a couple of times a week does me alright.

There was an informal trade in fiddles. Though a fiddle may be offered around to whoever wants it, an individual who botched a fiddle was blacked and excluded from the pool of labour when it came to new work.

At the time, it seemed unlikely that a big pay rise or shorter hours would result in less fiddling: many men would continue to integrate it into a new standard of living. This was borne out by the poll of retired firefighters: almost all said that the shorter hours and increased pay after the national strike of 1977-78 had virtually no impact on the amount of fiddling.

For every individual who fiddled for a bit of cash on the side 'to run your motor, or buy your 'baccer, or whatever', there were others for whom it was part of the family economy. Fiddling was both blessing and curse; in excess causing family trouble or nervous exhaustion. The most vulnerable were those recently married yet without children, who relied on the firefighter's wage, the wife's wage and fiddling to pay the mortgage.

*

Some fiddles were regular. Others came in bursts and were shared around a watch. One such, netted by Jonah, involved ferrying cars from Marshall's Engineering Works to various dealers throughout England and Wales.

I picked up a car from Marshall's one afternoon. I got up at 4.30 am the next day to drive it to Newport in South Wales. The plan was to hitch-hike back in uniform in time for the night shift, same day. Hitch-hiking in uniform by firemen, most of us did it, as motorists were usually happy to pick up anyone in uniform, usually squaddies.

Delivered the car, I was back on the road by 10.00 am. A Welshman, he wouldn't stop talking, offered to take me out of Newport to the M4 Motorway. But he couldn't start his car. So I followed his directions for about a mile on foot. I got a lift to the outskirts after about 20 minutes. I got nervous. I was an hour late and going is always slow out of a city. Then the Welshman picked me up, went out of his way a bit, took me almost to the Severn Bridge. He was an electrician and was going to Magor to do a wiring job with his son. He was cheerful, laughing. He had married an English woman from Hounslow. The next lift over the Severn was in a big AEC lorry. It driven by a slow-talking bloke from Bristol. Reminded me of my Grandad who was from that way. Then a man in a big new Ford Estate took me about 25 miles. I asked him if he were a kitchen equipment salesman. He had what looked like baking trays in the back of the car. They turned out to be alloy cylinder blocks. He wasn't offended. He had relatives in America; he'd been in the NFS during the War while working in a factory in Bristol: hard work, he said.

Then another AEC took me as good way to the Banbury-Oxford turning. This was very quiet and I began to fret again. Two other hitch-hikers appeared and staggered themselves on the ramp up to the Motorway. I moved down to the roundabout so the traffic could get a better view of me. Flagged down a huge Watney's beer rig. The driver turned out to be a quiet Cockney, just as well as the noise of the motor drowned him out. He took me to close to the London Liverpool Street railway station, near his depot in Whitechapel. I slept on the way. We went through Battersea and I looked out for the fire station, where there was a dispute on, similar to what was then going on in Cambridgeshire. At Liverpool Street Station, one woman thought I was a porter. She asked me to carry her bags while she took a disabled man to the train. As I put the disabled man on the train to Chelmsford, I saw the fast train to King's Lynn was about to leave. Bought a ticket in the nick of time. I changed into civvies in a toilet and as the train left; it were crowded; heard the comment, 'Well, don't speak, you snob'. It was Graham Williams and

Jonah, back from another job for Marshall's. We spent our lunch money
on canned Guinness. When we got back to Cambridge – on time – the
first thing was a Union Brigade Committee meeting. Me and Graham
drove to Huntingdon Fire Station.

(This meeting is described in Part 3.)

When the nine-week national strike took place late in 1977, the union
recommended that the firefighters give up fiddling for the duration of the
strike. The reason was that the employers could not point to part-time work
as an excuse not to award more pay and shorter hours. At Cambridge, the
local union leaders had a suspicion that one or two were still fiddling; but
this aspect of union action was virtually a hundred per cent solid.

2.7

Firefighters' Conversation: Thinking and Talking

I've always said, you can pick any passer-by off the street, show him a standpipe, hose and branch, and he can do the job.

Firefighter off duty in the street at a false alarm, wearing civilian clothes: Hello, I turned you out. I'm just back from Training School. I'm Savage, Red Watch.
Driver, leaning out of the cab: Oh you are, are you. Well I'm Bloody Annoyed, Blue Watch.

In one respect, there was nothing special in regard to the way that firefighters thought and talked; they were simply workers in one job rather than another. Yet their outlook on the world was conditioned by their job, the values they brought to it and their own social predicament. Few had any illusions about the job. There were some occasions in which skill and bravery made the difference between life and death. But much of the time, the firefighter's work was a routine matter of common sense which anyone among their peers in the working class, that is, with practical aptitude, could do with ease. It was, in other words, a job that anyone could do, but only those with aptitude and experience could do well. The breadth and range of the firefighter's craft was greater than the depth or intensity of skill. There were also numerous occasions where little had to be done at an incident, a reality which press reports and fire engines dashing about the streets tended to conceal. All this was recognised by most firefighters, though some elected to believe the official propaganda to legitimise their aspirations in the service. The value of the job was really the value of the sorts of skill, experience and aptitude that, in the working

class, would go largely unrecognised, but for the work of the trade union movement.

It is instructive to note where this all came from. Certainly, training and experience turned recruits into good firefighters. Some learnt better and more quickly than others. But all this has to be put in the context of working class education and upbringing. When teenagers, most of the firefighters had the usual induction into working class life and livelihood, which meant acquiring a series of skills that were then taken for granted. The skills in question were the whole range of the building trades, as well as maintaining cars, motor cycles and small engine equipment. There was also, often enough, a rough working knowledge of one or more specialised skills such as welding, servicing farm machinery, hydraulic equipment, diesel engines, front loaders and a variety of heavy road building equipment. This was true irrespective of whether the individual in question was apprenticed to a skilled trade. With this background, the transition to firefighting was not difficult: the higher the practical skill and experience of the recruit, the better a firefighter he was likely to be. But a low background in practical skills did not always result in poor firefighting ability: Bob Bunday had very little practical background when he became a firefighter but, as a Rider Station Officer, he was first class in every respect. Even the most 'anti-officer' of the firefighters and

Bob Bunday, Watch Officer, Blue Watch.

those whose abilities were phenomenal, never had a bad word to say about Bob Bunday.

Firefighters' thinking in general was anecdotal and derived from concrete experience. Stories and generalisations outside the social orbit invited scepticism unless they accorded with personal experience. It would be tempting to see in this a mode of reasoning whereby generalisations were derived from individual experience and a social cosmos created from concrete events. But this was not really so. The firefighters tended to have a common framework of beliefs about the world and social activity within it. Anecdotes were exchanged and put forward as tests or confirmations of these beliefs even when, as was common, the anecdotes were offered as a form of joking or satire. So modes of reasoning were dialectical with anecdotes taking the place of terms and propositions in logical argument. Reasoning was, if anything deductive, rather than inductive. Abstract reasoning, generalisation and social deliberation were not common.

Finally, it seemed in general that there was no neutrality in reasoning. An individual could be described as 'anti-social', 'anti-officer' or 'anti-sport', as if a person who is not with us, is against us. In fact, all this meant, often enough, was that the person had no strong interest in the subject concerned, but the language of 'anti-this or that' was opaque, concealing both hostility and neutrality.

*

Around the turn of the previous century, the British urban fire station was something of a segregated or 'closed' community. Firefighters spent days or weeks on the fire station, leaving only on fire calls, their odd days of freedom liable to be curtailed by the arbitrary whim of an overbearing officer. The firefighter ate, drank, worked and slept on the fire station or at least within the sound of the bells. Often his courting took place in a corner of the engine house, conventionally reserved for the purpose.

Important vestiges of the closed community survived well into the twentieth century, such as the 'wet' fire station. The firefighter as a local government employee was, later in the twentieth century, also an inmate of something resembling a military barracks. Within it there was a salient contrast: between the 'tyranny of the bells' and freedom of movement within the confines of the station, the freedom of stand-down time and that exercised through skiving. The result was a very fluid social life within rigid limits. There was immense opportunity for conversation but which was subject to curtailment both systematic and arbitrary – the alarm bells or the summons of an officer.

There were no formalities over entering or taking part in a conversation. Someone could interrupt if he had something important to say to one of the participants. That individual could join a group in sitting or standing around, interposing a remark or a contribution when he had begun to grasp what was going on. He could leave a conversation at will. In a conversation in the locker room just before a watch goes off duty, a dozen men would sit on the lockers, coming and going into the appliance bay as they were relieved. The situation was so fluid that a conversation might continue even though the first set of participants might have been entirely replaced by another set. It was as if conversation were autonomous, proceeding independently of particular participants.

Some found this fluidity uncongenial. They would sit on the end of a row of chairs or stand apart. They took part in communal conversation only if it was structured for them – a watch gripe in the lecture room, a union meeting, or while skiving in a place where they were supposed to be working. There were loners on every watch, a small but significant minority, hard to understand unless they were known outside the limits of fire station life. But then they tended to fiddle on their own, too.

Firefighters talked about everything under the sun; they had the time for it. But typically they talked about things close to home: work, house, family and car. There was among many of the firefighters a 'social order' where work, work mates and family obligation had their rightful place. Those who did not conform to the social order were 'wasters'. But within the social order there were a variety of opinions about (acceptable) behaviour. At one extreme, there was a puritanism and a dislike of dirt and casual chaos. One firefighter did not like getting dirty. Since he was a driver, operating the pump on the machine, he did not often have to put in his uniform for cleaning. The man was a jovial character and respected as a firefighter, so this quirk was not held against him. Had this not been so, he would have been regarded with disdain. At the other extreme, there was a sort of epicureanism that was held to be compatible with family duty. Thus habitual beer swilling was in order but keeping up with the Joneses was contemptible.

Then there were topics of conversation like the town, local people, workmates outside the service, sports local and national, television programmes, where firefighters had been, what they had been doing off the station, what they did before they joined the job. Cambridge was still small enough for the network of working class acquaintance to be strong and tight. A working person you might meet locally would likely be known to a mate on the station as 'old so-and-so's op-o'; or 'yes, used to know him at Marshalls'; 'works for Pye's' 'gets in the Golden Hind of a weekend'; 'was at school with him, bit of a cunt if I remember him right'.

This should be qualified. While there was a great deal of social intercourse between Cambridge and the surrounding rural areas (the working class culture of Cambridge was predominantly rural), there were a number of local cultures which differed in degree from each other. There was, first, the town, coloured by low paid work and dependency on the university colleges. Then there was the Fen country to the north of the city, where, it was supposed, life was poorer, more isolated and primitive. Finally, there were the other rural areas which had far more in common with the rest of southern England, with more wealth and mobility, less social deference than was to be found in the city and the Fens. Yet again, not all the firefighters came from the local community. Those close to retirement were sometimes ex-servicemen who had married local women in 'the war years' (prior to 1948) and in whom you could still hear the twang of East London and southern Essex. Then there was a steady stream of others who had transferred from other fire brigades. Among the recruits, some had not been raised in Cambridge; others commuted from outside the county.

The most common topic of conversation was work and the job, in which there were a number of themes. There were narratives of 'jobs' (incidents) and communal attempts at reconstructing them. Repetition over months and years, even decades, was common and accepted as a matter of course. There was also appraisal; whether the job was done right, whether the right decisions were made, without panic. Then there was discussion of the brigade and the station, how the union and politics were affecting the job. This amounted to a critique of the job itself.

There was much joking, ribbing and backchat. So it was natural that the station had a tradition of funny stories which went back decades. They were often related and repeated in sequence, especially if they were about a single individual. There was one harmless character who went in for all the *machismo* sports. He lived cheap in one of the few brigade houses in Cambridge. Among his pastimes was parachuting. One of the men, who had packed parachutes during the war in between sailing MTBs, offered to pack his parachute for him while another, an ex-paratrooper, challenged him to jump off the drill tower. The man took the challenge in all seriousness, but declined. Instead, the men had the lad in the dormitory in his underpants, demonstrating how to land from the air, using the beds as the plane and mattresses on the floor as the ground.

He had a falcon reputedly costing £70 which irked the family men trying to make ends meet. Early on, he took the falcon into a meadow for training, saw a pigeon or something and thrust the bird into the air from his arm. It was never seen again.

Once Dippy Lee was reversing a fire engine with the man seeing him back. Dippy looked in one mirror, then the other, then glanced at both in turn. No sign of the lad. He had fallen down a manhole. Then a crew of five went to a chimney fire. When it was finished, they left him behind so he had to come back to the station on the bus, wearing his fire gear and helmet.

'Over the other side, they loved him'.

Dave Pettitt was operating the pump of a water tender outside a house where there had been a small fire; a hose reel had been laid out. He saw a young man and his girl friend walking down the street towards the machine. The man was wearing an old National Fire Service tunic, bought from an army and navy store. Dave went round the machine to a locker, out of sight, and got out a roll of hose. As the couple passed, he leapt out from behind the machine with his hose, shouting 'Here you are mate! Get in there; you know what to do'. The man's girl friend railed at him: 'I told you not to wear that jacket when we go out.'

On another occasion, an officer had us in the yard timing us on a competition to see who could run out a length of hose and a branch from a hydrant in the shortest time. Dave thought it 'an insult to our intelligence' and crept into the stores where the Deputy Chief's tunic had just come back from the cleaners, brilliant red lapel flashes on a smart black jacket. He put it on and appeared round the side of the machine behind the officer, saying 'What's all this then?' The officer jumped, 'copped a nark', then broke into a smile, conceding defeat.

❉

Ikey's Stop Message:

Stop from Leading Fireman Williams, Ditton Fields, Cambridge.
Alarm caused by smell of cat's urine being mistaken for North Sea gas.

Ikey's K.433 Fire Report:

Cause of Alarm: Grass Fire
Equipment Used: Beaters
Premises: St. Andrew's Church, Chesterton
Owner of Premises: God

Leading From the Front:

That bloke in the white car, with the fire engines. Is he the governor?

Yeah, he's the watch officer.

Does he show you the way to go, like?

No, we show him where to go. In fact we sometimes try to lose him, so he hardly shows up to the fire at a*ll*.

Blue Films:

'Round the bar, we primed him good and proper. Said they were showin' films at ten bob a head. Then half a dozen blokes clears off. He can't resist it, can he? Down he goes, tries the quiet room, the locker rooms, the FP offices, everywhere. This lot of blokes, they're chargin' from one place to the next, trying to keep out of his way, rushing up the stairs, through the Clubroom, down the stairs again, keeping one jump ahead of him. Unbelievable it was. He must be bloody thick. Then George told him he thought the films were in the GPO room [telephone equipment]: down he goes, sniffing round the Radiation Room at the foot of the tower, thinking that's the GPO room. You couldn't get a projector in the GPO room, let alone six blokes. Anyway, the last of it was, we were all back at the bar, looking out into the yard and there he is, down there, switching the lights on in the back garages. He was fuckin' obsessed. And would you believe, we were on nights the next week and the bloody same thing happened.

Conversations were often a series of stories and anecdotes. It was rare that a conversation was not coloured by elements not direct, serious and functional. This was as true of the lecture room, union meetings and the drillground as it was of the locker room and the station bar. Ribbing, taking the steam out of someone, deflating an individual or criticising him in the form of a joke can all be described as 'taking the piss', involving a high degree of verbal agility and fluency of talk. But 'taking the piss' in this sense was part of something a lot more complicated, as the next chapter will show.

*

The language of firefighters was rich. Some of the expressions used were common to the whole country; others were local and regional (coloured by the rural culture); some were of long-standing usage while others came

and went, like yesterday's 'major, major, major' or today's 'what's your take on that?'

Foreign influences were few. The Afro-American hip-talk of the 'sixties had not penetrated Cambridge Fire Station, with its 'cool', 'hip', 'juice', 'zonked', 'shit-faced', 'crash', 'goof off', 'dude' etc. (There was no drug culture on the station, only beer and cigarettes, some of them 'roll your own'.) Terms like 'problem', 'situation', 'issues' and 'relationships' were coming into use, but problems were still 'troubles' and trouble with people was aggravation or 'aggro'. Phrases like 'do you have a problem with that?' and the inane 'We have a situation' were unknown.

Some phrases were constant. 'Bollocks!' was 'nonsense' or a mild curse, derived from balls (testicles). To 'get a bollocking' was to be told off in no uncertain terms by higher authority. But here too, there were ephemeral phrases like 'drop a bollock', to make a culpable mistake. To tear a strip off someone was to blow the dust out of his ears. An individual could be 'as happy as a pig in shit'. An opponent could be 'as cunning as a shithouse rat', which in its ripeness sounds Australian. An incompetent individual 'couldn't organise a piss-up in a brewery'; there was 'one in every squad'. A disagreeable individual was a 'right Brahma'. An odious individual was a shitbag, this having long replaced 'crapsack'. A thief on the station was a tealeaf. (For reasons unknown, but possibly because it was once the mark of commercially recycled tea, a leaf floating in a cup of tea was regarded as intolerable.) Disbelief at what someone did invited the response 'Did he, fuck?'

A worthless individual was a tosser or wanker (masturbator); something useless was 'wank'. Not to care was not 'to give a monkey's toss', as in 'I don't give a monkey's'. Other (ephemeral) names for poltroons, including incompetent officers, were 'gearbox', 'pudding', 'melt' or 'marrow brain'. Foreigners are rightly mystified by the epithet 'cunt' instead of 'jerk' or 'arsehole', when applied to a disagreeable or obstreperous male, especially as it was invariably used with some hostile passion in the saying: 'You *cunt*!' (In fact, the usage is ancient.) 'Bonking' for fucking was not yet common on Cambridge Fire Station, since bonking was still what Punch did with his stick to Judy in the show. She 'got bonked'. From there it was a short step from hitting with a stick to fucking with an implement of the same name. 'On bonk' for erect was heard; but not on Cambridge Fire Station. To be erect was to have/get 'a stalk on'. A man long married was still 'getting his oats'. Someone who had died of injuries had 'shat his potful'. The prize for sex-related expressions must go to an older firefighter, a war veteran: he approached the bar, wanting to buy condoms and asked for a packet of night fighters.

To express anger in a response was to 'cop a nark'. To respond to an interlocuter with direct hostility was 'to come the old acid', possibly derived from the Australian 'to come the king prawn'. Something that caused a disagreeable surprise would 'make his arsehole pout'.

'Old' was a term of affection as well as age, sometimes contradictory, as when a man's baby or infant son was referred to as his 'little old boy'. For a time 'lovely old boy' replaced 'good bloke' or 'good old boy'. Condescending terms of affection were sunshine or cherub.

As in the nation generally, soldiers were squaddies 'in the mob'; sailors were matlows (a corruption of the French *matelot*) and the Irish, Paddies. An Irishman called Paddy would be referred to as such; his mate Michael as Paddy Michael. These epithets were sometimes terms of affection or of hostility; more usually, they were neutral in intent, like calling the English limeys. An observation like 'I was in the Gold Coast during the war, teaching the wogs how to build airfields' was a casual form of racism; there was a racist contempt in 'Know what we did when a kite didn't work: bung it full of radar and flog it to the wogs'.

Homosexuals were shit pushers or arsehole bandits. There was the story from the navy of the Golden Rivet, where recruits were encouraged to bend over to inspect the jewel embedded in the deck. Male homosexuality was associated with anal sex; 'cocksucker' was rare. Anal expressions (again, more general in English society) included 'He thinks his shit doesn't stink'; 'Thinks the sun shines out of his arsehole', or 'He's up so-and-so's arsehole so deep he's coming out the other end'.

To go out 'on the piss' was to go out beer drinking; to be pissed was to be drunk. To have a lot to drink was a 'gutful' or a 'skinful'. More ephemeral were to 'have a few bevvies' (beverages), a tincture or a 'few gills', a gill being a micro-measurement of spirits in the pub and unknown to almost everyone but publicans and bar staff.

Of purely local expressions, few were heard. 'What do you think to that?' instead of 'What do you think of that ?' was common in Cambridge. A lunch box was a 'dockey'.

Incidents were referred to as 'jobs'. 'Did you have a job?' was a way of asking whether the incident was worth talking about. A job was a 'shout'. A botched job was a cock-up, a term not of course restricted to firefighting, though to 'car-park' a job was to 'lose' a fire, causing the building to burn to the ground.

Union language was not peculiar to the FBU. Raiding another union was 'poaching'. 'Scab' was used but 'blackleg' was heard just as frequently, which originated in the coal mining industry. A job or equipment as well as people could be 'blacked', though what this meant in practice depended on the context, like 'hot cargo' in the US. What is now referred to as an 'exit strategy' from a dispute was then called an escape route.

The Cambridge accent was a diluted version of that of the Fens, a high-pitched lilting whine, with expressions like 'go down there' sounding more like 'goo deown thayer'. 'When I was a student' became 'Win awza grad.' But the accent had severe geographical limits. A few miles to the north in Ely, you could hear an accent that was identifiably northern, akin to the West Riding of Yorkshire, but there was no trace of this whatever in Cambridge. In turn, the Cambridge accent rapidly disappeared at points west and south of the city. It was sometimes possible to glean from a firefighter's accent which part of Cambridgeshire he was from; more often not.

A Sense of Humour: Taking the Piss

An English Social Phenomenon:

'Not many months before this, I had been with my family to Euro Disneyland. Technologically, it had been stunning ... But it occurred to me now, as I sat in the immense conviviality of Granada's mock House of Commons debate, that not once at Disneyland had there been a single laugh. Wit, and particularly the dry, ironic, taking-the-piss sort of wit, was completely beyond them. (Do you know that there isn't even an equivalent in American speech for 'taking the piss'?) Yet here in Britain it is such a fundamental part of daily life that you scarcely notice it. Bill Bryson, Notes From a Small Island, Toronto, 1995, page 179.

A Set-up:

Ha' yer heard about the ouija board? Well, me and Davey, we 'ad Artie set up. It were gettin' all the answers right. He couldn't believe it. I asked him to whisper his granny's address, then o' course I mouthed it to Davey and, sure enough, the board got the answer. Then we got him to ask the board his girl-friend's address. That were when he were goin' out with Glenda. Board got it again. What we'd done, we'd gone in the office. We screwed the back off the filing cabinet and looked at his details, you know, his personal file, and all that rubbish, before the game started. Glenda was next of kin, with her address, there. Then we got him to do a forecast. The board, well it was Davey really, said it was curtains for him that night – road accident. He went off to bed, he was drained; he was

like a ghost. He wouldn't move off that bed. If them fuckin' bells had gone, he'd ha' stayed there. Me and Dave, we must have spent half an hour tryin' to tell him we'd set it up. But he wouldn't have it. We'd put the shits up him. He still don't believe we fiddled it.

'Taking the piss' is a form of joking. Joking may take the form of making cracks, puns and witticisms before an audience, which may be one or many. When someone tells a joke, the object or butt may not be present, or even a real person. Piss-taking is like the stand-up comic joke, in that both have a butt and an audience, in some cases these being one and the same. Piss-taking is akin to teasing but has a complex motive, structure and function.

Taking the piss out of someone can quite simply mean deflating someone in authority or a pretentious individual. The very expression suggests deflation, though the motive can vary: fun, malice or political purpose. Some visiting officers came to the station and passed Dave Pettitt in the kitchen. They asked directions to the conference room on the HQ side. 'Over there, mate' said Dave, telling them where to go. One of them got annoyed at being called 'mate' instead of 'sir' and said pointedly '*What* did you say?' Dave took him by the arm and said innocently 'Just up there, mate'.

On another occasion, an officer on the station expressed surprise that a certain piece of equipment was not carried on one of the machines. Dave pretended to be flabbergasted and said that the item had been removed two years ago and he was surprised the officer didn't know about it. In fact the piece of equipment had been removed a couple of days ago.

When the fastening gear of a 45' ladder broke, an officer went into the stores to return with a firefighter's leather belt to tie the ladder to the machine. A group of witnesses, one of whom detested the officer (the detestation was mutual), gasped in horror, saying (rightly) that the belt had not been tested and could not possibly hold the weight of the ladder. The other machine carrying a 45' ladder was 'off the run' (in the workshops) or miles away out in the county testing hydrants and there was inadequate rescue equipment on the station to cover the town. The officer stood there holding his belt, muttering to himself in quiet desperation as the group melted away, the men grinning and shaking their heads.

Debunking authority was only one style of piss-taking. Typically, there was a situation with piss-taker, butt and audience. If the exercise were to take place between two persons, there was a mutual piss-taking competition; but even here an audience was likely to take part in the business by way of remarks or general participation, and come and go, according to the modes of conversation described earlier. Another thing is that piss-taker, butt and

audience could and frequently did change their roles. So one member of an audience could return the fire by taking the piss out of the original piss-taker, and the butt became the audience. Where all of the players knew the game (that is, where there was mutual collusion), it was frequently accompanied by laughter and consists in repartee. Swiftness, succinctness and aptness of reply were the marks of a good session: the best man was the one who had the last word *of this sort*. Where there was a finale to the repartee – and the modes of denouement are yet to be delineated – there was often cheering and general celebration.

More often, however, piss-taking was done with a straight face and the mark of accomplishment was that the piss-taker should not break into a laugh. We were once out testing hydrants with the machine parked in a side-road when a man came up to the crew in the cab and was going on about how he had once been an industrial firefighter. 'Oh yes' said Gordon Powell, interposing flattering remarks at the right points. Ikey Williams was in the front seat next to Gordon and kept turning around to two of us in the back as the man continued to tell his story. 'I once had a jet', he said, 'that was so powerful it knocked a house down' and so on, with the most awesome rubbish imaginable. He told us how he and his mate were the best team the management had ever known: he was the ideas man while his mate did the practical interpretation. The bosses told him he couldn't do something or other and he responded in words Ikey never ceased to recall in a loud, plodding mock-rural accent, 'The word No ... to me ... is like ... a red flag ... to a bull'. Gordon was taking the piss by humouring the bloke and keeping a straight face; but it was Ikey who was stirring it up by trying to induce laughter from the others in the back and embarrass Gordon if someone cracked. Gordon was piss-taker and the stranger ostensibly the butt, though if someone cracked, it was Gordon who would have been on the receiving end and thus the real potential butt in the episode.

When someone is the object of piss-taking, he had one of a number of responses. He could reply in kind; he could ignore the ploy or he could 'bite'. Replying in kind was the most appropriate thing to do and tussles developed over who would have the final word. Ignoring the ploy occurred when one pretended not to acknowledge piss-taking (an art in itself) but more common was the situation in which the butt did not realise that the piss was taken out of him and both piss-taker and audience were trying to keep a straight face. The butt here was of course not so much an object as a medium in someone else's game. Round the bar, an ex-retained friend of a retired firefighter was going on about the retained and Dave Pettitt, behind the bar, said 'Salt of the earth, these retained boys'. The man jumped in both feet first, warming to the comment. Dave's face was as straight as

you like to the man, but to us he was laughing all over his face. Here, piss-taker and audience were in something of a competition because the party that breaks into a laugh has to face the butt and publicly acknowledge his failure in laughing. But there was also a challenge to the piss-taker in that he too could be goaded into breaking his own act. Among experts such as Dave and Ikey this was rare.

More often, the butt knew what was going on, pretended not to know, and bided his time before getting the appropriate dig in, in a way which revealed he knew the game all along. At its most complex, piss-taker, butt and audience were constantly switching roles: with two or three first-rate piss-takers involved, the display of wit was phenomenal.

Many of the best piss-takers were older men and they constituted a centre of moral authority on a watch. The younger members were afraid of their tongues and they were, collectively, a thorn in the side of official authority. Dave in fact was viewed as being at the centre of a clique and was transferred against his will to Red Watch. Though he was told he could return to Blue Watch if things went well, he was too proud to ask to be transferred back, developing a loyalty to his new mates. Of an officer in charge, afraid of the wit of the piss-takers, it was said, '*When they made him up to Sub-Officer, they looked for his spine to take it away, but found he hadn't got one. We are cruel, really*'. The principal mark of a person in authority who lacked moral courage was that he was 'spineless' in the face of a piss-taker.

The thing that a butt was not supposed to do is 'bite'. This means replying in a serious, agitated vein, in which case the audience jeered, or as like as not tried to get him even more steamed up. The piss-taker would then protest his seriousness, that what was taken for piss was misinterpreted, 'straight up'. He would lay on the exercise doubly, 'getting so-and-so going'. Some people 'bit' quicker and easier than others; knowing when a butt was liable to bite was essential to the game. When a first-rate piss-taker bit, he was well and truly had.

> You got to have a laugh. You got to take it. They had young Eva in
> tears yesterday; crying he was. He'll have to learn. If you start crying or
> sulking every time someone has a go at you, you might as well not be in
> the job. You aint got to be bone hard but you have to have a thick skin.
> That's the sort of job it is.

One explanation of piss-taking might go like this:
You have a collection of men who do not have a lot in common and who are thrust together for months or years on end. Apart from bursts of relief on fire calls, the atmosphere in the confined social space of the station is

in some ways stifling. The only items of individual competition are games such as billiards, chess, darts and table tennis. Only the last of these is highly active and exciting; only in table tennis was there a strong and serious will to win. This being so, there would have to be ways of relieving tension and expressing hostilities that did not involve physical violence. The function of piss-taking was to make observations and social comment on a host of personal idiosyncrasies and weaknesses or, furthest on the continuum, to express hostile criticism disguised as joking.

A number of things support this view. As Ian Grieg pointed out, there was less piss-taking after a big or difficult job. The atmosphere on the watch was easier, people were in better humour, yet they tended to talk more seriously. Further, piss-taking was episodic when tangible things like cars or fiddling were being discussed; it was endemic in conversations which were remote from the direct experience of the participants or which took on an abstract character. The more remote a topic, the less important it seemed to be and the more frivolous in its treatment. Conversations of this sort tended to be brief, ending in a joke and general laughter, as if there were really not a lot to be said about such things.

Then there was the undeniable fact that physical violence was not common on the station. People had to live with each other and expressions of disagreement or dislike would have solved nothing. Even the most detested got some recognition, occasionally in the circle of piss-taking but at least on the job, where conversation and co-operation were necessary. Rows between firefighters tended to be short in duration and few in number. Though individuals had their disagreements and their varying estimates of each other, they were rarely expressed in direct hostility and grudges were not commonly held. Many of the rows were institutionalised in club or union meetings, watch gripe sessions with the officer in charge, and meetings with the officers. On the other hand, fights and rows themselves were the subjects of repetition and long memory: who laid out whom, over the billiard table; the time when a firefighter poured a cup of tea over an officer; the occasion when a big man picked up another by the scruff, bundled him into a locker and shut the door on him. Horseplay was far more common than fights, in some cases no doubt a surrogate for physical violence.

One thing which this account fails to explain is the *content* of piss-taking. Much of piss-taking concerned individuals in their capacity as firefighters, including what they did off duty, such as fiddling. But it also concerned their position in the hierarchy of authority, which was omnipresent, including how they behaved towards peers, superiors and inferiors. This would reveal a concept of the person at odds with his own presentation of self: the discrepancy was exploited in piss-taking. Most humour thrives on a discrepancy. The most salient discrepancy with piss-

taking is between what actually happened in the fire brigade and what was supposed to happen, between how men actually behaved and how they saw (or professed to see) themselves as agents.

It might be thought that part of the explanation of why piss-taking took place was in order to induce a change in the ways of the butt; that it was an indirect form of social control, whether done with malice, in sheer good humour or affectionate collusion with the butt's vulnerability. Certainly, the antics of a silly young boy would become the object of piss-taking. In this way, a recruit gained a form of acceptance while being encouraged to change his ways. And sometimes there was a fear of loss of face, that if incidents were generally known, the piss-takers would have a field day.

Firefighter on the phone to another, his voice disguised.
– I'm from the RSPCA [Royal Society for the Prevention of Cruelty to Animals]. I have a report here that you murdered seven gerbils.

– I didn't. I looked after them. I really did. I gave them medicine. It wasn't my fault.

– I'm sorry sir, but this is the report I have. The information came from a Mr. Hoo-rell.

– Him! That bastard, I'll have him for this.

– It makes no difference. You will have to answer for this.

– Wait a minute ... It's you, you bastard.

But in so many other respects and in so many cases, piss-taking was a game which reflects a moral point of view in which the idea of changing the butt's ways was not important. As such, it implied a celebration of a static, ludicrous world in which institutions and those that embraced them were ridiculous and immutable. Given this celebration, you might see either the frivolousness of much of firefighters' conversation or else the fundamental unseriousness of what is taken to be solemn interaction, its notion that social change is an ultimate outcome an illusion. A third possibility is that firefighters assumed a social self on coming onto the fire station, of which piss-taking was emblematic. If so, such a self was no more or less an artifice than the self off the station: there are no grounds for saying that one presentation of self is 'real' and another artificial. At all events, if Bill Bryson saw in piss-taking a subtlety and sophistication in English society, he was surely correct.

2.9

Firefighters' Morality

Life and love:

He cocked it up good and proper. Lost his wife and his job. Still, they're all the same. Brain goes to their bollocks, and that's the finish of it.

Old bag. She must be bloody near sixty. Still, some blokes trying to prove she ain't tho'.

Mates:

He's not my old mate, but he'll do, if you know what I mean. I wouldn't want to see him in trouble, discipline and all.

He's a big bloke; could floor almost anyone on this station. But I reckon if you got one in quick he'd go down and that'd be the end of it.

Old George from the Elm Tree, he was a funny character. Looked like a gyppo, second-hand junk dealer, like. But he was a good old boy, nice to chat do, educated as well. Early one morning he came onto the station, his finger all swollen up. He had a stainless steel ring on and couldn't get it off. We sawed through it with the ring kit and got it off for him. He was a bit nervy and shaken up so we gave him a shot of port and brandy over the bar. I ran into him a couple of weeks later in the Elm Tree and there he was – with the same ring on, and all, hiding the cut in the ring on the inside. Then he disappeared, never saw him no more.

Respect:

Slack! You can call me bollock-face, or Rodney, or Fireman Slack. But not 'Slack'.

Recruits:

I know he's a nice old boy. He's welcome in the job, same as anyone else. Trouble is: for the next five years, he'll be a liability.

What's a bloke like you doing in a job like this; writing a book or something? – No, but it's not a bad idea.

When he came here, he couldn't even make a cup of tea. Saw them things you wash the kitchen floor with; didn't know what they were.

On his probation he pulled the lever to get the doors up; bit of metal flies off and hits Mallon in the eye. Then he caught his buttons in a ladder and his trousers fell down. Mallon wanted to fail him but he'd already passed his Leading Fireman's so he couldn't. Blokes like that go from brigade, getting made up, 'cause every brigade wants to get rid of 'em. So they end up, Chief Officer. Fuckin' real, ain't it?

He was bad enough when he started but time he was finished he was terrible. Fuckin' awful. There's no cunt like an old cunt.

Promotion:

I remember him when he came here, little old boy, all skin and bones. But he's a good fireman and I'm glad he's got on. He'll go a long way. Deserves to, too.

He's changed, same as the rest of 'em. Had the operation. Can't think no more.

Poor old Blox. We did the Subs.' exam. They told us to draw a picture, you know, labelled diagram, a Screw-Down Hydrant. So Blox does this beautiful picture with ruler and compasses, coloured pencils, perfect labels, and all. A- Level Technical Drawing stuff. Ten out of ten. Trouble was, it were a Sluice-Valve Hydrant, he did. No marks. Failed the lot!

Modern youth:

That underpass by 'The Ship', all the tiles they've put up in there: they've smashed that lot up. Didn't even give 'em time to go off ! Little bastards. Put 'em down the mines. They don't deserve facilities. Then they say they don't have enough. Bog seats in the youth centre: all smashed up. That was the girls, that was, not the blokes.

Private Enterprise:

You can always tell when a firm's in trouble. First they shut down R&D, then they stop cleaning the windows.

Off duty:

Fred, he had this poodle next door that used to come over and shit on his lawn. So one day he let him drop it, shovelled the muck in a bag, and tied it round its neck. Then he booted him back into next door: fuck off. No more trouble after that.

Racism:

Them black ones, you know, the West Indian ones. I love 'em. All that music and dancin'. But them others. What have they given us: hot curries and a Manual on shaggin'. They used to come into my barber's shop wantin' five-star, City and Guilds treatment for ricebowl prices.

Reading:

You wont learn much from the books. There's plenty of blokes with their heads full of that stuff. When it comes to a fire, they're useless. You know who they are, as well as I do. Me, if I come across something on a fire I aint seen before, I'll get it sorted out soon enough.

Shouldn't read the Telegraph if I were you, mate. That'll rot your brain. I suppose old Major Pugh-Deuce is in there again, writing to the Editor. Wants to have all trade unionists shot and fox-hunting made compulsory.

The chief virtues among firefighters were helpfulness, skill and good humour. The most salient vices were meanness and duplicity. The virtues tended to be collected in a single individual and of those of whom it was said 'He's a good old boy' had a rapport with others of their kind. There were exceptions, in which the virtues were uneven. Of someone who was not much of a firefighter, with little humour, it was heard said 'He'd do anything to help you' as if in strong mitigation. Such an individual, for instance, may be part of the web of mutual self-help, or may have been a union or club official. Those who were possessed fully of the outstanding virtues were characters of stature, centres of authority on a watch. Officers usually recognised that they were the mainstay of the station though the weaker feared them. This formidable elite – for that is what they were – were usually proud, quietly despising their inferiors, and ignoring criticism from those they considered beneath contempt.

Of skill, much has been said already. Of firefighters who joined the job in their teens without a trade or other skill and who made out well, it was said they were 'good firemen', as if this were remarkable. Practicality was the mark of the truly educated. The practical man knew, in the view of his peers, what was worth knowing. To leave a job unconcluded was a vice. By the same token, the practical individual was reluctant to take on a half-finished or botched job. 'I'm not touchin' that, however much he pays me.'

Of helpfulness, this was a virtue in individual appraisal but it was also, and essentially, a part of collective self-interest. Helpfulness was thus seen as less of a personal quality and more of the man's conformity to the web of mutual obligation. The mean, selfish or self-centred individual was regarded, in the end, as not part of the collective, 'not one of us really'. When such men left or retired, they were then rarely spoken of, except as an incidental part of some other conversation.

Of humour, one mark was taking the piss, though this was not necessarily the most salient aspect of good humour. Cheerfulness, dry wit and being slow to anger were also marks of good humour. The few humourless and selfish individuals were often mean too. Meanness in money matters and thrift were not the same thing; the thrifty for instance could be generous with their beer money, 'getting their round in'. Another vice was duplicity: with authority omnipresent, there was plenty of opportunity for it. So an individual could pose as a strong union man while at the same time grovelling to his superiors, courting favour for promotion or advancement.

Two-faced bastard. You got to watch him. He'll put the skids under you, given half the chance. You know how he goes on about how he treats

officers. 'I fuckin' told him this' and 'I fuckin' swore at him' and that. Well, I saw him on a farm fire once. He didn't know I was around. He was talking to the Major. He was grovellin' like you wouldn't believe. 'Sir' every other word and what we are going to do 'with your permission'. It was enough to make you puke.

Backbiting, of which there was plenty, was not generally regarded as a vice, unless it were hypocritical or part of the personality of a 'moaner'.

Regarding dishonesty, opinions differed. It was always wrong to steal from your mates but stealing from an employer or the government met with varying response. For instance, by-passing the electricity metre in the home was regarded as neither here nor there by some. Among others, particularly the older tradespeople, it was 'not done', something that only the disreputable did.

Sexual infidelity was not generally regarded as a vice. An individual's woman friend was referred to as his 'bit of crumpet' or 'bit of spare'. Despite a large amount of predictable male bravado, there was probably a lot less infidelity than one could suppose and far less effort devoted to getting laid. Of those who commonly disappeared after a shift, destination unknown, it was supposed that they had secret women friends; but this was impossible to verify. It was in order to make comments, even derogatory comments about a man's bit of spare but it was not in order to make comment or compliments about a man's wife, her figure, appearance or character.

Marriages could be turbulent ('having a barney with the missus' was a phrase commonly heard) but they were stable: divorces and separations were rare. On the whole the wives led less interesting lives than their firefighter husbands. Some individuals got perplexed at their wives alleged helplessness and general lack of competence, this was put down to female character rather than work experience or the lack of it.

Among some, there was a sentiment that it was entirely arbitrary that a man should have married one woman rather than another, something that went along with genuine affection for the person's partner. Mirroring this feeling of arbitrariness, there was a cheerful fatalism about marriage and the shape, character and demeanour of their partners. The firefighters were gratified when their sons emulated them in occupation, family aspirations and outlook on life. Of their daughters, they spoke little. A feminist critique of firefighters' attitudes and the predicament of their partners would be hard to quarrel with.

There is no reason to think that there were more bisexuals and homosexuals on the station than in any other walk of life. In conversation, references to 'shit-pushing' and 'arsehole bandits' were uttered with a

hostile vehemence. One gay man on the station was treated with derision, cartoons and the like about gays posted on his locker. Yet however unwelcome and distressing this undoubtedly was, there was nothing visceral about it, in contrast to conversation about third parties. Nor did the man suffer from discrimination in his career. The phenomenon was as much about recognition as a form of social criticism. This too was symptomatic of life on the fire station. Such ostracisation there was, as we shall see, a matter of deliberate political strategy, not casual hostility.

Part 3

In the Union

3.1

Introduction: Getting Into the Union

Union Negotiating:

One's dictatorship
Two's conspiracy
Three's democracy

Union Head Office:

Those blokes; they've been through it; then they get to the top and think it's all over. For them, things have got better. So they just want to stand still. You can't stand still. If you don't progress, you'll just go backwards.

The Over 40's Medical:

That medical every three years; that's all wrong. Suppose they find something wrong with me and want me out. What am I going to do then? All I'm good for is manual work and whatever I do, that's bound to be worse than this job. The union slipped up on that one.

Pay:

> It doesn't matter what you call it – rent allowances, FP work, or whatever.
> It's what they are prepared to pay.

When I joined the fire brigade in 1972, I had no experience of trade unions. While I was a college teacher in New York, I had been a nominal member of the American Association of University Professors, whose influence on the campus seemed to be minimal. My social background was not conducive to trade unionism. Both sides of the family came from the rural south of England. Almost everyone on my mother's side were farm labourers, gardeners or servants of wealthy families in large houses, the 'downstairs' of housekeepers, cooks, butlers, footmen, chauffeurs, and maids of all sorts – the house, the kitchen, the scullery and the lady's maid. They went where the work was, households from Kent, through Sussex and Surrey to Oxfordshire and Buckinghamshire. Their aspirations were to get to the top of their calling. My mother did so, in a sense, when she was cook to a rather small household; but only my father's older sister was a lady's maid, with the airs and graces that went along with it. Their children were expected to do the same, unless they joined the army or the clergy, a curious reflection of the views of the social class which they served.

My father's side was similar, except that some were petty traders such as shopkeepers and publicans (my grandfather had been a labourer and part-owner of a brickworks and it seems, was once the bailiff of Arundel Castle). Neither side of the family had experience of anything but village life, nor of industrial society, the natural home of trade unions. The only exceptions were three great uncles on my mother's side who migrated to the steelworks in South Wales, after serving in the Great War. My father was rabidly anti-union, believing, quite wrongly, that unions depressed his wages as a journeyman butcher. The most honest man I have ever known, he spent much of his working life boning out carcases in a windowless cellar, for a pitifully small wage. His opinions, vociferously stated, induced a reaction in me, leading to pro-union views. (A bigger rebellion against family was that of my youngest brother. He left school at the age of fifteen and was sent by my father and grandfather to work as an apprentice diesel mechanic at the local bus depot, the Aldershot and District Traction Company, 'the tracko.' Complaining that he had been pushed into 'the bloody tracko', he quit abruptly and found work as an electrician.)

My views of unions were thus highly theoretical and academic. I saw them as organisations which were there, not merely to improve the lot of workers but to change society radically, through some quasi-revolutionary

political organisation. Exactly what that organisation was and how it would change things, I did not know. One model was that of Tito in Yugoslavia, for whom unions were a tool in the wartime revolution and who had put in place one form of industrial democracy as a result. I had the usual sympathies with Leninism, followed by an admiration, much of it half-baked, for Trotsky. What put me off Communism, or at least Marxist-Leninism, was Stalin and all his works, which I have detested to this day. Even Crocker, who was neither Leninist nor Stalinist, could talk in matter-of-fact terms about the Russian experience, at which I was aghast and which led to shouting matches between us. I just could not see that a system which rested on the plain murder of millions of people could ever be of benefit to human kind, in whose name the mass destruction had been conducted. Some friendships are like that.

One effect of this world view was that I flirted with the rank-and-file firefighters' movement in East Anglia, which was centred in the Essex Fire Brigade. This pressure group was influenced by the Socialist Workers Party; whether it was actually sponsored by the SWP and its activists, I don't know. The movement differed from the Communist Old Left in that it claimed to be a grass roots groundswell, rather than the capture of the leadership by Party cadres. Tony Pettitt, who was the most senior Fire Brigades Union official in Cambridgeshire, frowned on this flirtation, but he did not actively discourage it. There were several reasons for this. One was that the Essex union men had to deal with a particularly vindictive employer; some of the actual policies and strategies of the rank and file movement found sympathy with the union in Cambridgeshire and East Anglia generally. Another reason was that the flirtation did not seem to affect my work as a Cambridge union branch official.

What turned me away from such a worldview was experience with union work and union members. It confirmed something of which I was dimly aware all along – that unions as quasi-revolutionary organisations meant in practice that union members were the unsuspecting pawns in someone else's political game. Unions were to be the cannon-fodder in a revolutionary war. That war, if won, would result in the ruthless suppression of those who had been its unwitting footsoldiers.

The union I joined was almost unique: the combination of a disciplined service with a militant, well-organised and decentralised trade union. So thin was my union experience that I did not at the time notice this discrepancy, this anomaly, if you like.

The authorised establishment for whole time members of the British Fire Service in the 1970s was 32,400, the vast majority of whom were members of the FBU. There were roughly 16,000 retained firefighters (part-time paid volunteers) in the UK of whom nearly 10,000 were union

Tony Pettitt, Brigade Chairman, FBU, addressing a union meeting: a study in character.

members. Among senior fire officers, the National Association of Fire Officers (NAFO), unaffiliated to the Trades Union Congress, was a rival to the FBU. While the rules of the FBU made one of its aims the organisation of all local authority firefighters, there was an uneasy truce between the two organisations at the national level. Both unions were represented on the National Joint Council for Local Authorities' Fire Brigades (NJC), on the Central Fire Brigades Advisory Council and on the National Joint Council for Development and Design. The FBU had negotiating rights for senior officers as well as junior officers and the ranks. Nationally, some junior officers were members of NAFO but since the organisation was not recognised as their negotiating body, membership among junior officers was more a demonstration of loyalties than a matter of immediate self-interest.

The FBU was founded in 1918 by Jim Bradley, son of a firefighter and a London park-keeper by occupation. One factor which decisively shaped the British Fire Service was the creation of the National Fire Service (NFS) during the Second World War. The FBU naturally organised members of this body, whose numbers reached 100,000 and also (controversially at the time), members of the Auxiliary Fire Service. The result was that by the time the Fire Service was denationalised in 1948, the FBU had secure national recognition. (The AFS was disbanded in 1968 as part of the dissolution of Civil Defence.) It was agreed that the establishment of the new local authority fire brigades should be 23,000; the FBU had argued for 30,000 and the employers for 15,000. The union and the war were primarily responsible for making the service what it became in the rest of the century; the ex-servicemen who retired en masse in the 1970s had everything to be proud of. Though the service was denationalised, a national system of governance persisted in the form of the NJC and related institutions, so that there were national standards of pay and service. Further conditions of service and work were negotiated locally.

*

The FBU was small, decentralised and successful. There were only five full-time officials on the Executive Council (EC): the General Secretary, Assistant General Secretary, and three National Officers. The rest consisted of a lay President, Vice-President, Treasurer, fifteen Regional delegates and an Officers' National Committee member. Each Region of the country had its own Regional Committee comprising an elected Chairman, Secretary and Treasurer, together with delegates from the various county Brigade Committees which comprised the Region. These Brigade Committees again had an elected Chairman, Secretary and Treasurer and representatives

from the constituent fire station Branches, both whole-time and retained, in the Brigade concerned. Officially, Brigade Committees were known as Area Committees, a relic of the organisation of the NFS into Regions and Areas.

Among branches, Cambridge was typical. The Branch Committee consisted of Chairman, Secretary, Treasurer, three watch representatives (shop stewards), a junior officers' representative, a control room representative, two Brigade Committee delegates (who usually included the Chairman, the Secretary, or both), two Cambridge Trades Council delegates, two auditors, and two local Labour Party delegates. The last six of these were positions whose level of activity depended very much on the individual. I became first watch rep., Cambridge Branch Secretary, then in addition Brigade Assistant Secretary. There were seven whole-time stations in the Cambridgeshire brigade and eighteen retained.

In the Cambridge Branch, one of the Committee-people acted as Station Collector, but by the end of the 1970s almost all union dues were 'stopped at source' by the employer (checkoff) and paid into the Brigade Membership Secretary's account. Of the half or dozen or so that remained, all were older men who considered that it was not the employer's business to handle union funds. The argument that dues collection was needed to affirm the union's presence among the members was not really valid as the opportunity for social contact was at saturation point in any case. The dues, including the optional membership of the Accident and Injury Fund, amounted in the mid-1970s to £18.20 per year, ludicrously small yet reflecting the fact that most of the union's work was undertaken by unpaid officials.

There was a hierarchy of authority from Executive Council, through Region and Brigade to the Branch. For instance, local disputes were authorised by the Brigade Committee, which could overrule a Branch. There was some conflict between the union in East Anglia and the rank-and-file firemen's pressure group referred to earlier. This did not compromise the effectiveness of the FBU and it is probable that the existence of a shop stewards movement pushed the union towards greater militancy in the 1977-78 strike.

*

At Cambridge, Branch meetings were held every couple of months, more frequently if there were a local or national dispute in the air. Meetings were invariably held on the station, a right and tradition that was confirmed in the NFS days, when the union had argued that much of its membership was tied to the place of work. They were usually held on a Thursday evening

in place of the drill period, Thursday having once been 'club night'. On club nights, visitors such as relatives and table tennis teams could come to the station, the drill period being waived in the event of a formal meeting or match. The watch on duty was of course a captive audience, though meetings were frequently disrupted by the duty watch turning out to a fire. Other union members stayed behind after the day shift, as they did for Social Club and Mess Club meetings, so that attendances of around sixty people were common, more if the committee had got round the membership for an emergency meeting or when pay and hours were somehow involved.

Resolutions could come from the floor or from the Committee, which then negotiated them with the Station Officer or the Divisional Commander. When nothing came of this, the issue was taken to the Brigade Committee, which could overrule the Branch, take the matter up with the Chief Fire Officer or (most often) negotiate the matter at Brigade level on behalf of all the constituent branches. In cases of great contention, the Brigade Committee referred the matter to the Region or the EC. This usually happened when the management attempted to destroy the status quo or was apparently going against the Grey Book of Conditions of Service, negotiated nationally.

Alternatively, issues of general importance could be raised by the Branch and sent, having been endorsed by the Brigade Committee, to the union's Annual Conference for discussion. If the resolution was carried, it became part of union policy to be negotiated by the Executive Council with the NJC. Another route was via a delegate conference called by the EC to decide on policy if important issues came up in the course of any given year. The most important issues discussed with the NJC were pay and hours. However, the liberal work routine described in Part Two was negotiated by the Brigade Committee. There were many conditions of service that were successfully negotiated locally before being accepted nationally.

These descriptions of negotiating procedure can give a distorted impression of the way the union worked. The Branch officials spent about half their time on meetings, negotiations and correspondence, for instance claims under the Accident and Injury Fund. Even then, some items arose not from the Branches but from the CFO or his entourage or from the local fire authority, for instance proposals to change the negotiating procedure. The other half of the time was taken up by a host of lesser matters which were collectively and for the members no less important than the resolutions emerging from Branch meetings. The Branch Chairman might come onto the station one morning to face a complaint from the rep. of the off-going watch concerning, say, a members' leave arrangements, a quarrel with an officer, vital equipment missing from one of the machines, or the deployment of appliances standing by all night on a farm fire when a portable pump

alone might have sufficed. The pair of them would seek a meeting with the oncoming watch officer or the officer in charge of the station. All the time, there was repetitious enquiry from various members over the progress of negotiations, the precise content of an agreement over training, stand-down time or 'tradesmen's work' that may be done as part of station work etc. The mark of a good official was to keep a large number of things running in his head at any one time, letting none of them fall by the wayside. One consistent thread in all this was that the union was most concerned over the effectiveness of the service, its equipment and procedures. Another was that the employer must stick to the rules, either the rules laid down in brigade orders or rules that had been negotiated by the union.

The FBU had its own informal traditions which the older officials tried to instil into the younger ones. The Branch Chairman, for instance, would call watch rep. meetings to discuss the tenor of life in great detail on each of the watches, comparing notes and trying to detect managerial patterns in the matrix. There was also much discussion as to when to depart from the norm of three-member negotiating teams or delegations, three being seen as the best guarantee that the members' interests were being properly served. As such, there was a great emphasis on grass roots union democracy along with what was almost a tight cellular organisation, the 'cell' being the watch. No doubt, this mode of organisation derived from the post-war communist leadership of the union. It was, in any event, effective.

Most members were, of course, well aware that the FBU was a national organisation of which the Branch was only one small part. Despite the fact that the service was denationalised, firefighters had the sense that they belonged to a national institution with standards which were largely won by the union on behalf of the membership nationwide. Yet 'the union' was for most members a predominantly local organisation requiring participation similar to the Mess or the Social Club. Thus the union was an organ of what is now called civil society, its formal, political role in the life of the nation notwithstanding.

As for negotiations themselves, openness and honesty, rather than evasiveness, caginess and duplicity, on the part of the officers won respect: an opponent was respected despite some harshness and an uncompromising nature. One Chief Officer (John Maxwell) was despised by the union, because of his pretentiousness and his deliberate managerial style of waffle, delay and evasion.

On the Brigade level (Cambridgeshire), items of negotiation could be classified in three ways: those which involved substantial financial expenditure on the part of the fire authority; those which involved conditions of service and little money; and matters which challenged managerial prerogatives and authority.

Those items which involved much money typically concerned the quality of the machines, the major items of equipment and crewing levels. For instance, both the union and the management wanted to see the existing Draeger Normalair BA sets replaced by suitable 'positive pressure' sets in which the intake of highly poisonous gases in minute quantities through the exhalation valve of the mask was substantially reduced. The union was the first party to raise the issue of an additional 'Rider Station Officer' for each watch, a move which was successful, raising the rank of the watch officer from Sub-Officer to Station Officer and having the latter ride the leading machine instead of a fire car.

The sorts of issue involving relatively little money included the way in which hose was to be coiled; the fixing of carrying handles on 45' ladders; the dangerous state of dummies being used for simulated rescues; the conditions under which claims for spoilt meals could be made and the abolition of the cleaning of officers' cars on the grounds that this had nothing to do with firefighting. The lack of an extension ladder longer than 13' on the HP was a long-drawn out contentious issue in which the management seemed unaware that in the event of a split turn-out, the HP could be rendered useless as a rescue vehicle.

As for encroachment on managerial prerogatives, such matters included pressure to have an observer on recruiting and promotion boards; the abolition of the test for Qualified Fireman and, in a dispute that turned bitter, a limitation of the management's right to hold training exercises off the station, without prior warning in stand-down hours. One of these management rights issues concerned the Officer's Mess. The issue is instructive, since it revealed the tensions between the two unions, officers and men, and the way that the design and use of Cambridge Fire Station reflected and reinforced these divisions.

The centre of the fire station was the appliance bay, with the big Clubroom or recreation room above it. One third of the Clubroom comprised the kitchen, mess room tables and a separate officers' mess. The middle of the room comprised a large open space with armchairs and dartboard, while the bar and store adjoined the kitchen. The remaining third, nearest the HQ side, was taken up by a full-size billiard table and table tennis table. Everyone on the station used the recreation room and mess. During the dinner (lunch) break at 1.00 pm one might have seen, for instance, the Deputy Divisional Commander, other officers and storemen, playing snooker with the firefighters on the operational side. But senior officers, certain sub-officers and civilians ate their meals and took their tea breaks in the Officers' Mess, a separate room.

There were two wings to the central area of appliance bay and Clubroom, the operational side and the HQ side. On the operational side, there were

washrooms, the locker room, dormitories, the BA room, the quiet room, the map room, a lecture room and two officers' bedrooms. The HQ side consisted of offices and the control room for dispatchers.

The structure and use of the building reflected the sociology of the fire station. The two wings of the fire station – the operational side and the HQ side – were literally two sides. 'The other side' was a common expression among the firefighters: 'going over to the other side' had the same sort of connotation as it does in warfare. One 'side' did operational firefighting work with some FP (fire prevention) duties in which machines with crew did fire prevention inspections while being on call for fires. The other side performed non-operational work and all its uniformed staff outside the control room were junior or senior officers.

Among the latter group, the senior officers were sometimes on call at home for firefighting work (going by car directly to the fire) but they were to all intents and purposes no longer manual workers, at least for the periods that they were assigned to FP or staff work. The lecture room on the operational side could well have been used as an FP office but it wasn't; the two sides were rigidly separated. On the other hand, people from the HQ side had to pass through the recreation room and by the kitchen serving-hatch before going into the Officers' Mess, which was closest to the operational side of the station. All this was a source of friction, even conflict. The work, the duty systems and the imbalance between the ranks were reflected in, and enhanced by, the structure and use of the building. The position and use of the Officers' Mess gave it focus.

> That mess has been a thorn in our side ever since we came on this station. They ought to knock that fuckin' wall down so we can hear what goes on in there. All fallin' over each other, grovellin'. Arseholes to 'em.

The Deputy Divisional Commander was a local man, John Beynon, who had spent ten years on the operational side before being promoted rapidly to the position of Divisional Fire Prevention Officer (FPO), mainly on account of his administrative and literary abilities. An intellectual, he was respected by most of the firefighters.

> I don't care about the pips and the white shirt. He's just John Beynon to me ... When he was a fireman, there were elaborate G1 report forms flying all over the place. I don't know whether he could understand all them long words he was writing down. Buggered if I could.

As a negotiator for the management side, the union found John Beynon on the whole easy to deal with, especially if the union had all the facts

Ernie Tyrell of Red Watch with John Beynon, Deputy Divisional Commander.

in the case being discussed. The Officers' Mess was a constant topic for negotiation. The union claimed that the Officers' Mess was an under-utilised waste of space and campaigned to have it abolished. John Beynon said off the record that the mess was used unofficially by the men in the evenings as a room for a second television. Provided the place was cleared up by the next morning, there was no objection. Why do you want to stir things up when you have what you want already, he queried. He knew as well as the union that the issue was not one of wasted space but one of rank and segregation. Beynon claimed that there was class division in the station mess so the officers' mess was not the real trouble. He pointed out shrewdly that the operational firefighters sat apart on the whole from the control staff, the civilians, and the mechanics. The mechanics blended in with the firemen that much more readily than the control staff, some of whom were women, with the civilians (mainly women) the most apart.

For all that, John Beynon saw the Officers' Mess as a symbol of managerial authority, to be guarded firmly and jealously. It was, among other things, a way of making an officer, newly made up, show whose side he was on. Before being made up (promoted): 'Fucked if they can make me take my meals up there!' Afterwards, it was usually a different story. A lone officer dining on occasion in the men's mess would be mocked: 'How come we are not good enough for you all the week and now you've changed your mind?'

3.2

The 'Spit-and-Polish' Dispute and Lockout of 1951

1951 was murder; ever since then, it's been a rose garden – *General Secretary, FBU, 1976*

Until 1951 the police and the fire brigade had enjoyed a degree of equality in wages and rent allowances. Before the war, more than half the country's whole-time firefighters were getting police pay as part of their normal conditions of employment in authorities jointly responsible for police and firefighting. Large numbers were actually enrolled as constables and this state of affairs only ceased with the creation of the NFS in the war conditions of 1941. However, the union succeeded in retaining the principle of parity with the police in pay and some allowances, though not over hours, nor of course conditions of work. From the denationalisation of the service in 1948, the local authorities were determined to eradicate police parity. In August 1951 the police received a large pay rise but a similar rise for the fire service was not in sight. Parity with the police had already been eroded, a fact which led the union's General Secretary, John Horner, to remark:

> ... indeed, it may well be that when you begin to reduce the standard of living of the working class as a whole, that is the time you have to improve the standard of living in the case of the policemen.

In the middle of 1951 a number of brigades went on a 48-hour 'fires only' demonstration. Firemen would answer fire calls and do any necessary servicing of the machines but nothing else, no cleaning or other duties. This was described in the Executive Council's report as 'rank and file action', demonstrating 'in this new way their support of their union's claims'. The EC convened a delegate conference and on hearing of what they considered to be

an unsatisfactory offer from the NJC, the delegates unanimously decided on a 'fires only' course of action on Monday and Tuesday 19 and 20 November.

Up to this time, Cambridge had not been involved in any 'fires only' action but the local Branch now took up the conference's resolution. At 9.00 am, Blue Watch was dismissed and the men waited outside the station to see what would happen to members of Red Watch coming on duty. Inside the station, the Chief Officer (Tom Knowles) had taken charge and the first thing he did was to give an order to a brand new recruit, Fireman Whittle. The new man declined to obey the order, saying he was in dispute. The Chief then ordered two of the older men to do certain routine duties, which they refused. Soon after 11.0 am the men began to trickle off the station as they were suspended from duty. As the Chief went through them individually, he ceased to order them to do routine duties but simply asked them if they were in dispute. When it came to his favourite union men, he summarily ordered them off the premises, telling them all to take their personal effects with them and that they were suspended on half pay. Twenty-one union members were suspended, including the recruit. As recorded in the meeting minutes, the branch declared

> ... in future years his action will be looked upon with pride by all, young and old, firemen, an example to all.

The branch called a committee meeting, which was held in Dusty Miller's mother's living room. The members compiled a statement for the local press, decided to report to FBU Head Office on what had happened, and called a branch meeting for 3.00 pm in the local Labour Hall. One item on the agenda was what action the branch wanted them to take with blacklegs.

At the Branch meeting, instructions from the Head Office were read out to the effect that members suspended should return to work to serve the public 'until evicted by the Law'. A motion expelling those who had refused to demonstrate was passed 27-4. All the members who had been suspended that morning returned to the station. Two gained entry before a Station Officer barred the door. But the two let the rest in by another entrance. They sat in their places on the machines wearing fire gear. The Chief brought in the police who, it was thought, had their Black Marias parked round the corner. He then said 'I have told you to leave the station and I now tell you in the presence of the police', whereupon the firefighters left the station.

When the night watch came on, a further eighteen members were suspended and ordered off the station. Like the others, they went onto half pay and were charged under the Discipline Code. The branch's report on the demonstration drew attention to the fact that all those suspended held the rank of Fireman. The eight members who remained on duty working

CAMBRIDGESHIRE FIRE BRIGADE

<div align="right">
Fire Brigade Headquarters,
43 Parkside,
Cambridge.
</div>

To: Fireman **K.A.Tanner**

From: Chief Officer.

 On 19th November, 1951 I served upon you a Charge Sheet under the Disciplinary Regulations in which you were charged with disobedience to orders.

 Under Section B of the said Charge Sheet, you were ordered to return the sheet to me within three days with Section C completed by yourself. Owing to various circumstances, this "prescribed period" has been left in abeyance but I now order you to return to me the said Charge Sheet in its completed form not later than 0900 hours on Wednesday, 2nd January, 1952.

<div align="center">
CHIEF OFFICER.
</div>

28th December, 1951.

A Charge Sheet from the 1951 Dispute.

the normal routines were all junior officers. In addition, two non-member firemen continued to work as usual. It was also said that the Chief had instructed civilian mechanics to ride the machines.

At a second branch meeting, held in the morning at 11.00 am, two of the blacklegs were allowed to defend themselves. The first said that he hoped they were united on other issues if not this one, which was treated with derision. The second accused the branch of going on strike. Their union cards were then taken, according to the previous resolution. The union's instructions as to returning to work after suspension were repeated but there was doubt as to the legality of this move. Two members contacted the police but this did not clarify the matter so it was decided not to return to work pending further instructions from Head Office, which had been informed of the previous day's evictions.

By 9.00 am on Wednesday the twenty-first, the demonstration was over. The vast majority of the country's fire brigades had taken part in the action; but police parity was not restored. Cambridge firefighters lost their rent allowance and guaranteed housing; their hours of work continued to be longer than the police. The union had not refused to do emergency work; it was the Chief Officer, not the union, who had reduced fire cover by ordering men off the station.

On November 22, the General Secretary of the FBU wrote to all Area (Brigade) Secretaries, asking for reports on the role of the police in the dispute. The Area Secretary responded two days later, summarising the role of the police at Cambridge, which was evidently one of the very few stations on which the Chief had called in the police.

As elsewhere, the Discipline Code had been used as a weapon in an industrial dispute. In the end, most of the charges throughout the country were rescinded as the union's condition of submitting the pay claim to arbitration, though it was said that a number of junior officers were permanently demoted. At Cambridge, the union threatened legal action over the firefighters' loss of pay; they were eventually paid in full for the period of their suspension. During the dispute, the Chief had a news photo of him cleaning the station windows with an heroic caption like 'we can carry on'.

A Junior Officers' Association was formed around this time. Several junior officers at Cambridge responded in the autumn of 1952 to their expulsion from the FBU, stating that they were joining that Association and would remain members. These letters have survived. Later, the Association became the Junior Fire Officers' section of NAFO and campaigned against the FBU: the Red Menace, workers usurping the functions of management and calls for a toothless federation of all ranks.

Such tensions between the junior officers and the ranks on one side, with the senior officers and the fire authority on the other, became a theme

in the industrial relations of the fire service in the coming decades. As a group the junior officers were in an anomalous position: in many ways they participated fully in the work of a shift and they were allowed to take part in industrial action, yet they were constantly reminded of their duty to supervise the rank and file of whom they were, in most ways, a part.

More generally, the dispute served to define the loyalties of those involved. Social relations on the fire station were determined significantly by the stance taken during the 1951 action, with characters like Tony Pettitt, Dusty Miller, Ken Chapman, Bill Gyles and Jock Tanner on one side and those who had been junior officers in 1951 on the other. Twenty-five years later, the dispute lived on. When a station cleaner who had been a Leading Fireman in 1951 asked the union for help over his cleaning duties, he was told to get lost. A Leading Fireman in 1951, John Mallon, respected though he was, was under a cloud which those new to the job came only slowly to understand and rarely to appreciate fully.

'Emergency calls only' became a common tactic on the part of the union, without on the whole the sort retaliatory action that was taken by the employer during the dispute of 1951. In this respect, the union had gained in power. Yet by the end of the 1970s both the issues and union action had overtaken the de facto regime established in 1951. 'Spit-and- polish' action became too easy and inadequate as a weapon in industrial disputes, as the national strike of 1977-78 proved. The dispute of 1951 was important in two other ways. Though the first actions in the dispute were unofficial, the Executive Council of the union did not condemn them. Rather, the Council exploited militancy in order to further the (official) aims of the union. This tactic was forgotten when more serious disputes arose in the 1970s. Second, the loss of police parity caused a running battle and collective grievance over pay and hours, which was only resolved many decades later, with the nine-week national strike of 1977-78.

Radical though the action of 1951 was, it did not result in a whole new range of rights and freedoms. Ten years later, Cambridge firefighters were still writing to the Chief, asking permission to attend demonstrations in uniform. Permission was granted, provided the men did not carry placards or take part in any activity 'likely to bring discredit upon the brigade'. A sort of deference still persisted, which only vanished in the turbulence of the seventies. A few even left the union in the sixties, citing a lack of will to fight, and rejoined only after militant local action in the mid-seventies. The Minutes of Cambridge Branch meetings, now, I am told, in the archives of Keele University, bear out this evident dearth of militant action.

Prelude to the National Strike (1): Glasgow 1973

If they're going to go, they're going to go. There's nothing the EC or anyone else can do about it.

I shouldn't want to go on strike. Think of my Mum and Dad sitting out there in Wilbraham without any fire cover. It's just not on.

I wouldn't go on strike, not even if we all voted for it. I don't care who hauled me off the machine, the police, the Chief or my own mates. I just wouldn't go on strike.

– FBU official, No. 12 Region

On Monday 15 October 1973 the members of the Glasgow Area (later Brigade) Committee voted in favour of strike action over a local pay claim. The EC declared the ballot unconstitutional and said it would remove the Glasgow Area Committee from office if they accepted a decision in favour of strike action. Mass meetings of Glasgow members rejected the Corporation's pay offer and endorsed proposals from the Area Executive Committee to go on strike indefinitely from 8.00 am on Friday 26 October. The EC then removed the Glasgow Area Committee from office, a move backed publicly by the General Secretary of the Scottish TUC and the General Secretary of the TUC in London. On 3 November, the Glasgow Strike Committee held a meeting and decided to recommend a return to work; the EC then reinstated the Area Committee. On 4 November, the Glasgow membership decided to return to work and accept the Corporation's original offer. Troops led

by non-FBU officers had done firefighting and other emergency work during the strike.

Cambridge went on 'emergency calls only' on 29 October on the recommendation of the Area (later Brigade) Committee and in support of the 48-hour week. This, it was thought, would 'solve the situation in Glasgow'. A very large number of other brigades took similar action.

The union held an emergency branch meeting on Thursday 30 October to discuss the Glasgow strike and the action of the EC, which had not only disowned the strikers but had made strong attacks on them in the press and on the radio. A motion condemning the EC for the way in which it had handled the situation and calling on them to resign was carried unanimously. A strike fund was set up for the Glasgow strikers (the FBU had no strike fund) which proved to be well supported. Members who did not agree with the principle of firefighters striking nevertheless contributed, as did a number of non-members and retired firefighters.

The branch held a second emergency meeting was a week later and a third on 15 November. By this time, the NJC had agreed to the 48-hour week though there was still some doubt on the matter because the government said it could not 'anticipate any legislation that may be in force in November 1974'. Nevertheless, it approved a programme of recruitment and training to work the 48-hour week throughout the country when it was to come into operation on 11 November 1974. So the branch had to decide whether it would lift the ban on routine work immediately or whether it would resume normal working only when it received a written undertaking from the local fire authority that it would introduce the 48-hour week.

The Chairman of the Area Committee, who was present, said that the Chief Officer (Cecil Carey) had gone so far as to *invite* the membership to continue the demonstration until it had received a written undertaking that the fire authority would implement the 48-hour week on schedule. This gesture may seem strange; it was an echo of a tradition in which the Chief Fire Officer functioned as an advocate for firefighters as well as a director. In view of the show of good faith, the Branch voted 28-4 to return to normal working the next day. The Branch Chairman called for a vote of thanks to the Control Room staff for taking abuse from the public over the phone every time a dispute arose.

The 48-hour week had been an issue for a generation but there were other important aspects of the dispute. There was in the Cambridgeshire brigade an almost total absence of official harassment during the dispute. Things need not have been this way. Cecil Carey was not an unpopular chief. Some of the older men reckoned that if he had responded in kind to the action of the union, he could have split the branch as his predecessor

had done in 1951. Nor was every Chief so reasonable: in a neighbouring brigade, the firefighters had to sit day and night in the machines wearing full fire gear until the demonstration was over.

A second aspect of the dispute was the attitude of the Executive Council. Whereas in 1951 the EC had endorsed rank and file action by calling for a national demonstration, the leadership in 1973 publicly condemned the local action. The move of the Glasgow members was more drastic than in 1951 as the use of troops showed; but it should be remembered that for some employers and Chief Officers it was as scandalous in 1951 that firefighters should disobey orders as it was that they should 'shut the doors' in 1973. There were other differences. The dispute of 1951 was over a national pay claim; that of 1973 concerned special payments for the members of one brigade under circumstances peculiar to Glasgow. The EC no doubt felt that it could not support such differentials in the face of a common pay scale for firefighters throughout the country; and equally it no doubt thought it was making good progress with negotiations for the 48 and over the project for the revaluation of the firefighter's job. But they clearly did not like the strike.

The EC was aware of the deteriorating situation in Glasgow long before the strike took place. Yet it did not take advantage of the Glasgow affair in pressing for the 48 until the recall Conference in London on October 29 and the subsequent meetings with the NJC. Exactly what role the Glasgow strike played in securing the 48 is an open question. In condemning the Glasgow strike, the General Secretary of the FBU noted that Glasgow Corporation had informed the union that 'it would strive to implement' the 48-hour week. The attitude of FBU members at Cambridge was that Glasgow's action was decisive and ought to be supported firmly. The Branch sent a letter of support and a donation of money collected, to the Glasgow strikers.

The neighbouring Essex Brigade Committee went further, calling on the General Secretary to resign over his 'employer-like attitude and threats' towards members and his 'despicable' treatment of the Glasgow strikers. The perception at Cambridge, both over Glasgow and in the national strike, was that the General Secretary, Terry Parry, was weak and pusillanimous. This, as it turned out, was not correct. What Parry feared was that a major disaster with loss of life would turn the public against the firemen, and weaken and split the union, reducing it to ineffectuality for a generation. It is quite true that he misread the mood of the membership, argued strongly against a strike and never believed it would actually come to a head in 1977. His cardinal mistake in 1977 was to talk to the press after the strike vote, saying that he was opposed to it. One thing that ensured the success of the union in the national strike was that some firefighters, in case of

dire emergency, actually broke their own strike by attending fires without riding the machines.

In such disputes, things are not always what they seem to be. It was quite possible that EC members knew from the start that the Glasgow strike was an opportunity for the union to exploit, regardless of the sanctions the EC imposed and the public statements that the EC made. Similarly, the Cambridgeshire Chief may have privately deplored the industrial action in his brigade but declined to oppose it on the grounds that its successful outcome was inevitable. Much more importantly, the Glasgow strike set the indispensable precedent for the successful nine-week national strike of 1977-78. Without Glasgow, both the occurrence and the outcome of the national strike would have been in doubt. All parties realised this, whether they admitted it or not.

The Cambridge Branch, as with the FBU more generally, was not clear as to whether the dispute was in support of the 48-hour week or in support of Glasgow, nor was it clear at the time whether the 48 would resolve the local issue over which Glasgow had struck. None the less, the branch gained in strength. It lost one member who was likely looking for an occasion to resign in any case. Four ex-members rejoined on the grounds that the union was fighting at last, one of whom (Bill Gyles) because he had earlier resigned on principle when the Branch had voted

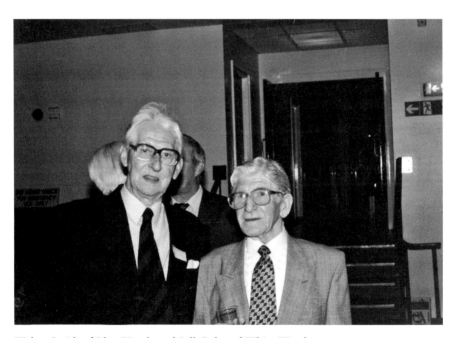

Walter Smith of Blue Watch and Bill Gyles of White Watch.

to reject the 48 in favour of the current 56 and the offer of a substantial pay rise. Five months later the branch nominated Jim Flockhart of the Glasgow Area Committee for the post of FBU Assistant General Secretary (he didn't get in).

In one respect, the attitude of FBU members at Cambridge was paradoxical. There was strong support for the Glasgow strikers. Yet the most salient attitude towards firefighters striking was negative. The predominant sentiment was that firefighters held a position of public trust in a humanitarian service, a trust that would be broken when firefighters went on strike. When the issue of a national strike came up four years later, attitudes had evidently changed. Later, we will look at the issue of whether attitudes had really changed or whether firefighters were responding to a new situation in which traditional values had no application.

3.4

Union Officials and Members

Bill Gyles:

Bill Gyles was the best union man we ever had. I was on the negotiating committee about fifteen years ago and it worn't so easy as you're making out in your book. (I'm not trying to praise what we did.) Billy was the only bloke who spoke to the Chief like he said he did – sit there shouting and banging the table. Knew just how far he could go, too. When he jacked it in, he got a letter from the Chief thanking him for his work! He was a clever bloke was Billy. Genuine too.

<div align="right">– Jock Tanner</div>

... that little ginger-haired cunt
– Chief Fire Officer

Active in the Union:

What does it take to be a good union man? Let's see. Well, there's a lot of things. You got to know the facts, all what you are after. You got to go through the procedure, be on the ball, so they don't catch you out. You got to be good at your job, being a fireman I mean, do things right, so they don't try and catch you out. Then you got to know all the rules and keep to 'em – half of them are bloody stupid I know but that's what you got to do. Then they can't put the knife into you. Try to keep one jump ahead of 'em. That's difficult, I know. Yeah, and don't let 'em frighten you. Show 'em you're not scared of 'em and you're half way there. You may not get far but at least you won't go backwards. That's about it, really.

Communists:

Communists? Good tradesmen, all of them. Had to be. The boss used any excuse to get shot of 'em. I never worked with a Communist who wasn't a good tradesman.

The Chairman of the Cambridgeshire Brigade Committee of the FBU was Tony Pettitt. He had also been Treasurer of the No. 10 (East Anglia) Region of the FBU for the past fifteen years. Tony Pettitt joined the fire brigade in 1949, straight from the armed forces. He had no objection to the fire service as uniformed and disciplined: 'being an ex-armed forces member, I was used to it'. He had a deep, strong voice but he was not particularly articulate; his vocabulary was limited and his sentences often ill-formed. This was of little consequence as he was rarely worsted in an argument; when his tactics failed, his bluster succeeded. Equally important was his presence: he seemed to fill the space he stood and moved in, as if he owned it.

When necessary, he would roar at the Chief Officer and his mates alike, the former in outraged anger, the latter out of desperation. At one meeting, the Chief played with him for about half an hour. Tony, knowing exactly what he was doing, suddenly threw a sheaf of papers on the table and shouted in a fit of temper at the Chief: 'Look, either you're bloody thick or you're deliberately misunderstanding me.' On another occasion, he threatened to walk out of a meeting and get on the phone, shouting 'If you don't bloody listen to me I'll bring this brigade to a stop in half an hour.' He would rail at the Chief, accusing him of being entirely without common sense, untrustworthy and ignorant: 'If you went to a fire for a change instead of sitting in your office, you'd know what we are talking about.'

For all this animosity, he spent an hour at one Fireman's Ball talking earnestly with the Chief, John Maxwell, topic unknown. The Chief had been a highly decorated flyer in RAF South East Asia Command during the war and held some decidedly old-fashioned views about firefighters' deportment and bearing. Maybe he respected Tony, who was an old soldier. But the Chief was also enamoured of the American industrial relations system, which he did not understand and from which he had, evidently, learnt only to conduct himself as a devious, evasive and duplicitous negotiator. Tony's view of Maxwell at the time was that 'You'll never understand him'; in 2007 his verdict was more negative. John Maxwell died following a road accident in 1989.

Tony was a domineering character who, by and large, had the confidence of the membership. Yet there was still some social distance: few tried to

take the piss out of Tony and he had no nickname. He could be rough with his own members. Once some Branch officials were sitting at the station bar after a union meeting. They were discussing with Tony and a few others the employers' latest offer for a 40-hour week. One official saw some merit in the employers' proposals and said that, if they were rejected, there was no prospect of reducing the working week from the current 48. Tony swung round on him, took two steps away from the bar and roared, 'That's defeatism. Are you a defeatist ... ?' and so on, much to everyone else's amusement.

Again, when an official had written a letter to the local press, signing it 'Branch Secretary, FBU' without anyone's knowledge or consent, Tony collared him in the muster bay and lectured him roughly for ten minutes. The official argued back and there was a running battle back and forth between the locker room, the muster bay and the machines. Not that it mattered. It wouldn't happen again.

Yet his principal opponent was so elusive that the Brigade Committee had only limited tactical success. In trying to tie the Chief down, it was understood that there would be an 'Agreements Book'. A year later the book remained empty. When told in a meeting of a complaint by a union member, the Chief, impressed by American industrial relations, announced in grandiose tones, 'Institute the grievance procedure'. No one knew what he was talking about nor, as it later transpired, did he. At the high tide of British trade unionism, the FBU locally in Cambridgeshire achieved little more than holding the line, advancing only a bit though never going backwards.

> He's had to learn his work over a long number of years. Now he's getting good at it.

Tony Pettitt was hardly dictator for the simple reason that most of what he argued had not been inaugurated by himself but had been passed on to him from the branches. Nor was he an iron character. In the car on his way to meetings with the Chief, he would lean over to the passengers in the rear and lecture them as if they were the adversary. He was rehearsing his act. We thought it was only his mates he used as an audience until his wife Olive described how he would stride about his living room shouting and waving his finger at her as she sat in the armchair. He was in fact a nervous man who suffered from migraine headaches. It was said that he acquired a stress disorder as a result of the Rose and Crown fire in Saffron Walden, at which he had operated the Turntable Ladder. At one meeting, arguing intensely with the Chief, his hands trembled, his voice shook and a bead of sweat ran down the side of his face, a small token of the personal toll that union work took of him.

Tony had no children and lived with his wife and mother-in-law. This gave him much time for union work. Even so, he was by choice overworked. In addition, he was a Justice of the Peace. Yet he was also a patient man who would get asked the same question by a succession of members in turn. He would take a plastic tin of tobacco from his pocket, proceed to roll a cigarette, brace himself by shrugging his shoulders and lifting his heels from the ground, pause and begin: 'What we've said is this ...' It was his trade mark.

The Secretary of the Brigade Committee was 'Tommy' Tucker; what his first name was, few people knew. He had formerly worked in the office of an accountancy firm. His mates got impression that his wife was a City Councillor; in fact, this was not the case. He was a big man, though he was somewhat shy with a quiet voice, to his clear disadvantage. One firefighter contended that Tommy fiddled too much at the expense of his union work; this again was not the impression of his fellow union officials. His method with the membership and his fellow-officials was to adhere rigidly to protocol and procedure. In negotiations, he would stick doggedly to his position, neither retreating nor particularly adept at seeing a way forward. As time went on he got appreciably better at the job and took on more of the Brigade Committee's work; this was fortunate as it was assumed he would take on Tony's job when the latter retired.

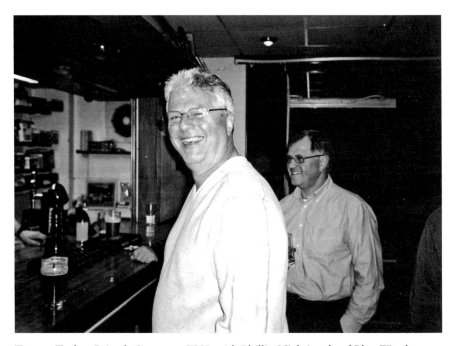

Tommy Tucker, Brigade Secretary, FBU, with Phillip Nightingale of Blue Watch.

The Cambridge Branch was the most militant of all the Cambridgeshire branches and supplied more than half of the full-time membership in the county. So it rankled when the branch was overruled by the Brigade Committee. Tommy's adherence to the rule book was reluctantly conceded but he was sometimes criticised for being over-cautious. On Tony's side, there was speculation that he had once run the union in Cambridgeshire virtually single-handed and was now being rivalled by other activists in the Cambridge Branch, often, like Tommy, young and able.

Tony and Tommy were not 'activists' in the contemporary sense of those who take up radical or unpopular social causes. They alone in the Cambridgeshire FBU were committed to a career as lay trade union officials, like thousands of others in different unions throughout the country. Yet neither, evidently, had ambitions to be elected as a National Officer or full-time union official. Tony once said that he just didn't know whether he would have been 'in the union' had he not been a firefighter.

Ken Aldred, '*Gawp*'

... when I joined in 1955 Bill Gyles was Branch Secretary, Jim Wheatley Chairman and of course The Godfather. In those days we were on a 60-hour week, i.e. week of days, week of nights, and a 24-hour shift every Sunday to change over. There was only two watches in those days which draws to mind how I got my nickname, playing cards one Sunday shift. Big Jim sat studying his cards some time and impatient me spouted up 'when are you going to stop gawping and play something', which caused great hilarity to think a sprog had dared to question The Godfather, hence my nickname.

When the late Bob Landels retired from the Cambridge Branch Chairmanship, Ken Aldred ('Gawp') took it over. Alone of the leading union officials, Ken was a junior officer, at which he had once had the reputation as being a hard taskmaster. There were contrary speculations as to why he had stood for the office of Branch Chairman. Some said that since he had failed to get promotion to Station Officer, he had mellowed and no longer sought to appear to be a hard officer. By the same token, he could afford to be identified with the rank and file, as a union leader. Others speculated that he willingly came forward to take office to have a crack at the management who had passed him over. When at the end of the year (1976) he stood down as firmly as he had earlier stood for office, the cynical then said that he had only taken office to 'get noticed' and put himself back in the running for promotion. Whatever the truth, the fact is that Ken was one of the best Chairmen the Branch ever had, perhaps as good a leader as Bill Gyles. Ken was a militant strategist who carried the Branch with him in everything he took on.

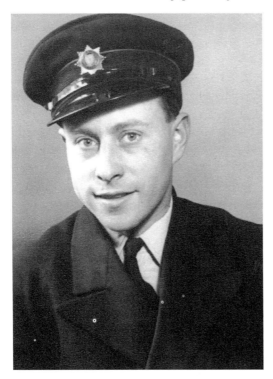

Ken Aldred as a Young Fireman.

He was a short solid man who strode about like a human bear. He came from the Fens about seven miles north-east of the city and lived in a house which he had built himself, with the help of his mates. His only child was a Cambridge firefighter. His was a face often seen in the Fens: a high, round forehead, moony blue eyes and heavy jowls. Yet he spoke not with the high-pitched sing-song whine of the Fens but with a strong Suffolk accent (in fact, he was born in Manchester and his father was Mancunian). His accent was something of a joke on the station but it was neither artificial nor assumed, nor did it change according to the company he kept, no doubt one reason why he had not been promoted. If held up by an awkward motorist on the way to a fire, Gawp would roll the window down and bellow abuse into the street: 'Get out of the way, you stupid, four eyed old bat!'

However, in a curious way he exploited his accent and speech, both socially and in the context of union work. He seemed to mispronounce words deliberately and form his sentences clumsily in order to keep himself within the conversational range of his mates on the station. He had a large vocabulary and outstanding powers of argument which were in effect disguised by a crude manner of speech and a refusal to use his verbal agility for the sake of elegant rhetoric. Ken Aldred is one of the most intelligent people I have ever known.

Ken and KC would spend an hour or so each evening on the station doing the *Daily Telegraph* crossword and would complete it often enough without recourse to the dictionary, defeated only by allusions to classical antiquity. After the crossword, they would come to the bar for a pint and the entertainment would begin. Ken was a riotously funny story-teller, especially when he aped the accents of the upper class or the bumpkins of the Fens. When Ikey joined in, it seemed that the world consisted entirely of the worthless rich, ignorant Fenmen and Yorkshire buffoons. Ken would wave his arms about in magnificent gesture, get up and stride about, frown, feign surprise, shake his head, lose his temper and generally burlesque the manner of the characters in the story. He would mock his mates in loud and raucous tones, bursting with good humour.

When in a meeting or informal conversation with the union membership, he was blunt and forceful; anyone who disagreed with him was met with emphatic rebuff, sarcasm or feigned disbelief. Though he was more patient, subtle and shrewd in negotiations than Tony, he could assume a similar blustering manner which he used to advantage. Yet again, like Tony and despite his reputation on the station, he was not a hard man. When talking of the upbringing of a firefighter not popular on the station, he looked at me searchingly and said 'There wasn't much love there'. When the wife of a firefighter, an implacable enemy, who had taken an entire retained station out of the FBU, died of cancer, Ken was the first to send his condolences.

Hard as you like on the surface; soft as shit underneath. We all are, I suppose.

He was a man of many parts, a countryman keen on shooting and fishing, who knew Cambridgeshire and many places beyond like the back of his hand. He had once been driving a tractor with a .22 rifle on board, which fell and stuck, muzzle in the mud. He then failed to clean it properly before he fired and, though the bullet emerged, the breech blew up in his hands. A doctor had to pick shrapnel out of his face. His eyes were untouched. He had been peppered with shot from incompetent guns innumerable times. He had a lead shot under his skin near the knuckle, which had worked its way down from the wrist. He organised the annual Brigade Fishing Match in the Fens, which attracted contestants from all over the country and was one of the largest events of its kind.

When Ken was Chairman and the author Branch Secretary, union membership reached nearly 100 percent (the average in the country was 92 percent) among junior officers and the ranks; only one control operator remained a non-member. Attendance at union meetings was

high, owing to agitation from the Branch Committee. The union also saved at least one probationer from dismissal.

I'm not taking Crocker in with me to negotiate. He's a liability.

Ken stood down towards the end of 1976 and his place was taken by Neville Cross ('Crocker'), a man as complex and able as Ken himself, though perhaps not his equal in intelligence. This too was deceptive, since during the national strike, he came into his own; his accomplishments were equal to Ken's in a much more challenging situation. Crocker, the scatterbrain and the liability in union negotiations emerged as a great organiser and strategist.

Bill Gyles agreed to take on the Secretaryship just before his retirement, until someone came forward to take it over. That individual was Graham Williams, Ikey's younger brother, who was strong and able, yet initially lacked confidence:

> I don't want much more of this. It's given me a headache already. I tell
> you: I was in here for seven hours one day last week, arguing with them
> over there, and that. You know what came out of it? Nothing. Sometimes
> I think we should jack it in and let the governors tell us what to do.
> Another firefighter: Then where would we be? They would just walk all
> over us.
> GrahamWilliams:Itstillgivesmeaheadache.[PicksuptheDailyExpressand
> beginstoread.]'Noofficerfirecoverlastnight'Oh,sorry…Generallaughter.

The FBU was alleged to be 'Communist-dominated'. Certainly, the aim of the CP was to create Communist 'fractions' on fire stations (more popularly known as cells) and to 'capture' the FBU leadership. Among the older firefighters, pro-Communist sentiments were commonly heard though it was never clear whether or not any of the union officials, or the rank and file, had ever been Party members. (Some of this left-wing militancy may well have originated among the Londoners, former servicemen who had been stationed in Cambridgeshire, married local women and joined the brigade after the war.) There was rarely any discussion of the ideology to which members seemed to subscribe, e.g. that of Stalin or Trotsky, nor of the controversies surrounding Communism, such as the Nazi-Soviet Pact of 1939, the Soviet invasion of Hungary in 1956 or the East German workers' rising. What was important was the impetus that Communism gave – or certainly appeared to give – to local union activity and the efficacy of local union organisation. The intensity of shop steward activity in minding the business of the watches was certainly a Communist trait

and good trade unionism to boot. Pro-Communist sentiment disappeared entirely among the post-National Service generation.

Tommy Tucker was active in the Labour Party. Ken Aldred had done a lot of work for the Labour Party in Cambridgeshire after the war, activity which centred on Lode Labour Club. Tony was a Labour Party member; he saw the party potentially as a useful tool in advancing the union's work. There was minimal interest in the Socialist Workers' Party and similar organisations; the lone member of the Workers' Revolutionary Party was not active. Little was heard of the Maoists or the Militant Tendency in the Labour Party. The Militant excepted, this was fairly typical of the nation as a whole.

No very clear distinction can be made between the officials and the members simply because, over a period of years, the former emerged from, and receded back into the ranks of the latter. Ken, Crocker and Graham were typical in this respect. There was on Cambridge Fire Station, as in most other industrial workplaces at the time, a 'union culture' in which the majority expected that there would be a union, expected or assumed that most if not all would be members, and that a degree of practical interest in the union's work was the norm. As a rough generalisation, members tended to put their trust in, and follow, their elected officials, only making their feelings felt at election time. They tended to do this irrespective of their personal appraisal of the officials. They might have a low personal opinion of an official yet support him in office. Failure as such was not condemned; only if it seemed to be the result of blunder or personal motive. Yet character and intention rather than accomplishment were the benchmark for evaluating officials.

This was true even among members whose politics were conservative. Some of these were gregarious and popular characters; others were solitary, accused of being anti-social or misfits; they were certainly oddities in a communal institution. They would never take a leading union office, watch rep. being the usual limit. They were adamant that politics and trade unionism should be kept apart. In union meetings, they would consistently vote against any motion that smacked of political interest outside the concerns of the branch. They tended to be cynical about the motives of officials, who would hold office, then quit 'when they got what they wanted'. Yet they were, by and large, good unionists, who attended meetings more than the average and often voted in favour of the most militant moves. They had little sense of the collective, seeing the union as a series of individual interests, of whom their own was one.

For the union, if not for the service, the rapid turnover of the 1970s was a problem. In the mid-seventies, more than half the membership had less than five years' service, a threat to the union tradition. This was partly due to the 'war generation' retiring and partly due to the recruitment for the 48-hour

week. Some of the newer men professed not to know what the union was about and sat through meetings, lost as to what was going on. When they tried to shrug off the union, they were reminded that had the union and the Glasgow firefighters not stuck their necks out, they wouldn't even be in the job, let alone enjoy the easy time they had now. Cracks were appearing in the union culture of the station, as they were throughout the country. Whether there were any long term effects on the FBU is for others to judge.

Other younger firefighters were different. They were better educated, more broad-minded and imaginative, without the familiar set of dislikes and prejudices about women, blacks, queers, long hair and rock music. Stories about the Battle of Arnhem, the Italian Campaign, merchant vessels under fire and National Service gave way to tales of hitch-hiking to the far east; working at Alice Springs or in New York City; crossing the Sahara in a Land Rover and Voluntary Service Overseas in India. Such younger men tended to have a readier grasp of what the union was doing, though the nature of this link with their experience was not clear. Because of their experiences, they were the older among the younger men.

The outstanding talent of some of the union officials stands in need of explanation. Among those who came into the job in 'the war years' one explanation is tempting. The war was the one time in their life when their skill and intelligence were valued in society. To have been a paratroop sergeant at the Battle of Arnhem or to have been the gunnery officer on a merchant ship loaded with explosives in the heat of the Red Sea were positions of huge responsibility and a real, not merely formal, leadership. When they returned to civilian life, they were once again reduced to a broad back and a pair of hands, told they were paid to work, not to think. Union office was one of the few avenues where they could again hold a position of responsibility and leadership, again in a communal and other-regarding capacity. Such officials showed talent because they were talented; union office gave them the opportunity to exercise it. A similar argument could be made about those rank and file firefighters who were unable or unwilling to aspire to promotion. There was more genuine leadership in the local union than there was among those against whom the leaders negotiated.

Biographical Note: Jim Wheatley

Jim Wheatley was FBU Branch Chairman in the 1950s. At the time of the Glasgow strike, Jim was the Chief's driver. When the Branch voted to go into dispute, this would have left Jim without any work and bad relations with the Chief, so he resigned from the union. 'Big Jim' Wheatley had been in a tank regiment during the war and was the holder of the Military Medal, about which he rarely spoke.

Prelude to the National Strike (2): Events at Cambridge in 1975-76

Einstein said – and I'm paraphrasing him – that community is what it's all about. People say that you lose your individuality, but, on the contrary, it strengthens it. Because part of you goes elsewhere, you see. A union is about community. And that's the key.

Studs Terkel, interviewed in Rolling Stone, Issue 874, 2 August 2001.

You're asking the Committee to put in a protest about him, him what's coming here. Well, that's fair enough. But I can't do it. I'm past it. Listen; in the 'fifties, they opened my letters and put a tap on my phone. I know because I had a mate send me a letter from London. They held it up and opened it; at Cambridge. I don't want it. Not at my age. I shall be off in a couple of months.

The key to the events of 1975-76 was the so-called wholetime-retained (WT/RT) duty system, whereby full-time firefighters on a 'day-manning' shift schedule, took on additional retained duties. Day manning was a system of day duties at a fire station in which firefighters were on call certain nights. Adding retained duties to day manning meant that some firefighters were doing day duties and were on call for much of the rest of the week. The union's objections to this system were several. The system smacked of the old continuous duty shift schedule, whereby firefighters were on or near the station for weeks on end, with only the occasional day off. The union could not argue for a reduction in working hours while the WT/RT system, with a far greater number of hours than 48, was in operation. At the same time, the WT/RT was the occasion for not

recruiting more full-timers. Some of those working WT/RT were earning far more than full-timers working the 48. All of the full-time stations in Cambridgeshire apart from Cambridge itself had a greater or smaller number of personnel working the WT/RT.

At a Branch meeting in August 1975, one member observed that, during a national dispute over the WT/RT duty system Cottenham retained fire station had been turned out to fires an unduly large number of times. Cottenham FBU members had all resigned from the union so that it was now totally non-union: they should not benefit from a union dispute. It was suggested that Cottenham be 'blacked' entirely. On being told of an enquiry by the Deputy Chief Fire Officer, the Branch decided that, if this were unfruitful, the issue would come back for further consideration.

At the next meeting in October, the Brigade Committee Chairman said that the Consultative Committee of the Cambridgeshire County Council had recommended to the Public Protection Committee that the WT/RT system end on 1 January 1976. On recruitment to the union at Cottenham, he said that there was one volunteer who was sounding out other personnel (he had also warned the Divisional Commander that the Branch would take sanctions against Cottenham during the recent dispute). None the less, the Branch agreed that (1) no food would be prepared for Cottenham on jobs; (2) none of their hose would be cleaned at Cambridge; (3) they would be sent to Coventry (ostracised); and (4) no equipment for their functions would be sent from Cambridge.

When the Divisional Commander was told of the sanctions, he said he was somewhat alarmed because the union appeared to be attempting to 'involve the Authority in your domestic affairs'. However, in a subsequent meeting, he did not query the legitimacy of the sanctions. The Brigade Committee was informed of this fact, when it was stated that the sanctions would continue and probationers were not at risk. Two members resigned, however, one a Sub-Officer with twenty-six years' membership. At a Branch meeting in December, it was agreed to step up sanctions against Cottenham by refusing to drill with them, which was then conveyed to the Divisional Commander.

All this while, the Brigade Committee had been silent on the issue of the sanctions on Cottenham. On one occasion late in 1975, Tony Pettitt accosted a branch official, saying 'we're not supporting Cottenham', meaning that the Brigade Committee would not support the branch's sanctions. This was strange, to say the least, because there had been no official word of the Brigade Committee's stance. But it was the response of a cautious senior official, concerned that a strong reaction on the part of the employer over a petty local issue would split the Branch as had happened in 1951. The potential for building the union was never exploited by the

Brigade Committee, a lesson that was learned by all at the outcome of the episode and was taken to heart in a bigger dispute later in the year.

The outcome arrived soon after. The Branch was told in January 1976 that Cottenham was prepared to join or rejoin the FBU, upon which all sanctions were suspended. In the event, every Cottenham firefighter joined or rejoined. There was a fraternal celebration at a Cottenham pub between the Branch Committee and Cottenham after their drill night, to 'heal the wounds'. The Deputy Chief happened to drop in and did a double take at seeing the whole company amicably assembled. He recovered his wits well enough to put £5 on the bar for drinks all around.

A bigger dispute ensued. Like Cottenham, it involved the WT/RT system. Nine FBU members at Huntingdon Fire Station had refused to accept the union's rulings over working the WT/RT system and one of them, a local FBU official, had written to the Chief Officer stating that the Branch would continue to work the system in spite of any rulings or actions on the part of the union. The letter was not the result of any Branch meeting or policy. For this, all nine had been 'expelled from the Union *sine die*', i.e. they had been suspended indefinitely. One of these nine had been promoted to Sub-Officer and was to take up his new position at Cambridge.

This time, the initiative for action came from the Brigade Committee, which supported the 'blacking' of the new Sub-Officer by the Branch. The Branch Committee met and decided to tell the Divisional Commander that 'The Branch will send this man to Coventry and adopt an attitude of total non-co-operation with him whilst he is on the station'. The Divisional Commander forwarded the letter to the Chief. Less than a week later, the Committee met again and decided that members should not ride with the Sub-Officer if he appeared on the station, a major escalation of the original action and one again endorsed by the Brigade Committee.

Ten days later, the Chief sent a statement to all stations in the Brigade and to all Cambridge firefighters individually. In it he summarised the promotion process and said that the union's action was discriminatory. He said that the move of the Sub-Officer to Cambridge would depend on the manning situation at Huntingdon (which gave the Chief discretion as to whether and when to precipitate the dispute). He then recounted the stages in the dispute. He said that he had told the Brigade Committee that if it were unable to have the branch withdraw its original letter, the issue would, as a matter of principle, have to go to the Joint Consultative Committee (JCC) of the County Council. The Brigade Committee spoke with the Cambridge Branch whose position did not change; there was then a meeting between the Chief and the Brigade Committee. At that meeting, the Brigade Committee alleged that the Chief had been provocative by confirming the Leading Fireman's promotion and that the Promotions

Board had been biased. The Chief said that there was no foundation whatsoever in these allegations and that he had now arranged an early meeting between himself, the Chief Executive of Cambridgeshire and the FBU Brigade Chairman. The Brigade Committee Chairman said that if the individual appeared at Cambridge, the whole branch would go into dispute as well as taking the action already announced.

At the same time, the Chief had very cleverly shifted the terms of the argument from one about the rights of union members not to work with a blackleg to one over the right of the management to promote according to procedure. It should also be assumed that in contacting the CEO of Cambridgeshire, the Chief had said that he could not guarantee fire cover for Cambridge in the event of the Sub-Officer taking up his appointment. There were shades here of the 1951 dispute. In that dispute, the union had not threatened fire cover. Yet the Chief suspended the members from duty and was responsible for reducing fire cover for the City. So with the current dispute. On paper, the Chief had a number of options, e.g. crewing the new Sub-Officer's machine with senior officers or keeping the new man on non-riding duties till the dispute were resolved. But no one seriously expected the Chief thus to condone the union's actions. If the Sub-Officer appeared, there would be an ugly dispute in which union members would be suspended and fire cover reduced.

The meeting was held the next day. Present were the Chief, the Cambridgeshire Chief Executive Officer (Mr. Barrett, also a member of the National Joint Council for Local Authorities' Fire Brigades), the principal Brigade civilian administrator (Mr P.E Casey), the Cambridgeshire Industrial Relations Officer (Mr. M. Smart) and from the FBU, Tony Pettitt, Tommy Tucker and this author. The CEO considered the Union's stance 'irresponsible and immature'. He was adamant that the new Sub-Officer would appear at Cambridge; that members would be disciplined if they refused to ride with him and that the Joint Consultative Committee (JCC) of Cambridgeshire would not be sympathetic to the union's case.

There was the same ambivalence over the nature of the dispute. The union first asserted that it was not objecting to the promotion of the individual, saying the issue was one of trust and comradeship, which were essential to firefighting. But the union was then drawn into a lengthy debate over the relation of the promotion procedure to the union's actions concerning the individual's appearance at Cambridge. It is not clear whether the union was being sidetracked or whether it saw the general promotion system as a way of settling a dispute about a particular individual. The meeting was inconclusive, the union saying it would report to the branch the same evening and that it would request a meeting over the promotion system, to be referred if necessary to the JCC. The CEO said that the FBU

could 'no longer go into dispute without some loss', a veiled hint from the management side that 'emergency calls only' had become too easy, a constant irritation that resolved very little.

At the same time, there were seeds of a compromise. The union suggested that the individual be posted to Cambridge, then quickly transferred, to which the CEO said that 'no management could agree to such a compromise'. The Chief's 'offer' was that the individual would go to Cambridge but that if he were found lacking, senior management would take appropriate action. The Chief said that there was no intention of the individual being sent to Cambridge until the 'full consultative machinery had been exhausted', meaning that he would no longer use manning decisions at Huntingdon as a way of precipitating the dispute.

Up to this point, all decisions had been taken by FBU Committees on behalf of the membership. At a Branch meeting following the day's negotiations, the Branch and Brigade Chairs explained the position and invited discussion. The first point made forcefully from the floor (by Graham Williams) was that promotion boards and the transfer of the individual were different issues and should be kept apart. This was a welcome clarification. A second point was if wages were stopped, it was likely to be that part of the 1974 pay rise which was for FP work. There was some protest at the initiatives taken by the Branch Committee but,

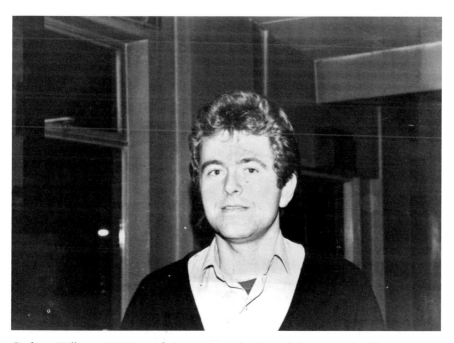

Graham Williams, FBU Branch Secretary at the time of the national strike.

in the event, its action was endorsed with only a few contrary votes and abstentions. The Brigade Chairman said he would seek support from the Regional Committee but that the dispute had not proceeded far enough to involve the FBU Executive Council. There was a protest against the Chief Officer's circular, which was seen as bypassing the union and which was to be referred to the union Head Office. Among the items of other business was a protest against the lousy design and poor construction of the pins holding the new cap badges, to which the Chairman responded 'let the bloody things fall off'.

The Chief made the next move. He contacted the union's Assistant General Secretary, Dick Foggie, informally, who in turn contacted the Brigade Committee over a proposal for a local closed shop (FBU membership to be a condition of employment) as a way of resolving the dispute. A further Branch meeting was held, in which the first point made from the floor was that the Chief had contacted a national EC member over the head of the Brigade Committee. Foggie's view for his part was that there would be no discipline charges against those who refused to ride, only some stoppage of pay. The branch, however, stuck to its guns and resolved that 'the FBU will not accept any overtures from the CFO' for the acceptance of the individual at Cambridge. In particular, it rejected the closed shop in return for the acceptance of the individual, since this would involve taking back someone who had been expelled. Like the issue of the promotion system, the issue of the closed shop was, for the branch, a non-starter.

The Brigade Chairman said that a meeting of the County Council Joint Consultative Committee was coming up and that the Chief would not do anything until the JCC reported its findings. The decision of the branch would be conveyed to the JCC.

On Thursday 2 September, the Brigade Committee, together with Bill Deal, the FBU Region 10 EC member and later President of the FBU, met at Cambridge Fire Station for a final briefing prior to the JCC. The group went to Shire Hall for 10.15 but were kept waiting for twenty minutes while the JCC was, presumably, working out its strategy. There were about fifteen of them, including the Chairman of the Council, Mr Horrell; the Chairman of the Public Protection Committee Mr. Franklin; the Cambridgeshire CEO, Mr. Barrett; the Industrial Relations Officer, Mr. Smart, and several other Committee members. The CEO opened the proceedings but was otherwise silent, though he no doubt had a lot to say during the two breaks in a four-hour meeting. The Chief was very much to one side. He looked down all the time and seemed half asleep while his boss and his employees did his job for him. One Tory was strongly against the union but the leading employers all seemed reasonable and

impressive in different ways. The Chairman of the Council was like a paternalistic doctor. The Chairman of the Public Protection Committee said little but again exuded authority and only opened his mouth when he had something definite to say – and always in favour of the union.

The FBU Committees had prepared a Submission, which this author wrote, for the Committee in which they rehearsed the history of the episode and stated their case. That the dispute was about the promotion system was explicitly denied. The stance of the Committees was that the JCC should allow the Chief to exercise discretion in the case, trusting that he would exercise appropriate judgement. The author queried this curious tactic in a tentative way; it was based on the supposition that the union would get a better deal from the Chief than from the fire authority.

It soon became clear that the Committee was unanimous that the new Sub-Officer would come to Cambridge Fire Station, whether the union liked it or not. During the breaks, the union Committee talked about time limits, after which the individual would go non-operational till transferred. But the County Committee would have no truck with time limits and the union had to take back a response without definite time limits.

In the event, the JCC did not hand the dispute back to the Chief but made its own ruling, which was surprisingly favourable. Whether anyone in the FBU had used their Labour Party contacts to influence the JCC is not known. In its ruling, the JCC said that it recognised the union's problem; it said that the individual would be transferred to Cambridge Fire Station but that the position would be kept under constant union-management review; that the Authority was 'prepared to transfer' the individual at the earliest opportunity; and 'it is accepted that there will be normal working' during the period of the transfer. The ruling also said that the management would have to consider the individual's employment rights. In response to the issue of the promotion system, the JCC said that the County's Public Protection Committee in consultation with the Chief would monitor all transfers and promotions within the service. This was presumably to head off a repetition of the current case. This was the ruling; it was not presented as an offer.

The 'offer' was discussed at a well-attended branch meeting the following month. Present were all of the Brigade Committee, Pat Baker of King's Lynn Fire Station who was the No.10 Regional Chairman, and Bill Deal of the FBU Executive Council. Before the meeting, there had been a meeting of the Regional Committee at Tony Pettitt's house. These Regional officials called the Branch Committee out of the lecture room just prior to the branch meeting and asked: were we going to recommend the offer. We all said yes and policy finally crystallised around the offer. Ken opened the meeting and explained the consequences of not accepting

the offer. He said that we had lost round one in that the Sub-Officer was coming to Cambridge Fire Station, come what may. He then said that the next fourteen rounds and the knockout were ours, inflicted on the Chief. He then went into the details of the offer.

Bill Deal spoke next but both speeches were low key and not obviously well received. Then one outspoken member got up and railed at us all for even considering the offer. During one of several breaks in the meeting I asked Tommy whether this individual was reliable, since it is the oldest trick in the book to put forward a principled position, knowing that it will be outvoted. Tommy said that he was. The individual's speech got Bill Deal going. He gave a rousing speech in which he said that he been involved in two similar disputes in Essex; how he had lost one and won the other; how the FBU General Secretary had refused to back the winner of the two; and how three thousand quid had to be raised to cover forfeited wages. This fetched applause. General discussion followed, centring round the possible fate of the new Sub-Officer. Crocker wanted to discuss what we were going to do, short of the normal working clause of the offer, but Ken steered him away from this, since we could not be seen to be engineering the non-working of an accepted offer.

In the event, Crocker was unpersuaded and, with four others, voted against the offer. He didn't stay for a drink but discussed it calmly on duty the next day. Jonah abstained and was shouted down by several of the nay-sayers for doing so. Surprisingly, he was upset about this and drew me aside after the meeting. He said that he had abstained because he was against the offer but didn't want to go against the vast majority. He talked about it later around the bar and cheered up.

The actual vote was typical of such meetings. As soon as the motion was proposed, the bells went down and four of Red Watch disappeared. Preparing for the vote, the bells again sounded, the men returning when the turnout was from another station. During union meetings, whenever the 'nines sounded, there was an immediate clattering of chairs and the duty watch strode towards the pole-drops in the corridor outside. Occasionally, a member was speaking when the 'nines sounded. He would continue speaking while moving towards the door of the lecture room, abruptly stopping when the big bells sounded. Since there was no indicator board in the lecture room, he had to descend to the appliance bay in case his machine were called out. As often as not, he would return, '... as I was saying ...'.

It had been clear for some time that the new Sub-Officer was, by accident or design, to be assigned to the least solid of the three watches. I approached Bill Gyles and sounded him out. He said that it was no bad thing that the individual was to go on his watch as it would force members

to come out in their true colours. Bill expected a repeat of 1951 and said that he would try to ensure that members behaved as the majority had done during the lockout. At a similar dispute at Battersea, concurrent with this one at Cambridge, the firefighters were not locked out. Machines from neighbouring stations were sent to fires. After the meeting at which the offer was accepted, the Brigade and Branch Chairs stayed behind to talk with the watch concerned, anticipating some trouble which later occurred.

In subsequent correspondence between Dick Foggie and the branch, the FBU Assistant General Secretary acknowledged that the idea of a local post-entry closed shop had not been a promising solution to the dispute. While urging the Branch to pursue the idea in co-operation with the FBU Regional Committee, he agreed that the position of members expelled over the WT/RT dispute (some hundreds nationally) would make a closed shop agreement very difficult. The closed shop avenue was comparable to the issue of the promotion system: it was neither the problem nor the solution.

Discussions on the closed shop did however continue with the fire authority into 1977, with the help of the Regional Committee, in which the Union Membership Agreement between the FBU, with other unions, and the Greater London Council was cited as a guide and model.

When the individual appeared on Cambridge Fire Station he was ostracised to the extent compatible with 'normal working' but several of the junior officers did not take part. A couple of written reports from firefighters complained that he had not done his job as No. 1 on a machine, e.g. checking his BA set, a job traditionally done by his No. 3. By the time the Annual General Meeting of the Branch was held in November 1976, the individual had been transferred off the station.

The Branch Chairman reported success in the first half of the year, especially over training exercises and the recruitment of all Cottenham personnel into the FBU, but said that this was marred by the biggest and most recent issue. He claimed that he had been let down through the way that certain members had behaved towards the individual transferred and that he was being ridiculed by those with whom we negotiated. He also complained of lack of communication with the Brigade Committee. He declined to stand for another year.

Concerning the way that certain members had behaved towards the individual, Ken was correct. Some junior officers – including a few who, as Firemen, had been disciplined as a result of the 1951 dispute – had welcomed the individual and made no secret of their disagreement with branch policy. One firefighter was bollocked by a junior officer for having been rude to the new Sub-Officer.

However, despite the talk of 'taking away their cards' and discipline by the branch, no action was taken against them, nor did any of them

resign from the union. The fact was that the most recent issue had been handled with skill and commitment. The compromise reached was very far from a sell-out. Ken Aldred left the chairmanship after a year of great accomplishment – and as mysteriously as he had taken union office.

There were a number of significant things about the most recent controversy. First, the union had succeeded in taking the issue out of the hands of the Chief and into those of the employer – the fire authority. Most local negotiations were with the Chief and the senior officers, with management rather than with the employer. Most of these in turn were of little concern to the fire authority, because they were not seen to increase costs or impair efficiency. In this sense, the union was mostly a vehicle for firefighters to argue among themselves. It was only nationally, on major issues of pay, benefits, and conditions of work that the union did indeed negotiate with the employer.

Second, the dispute was an explicit challenge to managerial authority. Even though the result was a compromise, the union could rightly claim that the employer alone did not determine who would work where, and under what terms. Next, the issues and what would count as a resolution were obvious. But the vagaries of the dispute, the leads, diversions, misconceptions and false avenues meant that neither side could be confident of a clear resolution, that there were weaknesses as well as strengths in both sides' conduct of the dispute. These strengths and weaknesses were not a direct expression of the industrial powers that both sides could bring to a dispute.

Further, the progress and the outcome of the dispute cannot be understood without reference to a whole series of events and informal contacts which were as important as the formal meetings and decisions. Early on in the dispute, the Chief had phoned Ken Aldred, ostensibly to talk about the brigade fishing match. Ken's responses were punctuated with rather a lot of 'sir's. He said that he had to go to see the Chief in the afternoon. Ken was then told in a phone call from Tony Pettitt that the Chief had contacted Dick Foggie, the FBU Assistant General Secretary. Foggie evidently told the Chief that the union head office would support the men 100 percent and said that it was a serious matter. 'Of course', wailed the Chief, 'they've refused to ride my fire engines'. It was at this point that the closed shop became an issue, as a term in the possible resolution of the dispute. Later Tony said that the Chief had called him about a brigade-level meeting on overtime and promotion boards – another palpable excuse to discuss the matter of the new Sub-Officer.

Tony also said that he had told the Chief off the record that the dispute would have to be won by someone and he had no intention of losing this one. He said that he foresaw a compromise in which the new Sub-Officer

would take up his appointment but both he and the Chief could come away 'heads high'. How so, asked the Chief. By giving us a closed shop. Perhaps he raised too the idea of the union also having an observer on promotion boards, which was being discussed as a further condition of settlement. All this while Ken was on his way to discuss the fishing match with the Chief.

Ken returned the same evening and said the Chief was falling all over himself to be of help over the fishing match, even offering cash out of his own pocket if the Council did not come up with enough money for the reception. The Chief then went on to ask Ken why he had not applied for promotion and this developed into a discussion as to why things were falling to bits in the brigade: because the Chief and co. were miles away at Hinchingbrooke, the brigade HQ, with a crowd of inexperienced idiots in charge in the South Division, said Ken, by his own account. The Chief said that he did not want to talk about the union, but it would be too much to deny that the Chief did not want to buy Ken off.

When the terms of a possible settlement were broached informally with Blue Watch, there was a strong hostile reaction, from KC and Graham Williams in particular. But Ken Aldred was among the compromisers at this stage, showing that his firmness of touch was not always complete. It was not the first time that the Committee people had misread the branch, earlier mistaking a genuine, open questioning of the Branch Committee's moves for a negative scepticism. Again, after the meeting with the Chief Executive, in which he threatened discipline charges and stoppage of pay, both Tony, Tommy and I were working out what we could salvage from the dispute. Even Ken thought that the vote after the meeting with the County Council would split the branch or that they would reject the offer, both speculations being far from the truth.

At a Brigade Committee meeting at Huntingdon Fire Station, the atmosphere was icy. The bar was shut and Tony's wife and young niece had to sit in an empty Clubroom. One Huntingdon member said that, yes, the Leading Fireman had indeed consulted the branch before sending his letter to the Chief, thus questioning one of the cornerstones of union policy.

All the while, the union was trying to read the intentions of the other side. Dick Foggie, for instance, based his projections of the employer's responses on the fact that he knew the Chief Executive Officer from the NJC meetings in London. The curious ploy in the union Submission to the County Council, requesting that the Chief be empowered to settle the dispute, was based on indications – to Dick Foggie and Ken Aldred among others – that he was anxious to settle the dispute. In informal discussions with Maurice Smart, the county industrial relations officer, Foggie said

that the Chief had gone to the NJC in London where he stated that fire cover was threatened and that troops may be needed. The NJC was giving him full backing. The Cambridgeshire CEO in turn was urging the Chief to put the new Sub-Officer on Cambridge Fire Station as soon as the County Committee had given him clearance. These deliberate leaks and scare tactics were accompanied by friendly sentiments on Smart's part, which was again taken as an indication that the Chief wanted a settlement.

It is arguable that the leading episodes of 1975-76 were really not significant. All they did, on the whole, was to restore a status quo, requiring the employer to acknowledge or stick to existing agreements, for instance over training exercises and the WT/RT system. This may be so. The fact is, however, that local union militancy over such issues was the lifeblood of the union. Without this sort of activism spread throughout the country, there could be little success on national issues and no foundation for a national strike. At the time, it was fashionable to play down the importance of local activism and the role of shop stewards in the industrial life of the country, seeing these things as ephemeral and not an essential part of industrial relations or the economic structure of the country. If these local disputes are a guide, this does not seem to be true.

At the time of the dispute of 1951, there was talk of the service being run by Workers' Councils, which gave way to the concepts of industrial democracy and workers' control. It is quite true that increasing the scope and content of bargaining and negotiation increases workers' control of their working lives; but it would be a mistake to see industrial democracy as a product of bargaining alone. In the end, there is still an employer, there are still two parties to an enterprise, there is still a party in power and authority which sets a limit to workers' control. What a few – a very few – firefighters envisaged was that workers as a group contract with the fire authority and organise themselves as they think fit, pretty much along the lines of union organisation and collective self-direction. This is a coherent and egalitarian idea but the danger is this: if a fire authority can contract with one group of workers it can also contract with another group or even a private company. (In North America, offering the existing workforce a contract, to be followed by general tendering, is a common mode of privatisation.) Workers' control from one point of view looks like privatisation of the service from another. However much the firefighters may have despised the bureaucracy of senior officers, their role in keeping the service public was crucial.

3.6

The First National Firefighters Strike, 1977-78

In retrospect, the first national firefighters'strike of 1977-78 seems inevitable. In 1971, police pay parity had been lost for twenty years, yet firefighters' pay was still £2.58 more than average male industrial earnings. By 1977, pay was £65.70 per week, which was £12.90 behind average male earnings. For over a decade, successive reports on firefighters' pay had been nullified by government incomes policy and wage restraint. This was the occasion of the nine-week strike; the intransigence of the Labour government was the main reason that the strike went on for so long. On the eve of the strike, the union's position was a pay formula that would bring the qualified firefighter's wage up to the national average of £78 a week, plus ten percent for hazardous work and special skills, for a total of about a thirty percent rise or £20 per week. The Labour government was determined to restrict pay increases to ten percent, which would have given firefighters less than a third of what they were demanding. At an FBU Recall Conference in November 1977, the 300 delegates voted on behalf of their members in support of the pay claim, 25,874 votes in favour of a strike on 14 November, 13,752 against, a majority of about two to one. There was an immediate and almost 100 percent response to the strike call. This was in marked contrast to the national vote against supporting the Glasgow strikers in 1973. At the Recall Conference of 29 October 1973, there were 20,302 votes in favour of Glasgow resuming normal working and backing the EC in the fight for the 48, with 12,197 against.

How was it that the attitude towards striking had so dramatically changed? Was it that firefighters had succumbed to peer-pressure? One reason for the apparent change in attitude towards striking was that the

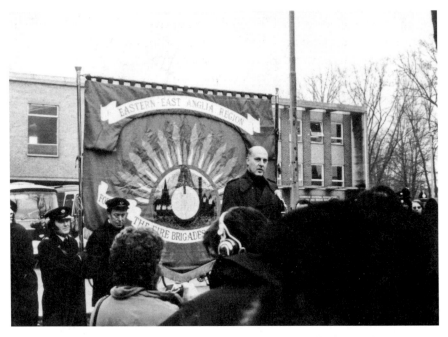

Gordon Honeycombe, author of *Red Watch*, addressing a rally during the national firefighters' strike. Bill Deal, a future President of the FBU, is to his right. (*Cambridge Evening News*)

situation was far more frustrating and desperate in 1977 than it had been in 1973. But the main reason, this author believes, was that the situation concentrated minds in a practical way that previous sentiments and speculations had not done. The firefighters' true beliefs were a function of the situation, not the product of polls or measures of attitude. Another reason was that, even while voting in favour of the strike, many conference delegates and union members thought that the threat of a strike alone would force the government into breaking the so-called Social Contract, known at the time as the Social Con-Trick.

At Cambridge, the picket line outside the fire station went up immediately. The aim was to publicise the dispute, to collect donations and to prevent the machines from being manned by strikebreakers. Johnny Mole, a local caterer who had employed firefighters part-time, donated a heated caravan (trailer) for the duration of the strike, supplemented by a brazier fuelled with scrap wood. The union branch sent 'flying pickets' to fire stations in the FBU Region such as St Ives, Newmarket and Bishop's Stortford. Firefighters also picketed Fire Service Headquarters at Hinchingbrooke Cottage near Huntingdon. The control operators at Cambridge were transferred to a central control for the whole county at Hinchingbrooke

and they continued to work throughout the strike – including a retired control operator whom the Chief had recruited for the occasion.

If the union did not use its Labour Party contacts in 1976, it certainly did do over the strike. In the days leading up to the strike, Tommy Tucker went to meet with the local Labour Party to convince them that to take on the Labour government was a good idea. Surprisingly, they agreed, even to the point of letting the union use their office and phone facilities for the duration.

The employer could call on several resources to meet the emergency. The first were the NAFO officers and other non-FBU members. Nationally, NAFO had reached an agreement with the local authority employers on the NJC that they would not work, not cross picket lines, but act only as advisers and escorts to the troops who were taking the place of striking firefighters. In several parts of the country, NAFO officers actually engaged in firefighting, which led to the picketing of army depots. In Cambridgeshire, officers did occasionally work, for instance at road accidents and smaller things like wielding fire extinguishers and turning off smoke alarms. However, this was not enough to cause bad blood.

The fire authorities' first line of defence were the ancient Green Goddess fire engines. These were machines built in the early 1950s for civil defence. They were equipped only with pump, hose, branches and a 30' ladder, no BA and almost no ancillary equipment. The government had 850 of these available, with 9,000 troops to man them. There was enough manpower to crew the machines week in, week out, but without much leave or a break in the shift schedule. The machines and crews were, however, completely inadequate for road accidents, large fires and even small ones, where skill, timeliness and proper equipment were needed. Most of the troops had only four hours training, plus whatever training the NAFO officers could provide. Since the crews did not know the topography of the city and the county, they had to be escorted to incidents by officers in fire cars. The union was hoping that there would be no loss of life during the strike but at the same time the troops would be worn down. Despite huge property losses during the strike, the troops do not seem to have suffered from exhaustion, which was one reason that the strike went on for so long.

There were two Green Goddesses stationed in a depot at Coldham's Lane in Cambridge, equipped with radios, though it took a few days to supply these machines with call signs and institute a radio procedure. The employer could also call on rescue vehicles and fire engines from local RAF stations: the record shows that these turned out to fires at about the same time that the government announced the availability of 33 such machines nationally. These were properly equipped all round, including BA and with trained firefighting crews. At Cambridge, this caused no resentment.

Crocker, as the FBU Branch Chairman and an ex-serviceman from an army family, attempted to establish fraternal relations with the troops at Coldham's Lane. When we consider that the Glasgow strikers applauded the troops as they left the fire stations at the end of their strike, we can see that the idea of a universal brotherhood of firefighters was more than mere sentimentality.

There were also local self-help groups, who attended fires and accidents, sometimes under supervision, at other times not. The union learnt of one such accident at the edge of the county where three children were trapped but fortunately not hurt. Naturally, the union did not object to this and advertised the fact that it would give assurance and advice on fire prevention to anyone, particularly pensioners, who asked for it.

The union had one great asset. Using a short wave radio, it monitored the Cambridgeshire fire control network, enabling the union to gauge the effectiveness of emergency response, how the system was bearing up under the strain and whether there was any strikebreaking going on. (The main purpose of the flying pickets was to reinforce the efforts against retained fire crews in the East Anglia Region who were still working.) In an operation worthy of military intelligence, the union kept an exhaustive and detailed log of incidents and responses. The mobiles on fire cars were identified in the messages by number. Sometimes, an officer would reveal himself by name; at other times the union used voice recognition and was able to identify both cars, their drivers and the resources that officers were utilising at fires and other incidents, such as the Green Goddesses, the RAF appliances and the self-help groups.

The fire control also, of course, used the phone system, particularly for communicating with self-help groups, and over this the union was quite blind. Or almost blind. Crocker gleaned that emergency phone messages were being passed from the police station next door to an officer in a fire car parked at the back. He marched into the police station, accused the police of taking sides in an industrial dispute, threatened to picket the police station and demanded that the fire car be removed. It was. On another occasion, he learnt that an officer was attending an incident near the fire station. He drove round to the street and surprised the officer who, in embarrassment, beat a hasty retreat.

Nationally, at the time of the strike, 9,500 of the 16,000 retained firefighters were in the FBU and 5,000 in a new rival organisation, the Retained Firefighters' Union, who crossed picket lines and fought fires during the strike, e.g. at Epping and High Wycombe. One individual was known to have approached Cottenham firefighters to induce them to join the retained firefighters' union and break the strike. There was a certain irony in this, as Cottenham had gone from being anti-FBU to one

of its staunchest supporters. In the Cambridgeshire South Division, some retained stations worked only in their own immediate operational areas, while others such as Sawston, Swaffham Bulbeck, Papworth Everard and Gamlingay 'shut the doors' .The only retained crew in the Cambridgeshire South Division which worked outside its operational area during the strike was Huntingdon, as well as the Peterborough Volunteer Fire Brigade, a unique service that had been part of Cambridgeshire since the local government reorganisation in 1974.

The union had no strike fund and firefighters were not paid for picketing duty. The branch relied on donations to pay expenses such as petrol and, above all, food. Donations came mainly from the collection box on the picket line, from individuals and from unions. There was even a substantial donation from NAFO officers, disguised as a contribution to the Mess Club. A main contributor was the union Chapel (branch) of the *Cambridge Evening News*. Two years later, the Cambridge branch of the FBU repaid the journalists in kind, during a newspaper strike, with the Father of the Chapel sending a warm note of thanks to the FBU. I had started this fraternal exchange in 1976 through my friendship with Ron Knowles, a *Cambridge Evening News* journalist, later a National Union of Journalists Executive member, the scourge of the press barons and the editor of *The Journalist*, the union newspaper.

Tommy Tucker handled press and media relations on the brigade level while Crocker did the same for the branch. Crocker's letters to the *Cambridge Evening News* attracted several responses. Some were sympathetic, others simply comments, and the few that opposed the union's actions were always respectful in tone. Throughout the strike in Cambridgeshire, public support was initially strong and did not flag much during the strike. In the East Anglia Region, the Chairman, Gary Burfield, was injured in a road accident and Tony Pettitt took over his responsibilities. He spent little time on the Cambridge picket line, something that did not go unnoticed and which caused resentment in some quarters. The bulk of the work on the Brigade level thus devolved on Tommy Tucker and on the Treasurer, Alan Payton, another example of the way that those with no particularly strong union views rose to the occasion, in both effort and achievement.

One of the many issues that Crocker had to handle was the use of the fire station by the strikers; on this, he had a friendly meeting with the Chief's representative, Divisional Officer Smythe, one of a succession of outsiders who had taken The Major's job. Smythe was prepared to turn a blind eye to the use of the kitchen but insisted that it must be kept clean. Over sleeping on the station in the dormitories, Crocker had to

put his foot down, reminding members that Johnny Mole's caravan slept four.

In this, there is a clue as to the attitude of the NAFO officers. Most of these were still local men, not the career officers who flitted from brigade to brigade, promotion to promotion, 'like gypsies', as one union member unkindly described them. John Beynon visited the picket line; another officer wrote a highly sympathetic letter to the *Cambridge Evening News*, in support of the strikers and their grievances. Not all of this was fraternal and altruistic since the officers would benefit proportionally from any gains the firefighters might make as a result of the strike. Nevertheless, relations were far from bad: at one union meeting early in the dispute, Crocker invited three of them (Bob Bunday was one) to a union meeting to 'show local solidarity', and promising them a courteous hearing. There was method in all of this, yet the offers to the officers and the troops were all part of Crocker's mental and practical outlook, combining generous gestures with uncompromising militancy. What a guy! He even had flowers sent to Johnny Mole's wife.

One of the many jobs of the branch officials was to ensure that the strikers got social security benefits for their families. In this, they got the help of the Claimants' Union, which visited picketers at several fire stations. When the government restricted benefits in what was in effect an ill-advised provocation, this let to a union sit-in at the local social security office.

Early in January, some firefighters were already drifting back to work, particularly in the south of England. At the Recall Conference in Bridlington on 12 January 180 delegates from 63 brigades voted by a majority of almost three to one (28,729 to 11,795) to return to work. Technically, the strike was a defeat, since the government had stuck fast to its policy of wage restraint. In the longer run, the strike was a resounding success: the new pay formula came into force the following year and the 42-hour week in November 1979, by adding a further shift, Green Watch, and additional personnel.

Before the strike, the Chief had made up a few junior officers to Station Officer, to get them out of the union and on the employer's side during the dispute. During the strike, one member resigned for financial reasons. Another, an anti-union individual, had been talking about retirement in the year before the strike and did so during the dispute. One other individual objected to firefighters' striking on religious grounds. The branch discussed his case at a meeting on November 24. It was agreed that he could work by standing by as a fire picket at a local home for disabled people, but as so often in such tense and messy situations, the attempt at compromise failed and the individual quit the job. One alleged reason was for the

failure of compromise was that the individual made anti-union statements to the press. In all, said Tommy Tucker, about five firefighters in the South Division continued to work, 'but they did not do anything constructive as there were no facilities for them to use'.

Nationally, nearly 2,000 FBU members were recommended for expulsion from the union for not striking; but in the end, only about 200 were deprived of their union cards. Of these, even fewer lost their jobs as a result of a local closed-shop agreement. Many more were forced out because of the sort of animosities that arose out of the dispute of 1951. Of the thousand or so who resigned during the dispute, most were said to have left because they thought the resolution and return to work were a sell-out. The limited evidence of Cambridge suggests that the predominant reason was hostility to the principle of striking.

When the Cambridge firefighters returned to work after the strike, there were tense moments, with both the officers and the union leaders looking out for provocation. One such incident was a memo from the City Council on 'guidelines' for the union over returning to work. This was regarded as an insult, since return to work protocols had been agreed nationally and there was no need to insist in detail on the terms of local working. There was an attempt to discipline Crocker for insubordination: he had invited the President of the Trades Council to a union meeting on the station to thank him for support during the strike. Crocker fought back and, with Tony Pettitt's help, the employer's case came to nothing. Graham Williams at one watch meeting in the lecture room ostentatiously turned his chair and his back to the officer in charge. He had clearly come a long way from the neophyte Branch Secretary who professed not to know why we were union activists. But these tensions soon died down. The men were anxious to get back to a normal life.

Epilogue

They all want to be Chiefs

In 1977, I applied for a job as an Industrial Tutor in the Eastern District of the Workers' Educational Association. The job was to teach WEA courses in the whole range of trade union issues, with a focus on TUC courses in shop steward training and workplace health and safety. Though I was then thirty four years old, I did not feel any urgency to change jobs. I had still not decided whether or not to pursue firefighting as a career and I had a good regular fiddle as assistant boatman for Peterhouse, under the direction of Roger Silk, the boatman of St John's College. I had also finished my PhD thesis on the station typewriter in the map room in between fire calls and I had already started to write non-fiction, for which there was plenty of time. The life was agreeable. On the other hand, I had not taken the promotion exams seriously and did not do well in them, finding the Manuals of Firemanship stuffy and tedious. Tony Pettitt agreed to write a reference for me, despite some caustic comments about my flirtation with the rank and file firefighters' movement: by this time, the rank and file movement had reached national notice, with suspensions from office of FBU officials, one of them from Essex. So I left firefighting just before the strike of 1977-78 and took up instructing WEA courses. Most of these were in the industrial new town of Harlow but there were also some at Bayfordbury House in Hertfordshire. This was a rather dingy nineteenth century country house whose only distinguishing feature seemed to be an original Thomas Crapper flush toilet.

The principal characters in this book have all retired, some of them prematurely with back trouble, the bane of the firefighter's life. Their

contact with fellow firefighters faded with time, so 'mates' dwindled to 'friends', with only a wider contact at station reunions or a fire brigade funeral. Tony Pettitt, for instance, vanished from the social life of the station, whereabouts unknown. (He had in fact continued to live in Cherry Hinton and, to everyone's surprise, showed up at the 2007 reunion.) The intense comradeship and social contact was very much a function of the shared predicament at the time.

One of those who had retired was the late John Mallon. John Beynon, Mallon's Deputy Divisional Commander, gave the speech at his retirement dinner. It was said that John Beynon did not get The Major's job because he had praised Mallon as a true firefighter whose heart was in firefighting and who led from the front. This was not the sort of language the Chief wanted to hear, nor the sort of profile of a Divisional Commander that he wished to promote. While the true version of the story is more complicated, Mallon's retirement marked the passing of an era. Fewer ex-servicemen and qualified tradespeople joined the fire service, more with formal educational qualifications. Increasingly, the job became a career rather than an occupation, however singular. Much of the rebellion, piss-taking and bonhomie disappeared from the job, replaced by the earnestness of getting on in life. The Club bar was limited to special occasions and staffed by off-duty firefighters, those on duty forbidden to drink, or even to be in the Clubroom while the bar was open. Those who were now the older firefighters complained 'the job isn't the same' as the previous generation had done before. There were more fires involving synthetic and toxic materials, more chemical incidents. Yet at the core, the job was the same. Firefighters became fitter, with regular organised exercise replacing the occasional volley ball, weight training and drillyard running.

One day in 1983, the HP vanished from the appliance bay after eleven years' service, replaced by a water tender. The TL was replaced in 1979 and exported; it continued its long career as an appliance on the Algarve. With fire control increasingly centralised, the control room disappeared and much of the headquarters side emigrated to purely administrative centres in the brigade. The fire station became lop-sided, with the HQ side for a time in near-permanent darkness, sealed with coded locks. It later became the South Division HQ.

Nationally, the service became demilitarised, as was inevitable, with a determination to do away with all things military. The military ranks were replaced with civilian titles such as Crew Manager for Leading Fireman. Some of the boys of the old brigade thought this bizarre, supposing that fire crews were there to be led, not managed. The uniform gradually changed. Belts and axes, the symbols of the firefighters' trade, had been phased out in the early '70s. Gone now were the leather boots, the distinctive helmet

and the heavy woollen fire tunics, to be replaced by the drab brown of American firefighters.

The biggest change was in the personal life of the firefighters. In the eighties, there was a rash of divorces and separations, even among those whose marriages had long been stable – another manifestation, perhaps, of individualism, the 'me-generation'.

For the union, the strike of 1977-78 was a watershed and the high point of the union's success. Whereas Glasgow 1973 had been the rare exception, regional and local strikes and disputes became the norm. The militancy of FBU members stopped privatisation from becoming a serious issue, but in other respects the union fought a defensive – and largely successful – battle to preserve the status quo of the late 1970s. The main campaign was to uphold national standards, partly against the NJC which at times wanted to erode or abolish them, partly against local fire authorities who made and broke their own rules. The Firemen's Pension Scheme, an Act of Parliament of 1973, was eroded and made voluntary. Local authorities denied disability benefits to firefighters, which were usually restored only after a struggle, legal or industrial. As long as the Discipline Code remained, it was flouted or bypassed. Every ploy was adopted – arbitrarily putting an experienced firefighter back on probation or putting non-firefighters in uniform to break a strike. The era of Margaret Thatcher was not a happy time for the union; but in an era of union-busting, the union survived, grew and prospered, a legacy of the successful strike of 1977-78.

One result of the strike, the Fire Service Pay Formula, linking wages to the upper quartile of male industrial workers, lasted for fifteen years. The first signs of union discontent with the formula appeared early in 2002. This led to the second national strike, which lasted a total of fifteen days between November 2002 and March 2003. The resulting pay increase was substantial but the new pay formula did not enjoy the lasting success of its predecessor. The employers modified the formula and dragged their feet over implementation, tying the promise of continuing payment to changes in working conditions and crewing levels.

Some local authorities made arbitrary changes to conditions of work and crewing levels, leading to renewed threats of industrial action. The FBU in Cambridgeshire largely succeeded in bucking this trend (at least in theory), by negotiating a crewing agreement that essentially confirmed the agreements at the national level. But in general, the mid-2000s were characterised by a constant battle to negotiate, then implement, national standards, in the face of local authorities who were determined to go their own way over fire cover, employment, working conditions and crewing levels.

APPENDIX

Questionnaire Revealing Firefighters' Attitudes to Their Job

This questionnaire was distributed to retired firefighters in 2007. Twenty-one responded. The responses are in bold: where figures do not add up to twenty-one, this is because in some cases, no response was given to the particular question.

NAME (OPTIONAL)

1. What year were you born in?
2. Where were you born?
3. Where did you go to school?
4. What year did you join the fire brigade?
5. What was your occupation before you joined?
6. Did/do you have any close relatives who were firefighters?
 Yes = 11; No = 10
7. Do you think it was a good idea to end the military, disciplined service that we had?
 Yes = 2; No = 18; ambivalent = 1
8. In your opinion, did fiddling among firefighters generally increase or decrease as a result of the higher pay and reduced hours after the strike of 1977-78?
 Increase = 3; Decrease = 0; About the same = 17

9. Do you think the strike of 1977-78 was a good idea, bad idea, or no
 opinion?
 Good idea = 16; Bad idea = 4 (among FBU members: 3); ambivalent = 1

10. Do you think we won or lost the strike of 1977-78?
 Won = 7; Lost = 0; Won in the longer run = 11; No opinion = 2

11. In your view, did the firefighter's job become more technical from
 about the 1970s onwards (please tick one)
 More technical = 18; Less technical = 0; About the same = 3